MINIMALIST LIGHTING

Professional Techniques for
Location Photography

KIRK TUCK

AMHERST MEDIA, INC. ■ BUFFALO, NY

DEDICATION

It's so much fun to be able to dedicate something. Of course, the dedication has to be to my wife, partner, critic, and the queen of calm, Belinda. Without her, nothing would ever get done. If everyone had a partner like her, there would be no war, no hunger, and lots of great art in the world. She and our son Benjamin are the constant source of light in my world.

ACKNOWLEDGMENTS

I've been blessed to work with some of the most talented advertising and design professionals in the world during my career, but few have been as helpful to me personally and as instrumental in my growth as an artist than my friends, Mike Hicks and Greg Barton. They've guided me in both business and visual growth.

I must also acknowledge the work of writer/photographer David Hobby. His Strobist web site provided the genesis for this work. He is a gifted person and quite the futurist where our profession is concerned. One day I hope to meet him in person.

Any business acumen I have at all is the result of my long friendship with Deborah Kobelan. She is the last word on business, negotiation, and workplace ethics, and I value her judgment above all others.

Published by:
Amherst Media, Inc.
P.O. Box 586
Buffalo, N.Y. 14226
Fax: 716-874-4508
www.AmherstMedia.com

Publisher: Craig Alesse
Senior Editor/Production Manager: Michelle Perkins
Assistant Editor: Barbara A. Lynch-Johnt
Editorial Assistants: Carey Maines, John S. Loder

ISBN-13: 978-1-58428-230-3
Library of Congress Control Number: 2007926862
Printed in Korea.
10 9 8 7 6 5 4 3 2 1

CONTENTS

ABOUT THE AUTHOR

Kirk Tuck attended the University of Texas where he dabbled in electrical engineering and English literature before accepting a position as a specialist lecturer teaching photography in the University of Texas College of Fine Arts. Soon, he was lured into the world of advertising photography and served for seven years as the creative director for Avanti Advertising and Design, where he won awards for radio, television, and print campaigns. In the 1980s, he de-

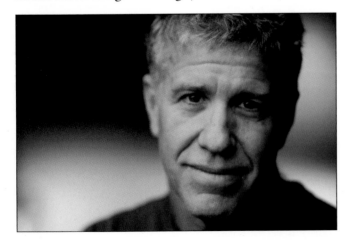

cided to become a freelance photographer, a career he has enjoyed ever since. Kirk's clients include IBM, Tivoli Systems, Dell Computer, Motorola, AMD, Freescale Semiconductor, *Elle* magazine, *Private Clubs* magazine, Time Warner, Pharmaco, PPD, JSR, The Arts Council of Texas, Southwest Water Company, Adventure Tours, and many advertising agencies. He resides in Austin, TX.

Taken during lighting tests for an advertising shoot at the Austin Lyric Opera. Suave and debonair, the author nevertheless forgot to shave and so ruined what could have been a perfect shot (humor intended). Photo by Kirk Tuck.

When I sat down to write this book I was working from the position I knew best, that of a working professional with twenty some years of experience in lighting and shooting. My big struggle was to get rid of the preconceived notions about lighting equipment I carried around and to refocus on the idea that I could get more with less.

I realize that many readers might be new to photography and have none of these prejudices. If that is you, then I hope you are interested in reading about the steps of my conversion to a minimalist style in order to understand the way photography has evolved. You needn't have the experience of working with last-generation studio flash equipment to get a lot out of the concepts we'll cover in the book. In fact, I envy you if you are coming to photography in general, and lighting specifically, with a clean slate. That means you won't have to unlearn bad habits. You won't find yourself hampered by the tyranny of too many choices, and you'll be able to work on developing a style that works well for you.

I have many friends and acquaintances who have taken up professional or semiprofessional photography recently because of the new wave of digital SLRs, which are both powerful and inexpensive. Many are starting businesses as portrait photographers and wedding photographers, and they've approached me frequently looking for advice that will make their images better and more salable. Many are finding that brides and moms are getting more and more demanding about the way photos look and are pushing new photographers to learn how to light beyond just sticking a flash on the camera. This book is really aimed at them and all photographers who want to get great results from lighting without a huge hit to their wallets and without too much complexity and encumbrance.

Photography is one of the most popular hobbies in the world. Tens of millions of cameras are sold each year. Paying more attention to lighting is a way to rise above the routine and do something special. The challenge is the fun!

INTRODUCTION

All good photographers eventually come to the conclusion that the quality of light is one of the single most important "secrets" of great photography. Great landscapes depend on the combination of unique points of view and interesting natural light. Compelling portraits depend on lighting that reveals the human face in a unique way. Product photography is made alluring when imaginative lighting is used skillfully. In many instances, photographers need to add light to a photograph to make it pleasing. The methods photographers use to add light to an image have evolved over the years, and that evolution has accelerated over the past ten years.

When I started my career as a professional studio photographer, we needed to use lights for every single shot we created. Our days in the studio revolved around designing lighting that emulated, and hopefully improved upon, the light found in the real world. We accumulated large collections of specialty lights, light modifying accessories, and yards and yards of various fabrics meant to diffuse light rays. As my career progressed and changed, we started doing more and more photographs on location around the town and across the country. It was only natural to pack and carry all of the heavy-duty accessories we used in the studio out to these locations. After twenty some years, my back was aching and I no longer looked forward to taking the show on the road. Photography had become more about packing and porting and less about designing beautiful light.

Several years ago, I challenged myself to do more with less in my professional photography. I looked back over years of shooting and realized that half the battle of location lighting was the logistics of dragging hundreds of pounds of equipment from my studio to my car and from my car to various offices, manufacturing plants, and other venues in order to make well-lit photographs for my clients. With all the advances in digital cameras, battery-powered flash units (now small and computerized), and lightweight accessories, I became convinced that photographers could do many of the assignments we'd done in the past without having to employ heavy lighting equipment originally designed to be used in studios.

WHY GO MINIMALIST?

With each pound of equipment I've jettisoned, I've found that I arrive on locations with more energy and a better ability to focus on creative problem solving. When I go home at the end of the day, I'm not worn out from dragging around a cart filled with hundreds of pounds of heavy equipment. And while I'm shooting I'm able to do many of the adjustments to my lights from the camera position using a wireless controller. That helps overcome the attitude of "good enough" that seeps into our creative work when we're physically tired.

With each pound of equipment I've jettisoned, I've found that I arrive on locations with more energy and a better ability to focus on creative problem solving.

THE BASIC EQUIPMENT

This new paradigm of lighting calls for replacing bulky, plug-in-the-wall studio lights with the kind of portable electronic flash equipment made to fit in the hot shoe of most professional digital cameras. Instead of using these flashes on top of cameras, we can better leverage the advantages of their built-in electronics and wireless con-

trollability by moving them off the cameras and into lighting situations that were once the exclusive preserve of ponderous power packs and flash heads.

Most of the location jobs I handle these days are done with a small kit of lights that include four Nikon shoe mount flash units, an infrared flash controller, a few small stands and clamps, and two or three little light modifiers. Everything I need for the typical location portrait or editorial photo shoot, including my cameras and lenses, packs down into one wheeled case. On a more complex job, I may also throw an extra camera bag on top of the wheeled case with some extra gadgets and rolls of tape.

A WORST-CASE SCENARIO
WITH THE "OLD SCHOOL" APPROACH

A few of my clients questioned my approach until they saw how much more quickly our projects went—and that we still delivered the same level of quality we had in the past.

Some of my fellow photographers still shake their heads when I talk about minimizing our lighting loads. They have methodologies that they believe work well for them, using equipment they've already bought and amortized. For years, I shared their viewpoint and kept a complete inventory of very expensive European flash systems and their equally pricey accessories.

The turning point for me came when I heard a story from a very frustrated fellow professional photographer who had just returned from a job that had turned into a disaster. I'd like to share that story with you so that you'll understand why I am more than happy with what I call "the minimalist approach."

I'll call the intrepid photographer in this story "Bob." I'm leaving out Bob's last name because, in reality, he could be one of any number of respected photographers who have been working steadily in the commercial photography sector for the last ten to fifteen years. Let's follow our traditionally equipped photographer on an out-of-town job that takes place in 2003.

Bob and his assistants are flying from Austin to Phoenix. In Phoenix, they will rent a large SUV and head to their assignment in Scottsdale, AZ. Bob was hired by a designer in Austin, TX, who is working on an annual report. Her deadline is pretty tight, but all of the photo-graphs will be portraits in interior locations, and she's seen a lot of stuff in Bob's portfolio that she likes. Bob's mission will be to go to a huge, high-tech manufacturing facility and photograph six or more key executives. The brief calls for "environmental portraits" that show interesting parts of the facility in the background. Each executive should be photographed in a different location within the facility. The budget and the deadline suggested a one-day shoot.

To complete his job, Bob is bringing a large carry-on case of digital cameras and lenses. All his other equipment must be checked. Bob is "old school" in that he uses the studio electronic strobe flash units (packs and heads) he bought ten years ago when most of his work was shot in his studio with Hasselblad medium-format cameras. Bob is a perfectionist, and he really trusts the heavy studio lights he uses. They are an expensive European brand and they've never let him down.

Bob figures he'll need four flash heads to cover every possibility. He packs two strobe packs (the flash generators) because, like a boy scout, he is "always prepared"

The turning point for me came when I heard a story from a frustrated professional photographer who had just returned from a job that had turned into a disaster.

for problems. Each pack will power up to three flash heads. Another reason to bring the extra strobe pack is to be able to position some lights farther away from the camera position than others. The cables linking the flash heads to the strobe box need to be fairly short to limit power loss. If Bob wants to put a light 20, 30, or 50 feet away from the other lights, it will need its own strobe pack.

Bob also realizes that, for some strange reason (probably governed by Murphy's Law), electrical outlets are usually situated farthest from the best-looking locations. With this in mind, he packs several hundred feet of heavy-duty extension cords. They fit in a rugged, well-worn hard case along with all the traditional accessories such as reflectors, connectors, sync cords, and lots of the white gaffer's tape, which Bob's assistants will use to tape extension cords and cables to the floors at their locations so that people don't trip over them and get hurt.

Bob and his assistants also pack solid, heavy-duty light stands and the massive tripod he bought fifteen years ago to hold his large- and medium-format cameras stable during long exposures. In all, Bob and his crew spend half a day testing and packing five rugged hard cases of equipment. The two-light cases tip the scales at seventy pounds each. The tripod and stand case weighs in just shy of eighty-five pounds. The accessory case, with 200 feet of heavy-duty extension cords, is right at ninety pounds. The hard-sided case for the softboxes and umbrellas that Bob might need isn't as heavy, but it is bulky. With all this gear, Bob realizes he will also have to include, and check, his heavy-duty transport cart.

All the gear fits comfortably in Bob's old Chevy Suburban. He wishes he could trade in his old gas guzzler for a new, more economical car, but today's shoot reminds him of just how much gear he needs to carry and how important the large cargo space of the Chevy is for his business.

With the sheer amount of gear he's packed and the tight scheduling the assignment calls for, Bob decides that he will need two assistants instead of one. The three of them meet at Bob's studio at 5:00AM to load the gear into the Suburban. It's already a toasty August morning in Austin, and last night's low temperature of 85 degrees has Bob and his two assistants feeling a bit sweaty as they haul the last boxes into the car. They are all in good spirits as they head to the Austin-Bergstrom Airport.

With the sheer amount of gear he's packed and the tight scheduling the assignment calls for, Bob decides that he will need two assistants instead of one.

The faded silver Suburban arrives curbside right at 6:00AM. This gives Bob and his crew the recommended two-hour cushion before their 8:00AM flight. They begin to off-load their equipment in front of the skycaps' station for their chosen airline. Everything is nice and friendly until the first case of gear hits the curbside scale. "Sorry, sir," says the muscular skycap, "this one's over the weight limit. We have to charge you the new overweight charge. It's $125.00 per overweight bag."

Bob tries the universal gambit that worked so well ten years ago. He calmly pulls two $20.00 bills from his wallet. The inference: "Here's a big tip to look the other way and ignore the weight of the bags." The skycap shakes his head, "All the bags are reweighed when they get put on the belt, sir. They're going to get you one way or the other."

Four of the five checked bags are overweight, which adds $500.00 to Bob's transportation bill. It will also add $500.00 to the return trip. He gulps but figures he can go back to his client and explain this cost overrun. He knows the overall budget is tight, but what else can he do?

Bob and his crew head on to check-in. He's got his roller case of cameras, and each assistant has a small bag with a change of clothes and their personal items. Bob realized he would be limited to one carry-on and packed his extra change of clothes, toothbrush, etc., in one of the lighting cases.

Upon arrival at the Phoenix Skyport, Bob has the assistants wait for their cases to come rolling off the baggage claim carrousels while he goes to retrieve the Ford Explorer SUV he has reserved. The second big glitch hits: there are three conventions in town and all the SUVs are gone—even the one Bob carefully reserved weeks in advance. Bob now needs to rent two full-sized (read "luxury") cars to haul all of the gear. Thank goodness his first assistant is over twenty-five and has a good driving record! After more than an hour's delay, all the gear is loaded into the two cars and the photo crew is off to meet up with the client's contacts in Scottsdale.

Parking around the high-tech facility they'll be shooting in is tight and security is tighter. Bob's team ends up on the top floor of the parking garage, located a hundred yards from the facility entrance. By the time they've unloaded the cars, navigated the elevators, negotiated the ADA (Americans with Disabilities Act) ramps, and checked in with the facility's security representatives they are an hour-and-a-half late for their first shot. Now the fun begins.

The first executive on the day's schedule couldn't wait and will need to be rescheduled. Bob and his on-site contact, Greg, scout out the first location, and the crew gets to work disgorging the gear from the cases. Ignoring the exceptionally well-designed and well-implemented ambient lighting, they move quickly and set up their "usual"

environmental portrait lighting configuration. This consists of one flash head in a large softbox set to the left of the subject's mark, two lights in umbrellas illuminating the interesting architecture in the background 30 feet behind the subject, and one more light directly behind the subject to act as a kicker light and give the impression of added dimension. The total time elapsed with setup and test shots is one hour. Now they wait for the harried, impatient vice president of manufacturing.

After a bit of trial and error, the lights are set properly and Bob is ready to shoot. The images are good. Bob is in sync with the vice president, builds a good rapport, and the portraits are looking great. Then Greg, the company contact, sidles over to Bob and asks, "Do you think we could move over 10 feet and get that shiny logo in the background?" Bob gives in and they start the process of relighting. Fifteen minutes later, the vice president looks at his watch and announces that he can't wait any longer, then he walks away.

Bob, his client, and the crew feel a bit deflated as they begin packing up and getting ready to move to their next location. Bob reminds the assistants to let the modeling lights in the flash heads cool before moving them. They set about pulling up the taped extension cords from the floor. In half an hour they're packed and ready to move. Greg, the company marketing guy, announces that they may as well break for lunch, as all the VPs are scheduled for things other than photography during the lunch hour. The assistants are happy with this plan as their last meal was a bagel and coffee in the Austin airport.

Bob is starting to get nervous. His original client anticipated getting six location portraits done during the day. Now it's noon and they have completed just one. The next portrait is scheduled for 1:30PM. They would have to try to add the person they missed in the morning to the end of the afternoon schedule, if possible. Rather than break for lunch, Bob decides to go on to the next location at the facility. Once there, he'll send one of the assistants to the cafeteria to get lunch for everyone.

The crew rolls the four-wheeled cart, piled high with over four-hundred pounds of lighting gear on it, down the long hallways to the next location and goes through the same process again—unpacking, assembling, adjusting, taping down extension cords, and struggling to over- whelm all of the existing light with their heavy-duty strobes.

The bottom line? Bob and crew needed to add an extra day on location to get the six shots his client needed. Bob came home exhausted, frustrated, and over budget.

The bottom line? Bob and crew needed to add an extra day on location to get the six shots his client needed. Bob came home exhausted, frustrated, and over budget.

Far from being an isolated incident, shoots like this happen to photographers all the time. In my own business, we often had to go into overtime, keeping people on locations until 8:00 or 9:00PM to finish a "day's work" with our traditional equipment. There were always surprises that slowed down the progress of our projects. We would start setting up equipment in one area only to find that the closest available wall socket was 50 feet away and could only be accessed from across a busy hallway. Liable for any accidents, we had to spend time taping the extension cords to the floor so that no one would trip over them. At least once on nearly every annual report project the client would insist on shooting in a location that was only accessible by stairs or ladders, which meant pulling all of our equipment off our heavy-duty cart(s) and porting it up and back. When working with studio electronic flashes, nearly every light demanded its own power pack and attendant wall socket. And, remember, every setup had to be tested and previewed with Polaroid test film.

GOING ON AN EQUIPMENT DIET

At first I couldn't believe that I could switch to a much smaller and more portable lighting kit without compromising the technical quality my clients had come to expect. The missing piece of the puzzle, the change that made minimizing my lighting load possible, was the radical improvement in digital camera technology. Color balance became simpler, and the clean performance at high ISO settings reduced the need for higher-powered lights. Now, I turn to the small, portable lights first and think of the ponderous studio flashes of yesterday as specialty equipment! I consider myself a lighting minimalist, and I'm committed to doing more with less.

When I talk about minimalism, I'm referring to a late 20th-century design movement that called for reducing elements in art work or interior design to the bare minimum. In the art world it meant reducing a visual mes-

On any assignment that doesn't call for massive infusions of light, you'll be happy you decided to minimize your load—and you may be a lot more productive.

sage to its elemental core. Our practice is to pare down to the essentials the lighting equipment necessary to make great photographs on location. I've changed my style, over time, to what I call a minimalist lighting style for three critical reasons:

1. The new digital cameras and wirelessly controllable portable flashes have radically changed our profession, letting us work more quickly and with much more creative freedom. The reduction of heavy, bulky equipment lets us save our energy for our real work: making images.

2. The lighting style afforded by using just what we can pack in one case (plus a bag of lightweight stands and modifiers) makes it easier to leverage the existing light on a location and blend it with our miniature lights for a more natural and fluid style that matches the look we're all interested in creating.

3. Most importantly, our clients are pushing us to change. Whether it's in the field of advertising or weddings and portraits, clients don't seem to mind paying our creative fees—but all of the extra costs of unnecessarily large productions blow their budgets. This pushes them into using more and more stock photography (or to curtail coverage in the case of weddings). Advertising and corporate clients need photographers who offer a new level of flexibility and creativity, with no compromises on quality.

Minimalist lighting isn't the answer for every shoot, of course; there are still plenty of photography assignments that call for lots of light and traditional production techniques. In those situations, it makes sense to use bigger strobe packs and all of the baggage that goes with them. If you're an experienced professional and you have good preproduction meetings with your clients, you'll know when you can go in light and when it's necessary to bring the "big guns." But on any assignment that doesn't call for massive infusions of light, you'll be happy you decided to minimize your load—and you may be a lot more productive. If you have the luxury of lighting and photographing just for yourself, you'll be happier traveling unburdened.

WHO BENEFITS FROM MINIMALIST LIGHTING?

The advantages of traveling light are obvious for professional photographers who work on multiple locations, especially for those who travel frequently on airplanes. But lighting well with smaller, less expensive gear also opens the doors to many younger, aspiring photographers. Doing more with less levels the playing field by lowering the financial barriers for a whole new generation. For interested amateur photographers, it is another way to achieve better results in their photography without breaking the bank.

If you are an editorial photographer doing environmental portraits in lots of different locations, this approach is made for you. With a few well-selected lights and a handful of color-correction filters you'll have the freedom to create portraits that integrate existing light with your added light to a degree that was difficult with conventional studio lights.

From another point of view, my friends who are wedding photographers are very interested in getting away from using a flash directly on their cameras and are looking to use new, multi-light techniques to make images that will separate them from the pack. They are adapting these techniques because brides are becoming more sophisticated customers and are no longer interested in the concept of shooting everything with available light only.

Portrait photographers will also do well with many of the minimalist lighting techniques, especially as more and more of their customers request moves from traditional studios to more interesting interior and exterior locations. They'll be able to offer more variations, with less time invested, than ever before.

BREAKING OLD HABITS

For some established professionals it takes time to break old habits; truth be told, I kept a pair of Profoto monolights in my car for the better part of a year . . . just in case. Occasionally, I really needed them. Usually, however, I could get what I wanted with my miniature lights. There *is* a learning curve, but after working on the methods outlined here, calculating how to get the effect you want in a pared-down fashion becomes second nature. This book is intended to introduce these techniques to a wide audience of photographers—seasoned professionals, editorial shooters, wedding pros, and dedicated amateurs. To really appreciate the thrill of going "lite," though, we must consider what photographers from previous generations went through to light on location. That is where we will begin the next chapter.

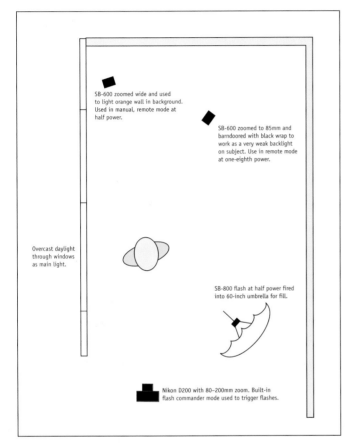

SB-600 zoomed wide and used to light orange wall in background. Used in manual, remote mode at half power.

SB-600 zoomed to 85mm and barndoored with black wrap to work as a very weak backlight on subject. Use in remote mode at one-eighth power.

Overcast daylight through windows as main light.

SB-800 flash at half power fired into 60-inch umbrella for fill.

Nikon D200 with 80–200mm zoom. Built-in flash commander mode used to trigger flashes.

This environmental portrait of AMD Vice President Kevin Knox was lit using the minimalist techniques that will be discussed throughout this book.

1. A BRIEF HISTORY OF PHOTOGRAPHIC LIGHTING

EARLY TECHNIQUES

The first photographers, in the middle of the 1800s, used materials that were so insensitive to light that only long exposures in direct sunlight were bright enough to make an image. As materials became more sensitive, photographers began experimenting with novel ways of producing enough light to make exposures without the help of the sun. Early techniques could be quite dramatic. One of these methods called for igniting a quantity of highly flammable materials while holding the camera shutter open during a long exposure. This flash powder was typically a magnesium compound that was basically exploded on a little platform. The fast burning of the magnesium put out a very high level of light, as well as a lot of smoke. Any miscalculation of the amount of powder required could start a fire—or produce third-degree burns. Because of the thick smoke and nasty airborne residue produced by the flash powder, the photographer could count on getting only one shot before his subjects fled in terror.

The Early 20th Century. Photo plates and films got faster and photographers turned to the kinds of movie lights that filmmakers in Hollywood depended on. These lights were quite large and heavy and they generated a tremendous amount of heat, but they were a vast improvement over the use of explosives! Studio photographers used this kind of lighting (scaled down for their needs) right up until the 1950s, when the first heavy-duty electronic flashes were brought to market.

The plight of location photographers was a bit trickier. Manufacturers began, in the 1920s, to perfect flashbulbs. These provided a burst of bright light that was short enough in duration to reasonably freeze action while providing enough direct light to adequately illuminate a small room. With the slow films of the times, the flashbulbs were almost always used directly, which rendered a harsh and unnatural lighting effect. Also, a flashbulb was good for one shot only and then needed to be replaced. I remember reading about an architectural photographer shooting for a major magazine who once lit an entire factory with dozens of flashbulbs. All of them had to be wired together in order to be triggered. The photographer and his assistants spent the better part of a night hanging flashbulbs up in the rafters and wiring them together. The photographer shot one test shot and

Location photography with lights was a challenging profession that pushed its practitioners to experiment and innovate in order to create good photos.

went back to the studio to develop the film (these were pre-Polaroid days). The next evening, they came back to the factory, replaced all of the bulbs, and did one additional exposure based on their previous test results. Obviously, the margin for error was slim.

As you can see, primitive lighting was costly and time-consuming. Additionally, without the modern conveniences of flash meters, Polaroid instant proofing films, or the instant-review feature of digital cameras, most lighting was really done by trial and error. Location photography with lights was a challenging profession that pushed its practitioners to experiment and innovate in order to create good photos.

The Late 20th Century. As recently as twenty-five years ago, most hobbyists owned 35mm SLR film cameras, a few lenses, and maybe an automatic flash, which

spent most of its life in the camera's hot shoe. Working professional photographers generally worked with at least two different types of cameras and usually all three of the major film formats: 35mm, medium-format roll film, and 4x5-inch sheet film. Professionals were still routinely working with slow (25, 64, or 100 ISO) films because they provided a high degree of sharpness with very low grain (noise). The films were balanced for one specific light source (or color temperature) and correcting color shifts in postproduction was brutally expensive and time-consuming.

While professionals were quick to adapt Polaroid instant films to test exposures, the lack of strong output from portable lights (and primitive battery technology) remained a real issue—even with the relatively powerful and reliable portable electronic flash equipment that began to be introduced in the 1960s.

As a result, professionals still brought along their bulky studio electronic flashes on location (along with an army of Sherpas to transport them). These studio strobes ensured the repeatability and consistent color quality that was much in demand. They also enabled the photographer to work at smaller apertures in order to keep everything in focus. This is an important consideration when using a large-format camera.

When I started working in the studio in the 1970s, we used Norman PD2000 flash generators—and each of these monsters weighed about 38 pounds! The flash heads (which often weighed between 10 and 15 pounds) were connected to the packs with heavy cables. As a result, going on location with two power packs and four flash heads meant hauling around over a hundred pounds—not including the heavy-duty light stands, umbrellas, extension cords, and other accessories. Often, our complete lighting kit would tip the scales at three-hundred pounds! And any time we needed to shoot outdoors, away from AC power, we also needed to bring along a gasoline-powered generator and lots of heavy-duty extension cords.

One consequence of all this weight and bulk was the need to hire assistants for every outing—and to feed and insure them. You can also imagine how time-consuming it was to change locations with all this equipment. Additionally, the strobe systems of twenty-five years ago

didn't have the fine-tuning capabilities that modern systems do. If you needed less power, you could dial down most of the big units to around 400 watt-seconds; after that, you had to add additional flash heads and point them away from the shooting area to bleed off power—or you copied the film industry and used metal screens in front of your lights to cut down on the output.

THE DIGITAL AGE

Around the turn of the 21st century, everything changed. Canon, Nikon, and other manufacturers of digital SLR cameras leveraged the built-in computer power of their new cameras to control an equally new generation of smart flashes.

One consequence of all this weight and bulk was the need to hire assistants for every outing—and to feed and insure them.

Using the Nikon flash system as an example, you can now wirelessly control up to three groups of off-camera flashes from your shooting position. You can use the flashes in the TTL (through the lens) metering mode, the AA (automatic aperture) mode, or in the manual mode. You can raise or lower the flash level of each group separately for complete control of ratios. You can turn groups off and on from the camera position, and you can do all this while shooting with your camera in its automatic modes. There is as much lighting control as you could ask for in almost any shooting location.

Another technology that is becoming affordable and widely available is wireless radio transmitters. Instead of wiring flashes to your camera, you can attach a low-cost wireless receiver to each of your flashes (as many as you like) and trigger all the flashes via a wireless transmitter sitting in your camera's hot shoe. This works with just about any flash designed to fit in the hot shoe. These are best used in a manual mode—and it's a real plus if the flash allows you to reduce its power in measured and repeatable steps.

I should mention that you don't need the latest flashes from big-name manufacturers in order to use the minimalist lighting philosophy. Any recent-model flash that allows you to control the amount of power it puts out in

the manual setting should work just fine. In fact, you don't even need to use flash to practice the "minimalist way." If most of your work is done on interior locations, you may be able to get away with using fluorescent fixtures or even small tungsten lights designed for video cameras. The idea is to get away from "bigger is better" and get back to "just the right size" when it comes to lighting. Many of the techniques we cover using small flashes can be practiced, with good results, with other types of lights. The secret is the mind-set of putting your equipment on a serious diet, coupled with the use of creative improvisation!

WHY DOES MINIMALIST LIGHTING WORK SO WELL?

There's been an intersection of coincidental evolutions in photography. We now have digital cameras that give remarkably clean files at sensitivities of up to 1600 ISO. When you shoot at 1600 ISO (or 800) you need just a fraction of the light that you would have needed at 100 ISO to achieve the same aperture and shutter speed set-

tings. That means a small hand held flash can easily do the same kind of work the old 38 pound Normans could do.

We now have a new generation of electronic hot shoe flashes that can be used at full power or "dialed down" to $\frac{1}{64}$ power or even $\frac{1}{128}$ power. New battery technology means these flashes run longer and recycle quicker than ever before. Rechargeable nickel metal hydride batteries (NiMH) can be reused for five hundred high-powered usage cycles and cost little more than disposable alkaline batteries.

An important part of the shift to smaller electronic flashes is a result of the instant feedback photographers get from their digital cameras. A quick test shot lets you know if you need to fine-tune your exposure in real time. You can lighten or darken your image, change your light ratios if need be, and then go on to photograph your assignment with confidence. If you need to use a smaller aperture to extend your depth of field, you can change your camera's ISO setting to compensate.

Model: Autumn, for Austin Lyric Opera advertising campaign. This image is my favorite example of the advantages of minimalist lighting as it pertains to limited depth of field.

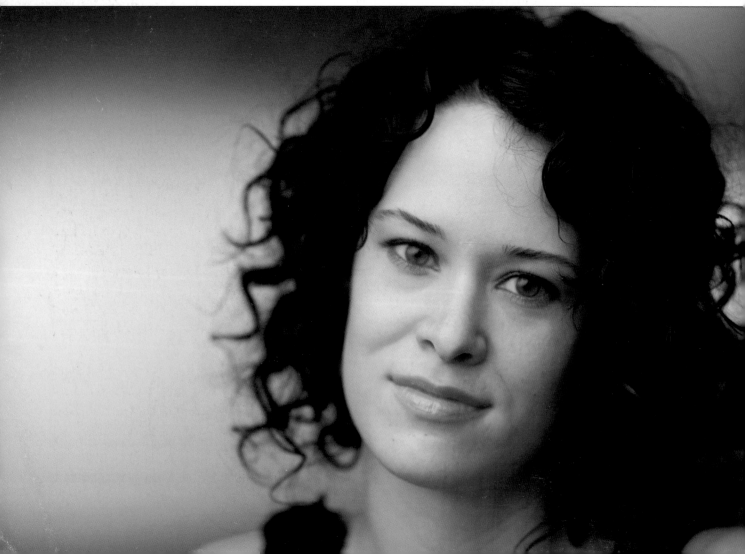

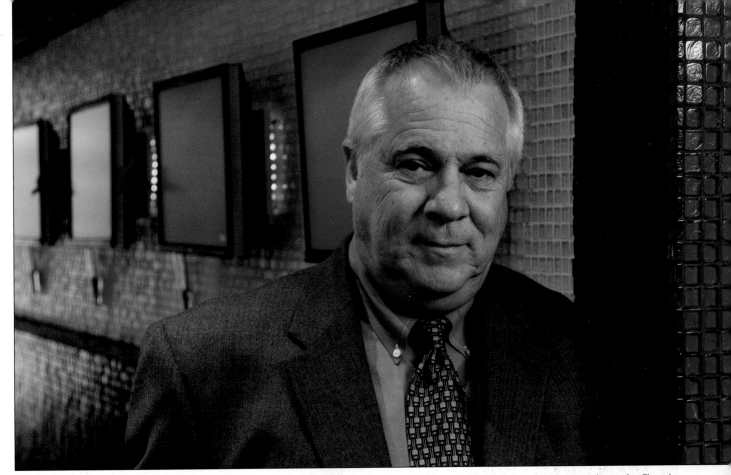

This shot is from a series of images created during a typical portrait assignment that calls for a mix of standard head shots and environmental portraits. The subject, David Brown is a vice president at Dell, Inc. For more on this shoot, see pages 108–11.

We can now operate our multiple lights automatically using our smart cameras as control centers. All of these changes add up to a powerful change in the field of lighting. The amazing thing is how these changes are driving new styles of photography in so many areas.

CHANGING PHOTOGRAPHIC STYLES
ARE ACCELERATING THE MOVE TO MINIMALIST LIGHTING

No one knows which came first, the chicken or the egg. And it's a safe bet that no one knows which came first in the prevailing styles of photography—new flash technology or a move to images with less depth of field and more integration with existing light. It seems obvious that art directors and other clients are attracted now to images with isolated areas of sharp focus, totally out-of-focus backgrounds, and lighting that complements the atmosphere of a location rather than overwhelming it.

A number of well-known photographers are using Canon's 85mm f/1.2 lens (and similar lenses from other manufacturers) to get images with very narrow depth of field. Many images need just a touch of light to fill in a shadow, add sparkle to a subject's eyes, or to separate the subject from the background. The touch of light may mean the light of a flash diffused through a diaphanous piece of silk close to the model. With the camera wide open the lighting required may be no more than $\frac{1}{16}$ the flash's total power. None but the most expensive studio units would offer this kind of power reduction control. With a Nikon or Canon flash, it's as simple as pushing a button.

These flash techniques depend more on finesse than raw power. You need to be able to convert the color of your flash to match that of your existing light. You'll need to see when it's important to add less light, and you'll need to see the balance of the total illumination in a scene. When you figure out the essential techniques, you'll have a much better chance hitting the "sweet spot" of the unconstructed, unforced style that designers and marketers are looking for.

In the next few chapters you'll get suggestions about choosing the right equipment to meet your needs for high portability and high-quality results at a reasonable cost. Then, once we've got the lighting gear taken care of, we'll cover the peripheral equipment that makes our

style of location photography quicker and easier. Once we've gotten through the basic hardware we'll go through the concepts and techniques that allow minimalist lighters to mimic the results traditional studio lights provide with the new generation of small, portable lights and light modifiers as well as implementing new looks that are coming to the forefront of photographic art today. One of the best ways to learn is to see how others approach the technical side of lighting and then interpret the lessons into your work. There are a number of illustrations and case studies in this book that illustrate the new lighting style. But first, let's talk about the minimalist lighting philosophy and the basic concepts of lighting.

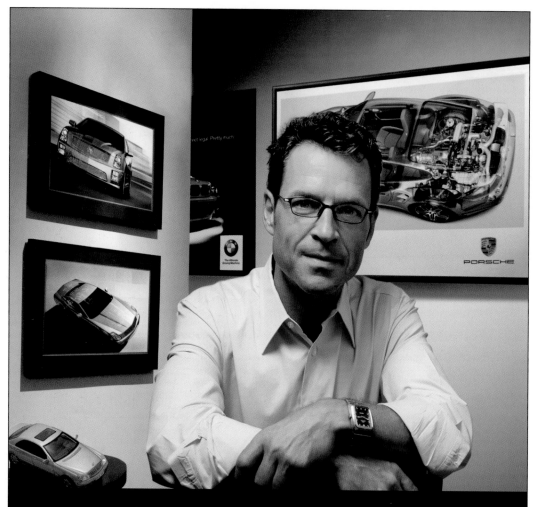

Today's designers and marketers are looking for more of an unconstructed and unforced style. Minimalist lighting techniques can help you achieve this.

2. EMBRACING THE PORTABLE APPROACH

More with less. That's our goal. The less we're encumbered by unnecessary stuff, the easier it is to arrive at our destinations ready to work. I like to think in terms of analogies, and here's the one that springs to mind: "all the capability of lighting we used to pack in a Chevy Suburban neatly packed into the trunk of a Toyota Prius."

The bulk of equipment necessary to do a project seems inversely proportional to the creativity you can bring to a project. For the pro, each heavy case and each extra pound creates more and more mental resistance to releasing your real creativity. If you are a working professional, you become dependent, on some level, on your comfort level with your equipment and your routines (however inefficient) and you become afraid to change. You may buy a new, smaller flash, but you bring along the "safety blanket" of the big strobes, the expensive softbox, and the other trappings.

The sheer momentum of all the heavy equipment begins to wear you down. Imagine starting with an absolutely clean slate. Imagine abandoning all the preconceived lighting schemes you've been using and creating a whole new language of lighting with precise control and less physical strain. Now imagine that this whole new lighting kit fits in one little roller case with your cameras and lenses. This is your chance to reframe how you'll work going forward.

For professionals, this sort of evolution is really a matter of life and death for their businesses. Styles change, and imaging work is most salable when it mirrors what's going on in our cultures. If the equipment you own pulls you back from trying new styles of lighting or new "looks," your assignments will decline. Shooting new and different work gives you something interesting to share with your favorite art director or client. Reducing your lighting load may give you just the impetus you need to kick your career back into high gear.

From the nonprofessional's point of view you've probably always thought that the "big strobes" were the "price of entry" into a secret world of glorious lighting. You may have thought, "If only I had $10,000.00 to spend on studio strobes, I'd be able to do the kinds of photographs I see in magazines and in ads." Twenty years ago, there really was a strong financial barrier to entry for new photographers. The best work really did demand expensive gear—and the knowledge to use it well. Now the only thing that remains to separate amateurs from pros is the knowledge of how to leverage the light coming off your flash(es) with solid concepts about lighting, light placement, and light modifiers. That is the essential idea behind simplifying.

> Imagine abandoning all the preconceived lighting schemes you've been using and creating a new language of lighting with precise control and less physical strain.

The minimalist lighting philosophy can be summed up in a ten-point list:

1. Never use a big light when a small light can work just as well.
2. Find the lightest equipment you can, but make sure it does the job.
3. Never use a cord or a cable when a radio slave or wireless feature can do the same job.

4. All your lights should fit in one small case. Your case should be small enough to fit in the overhead compartment of your favorite airline.

5. Don't light the volume of a space, light the visible planes.

6. Your equipment should fit in the trunk of the smallest rental car.

7. It shouldn't take more time to pack and unpack your gear than it does to actually do the assignment.

8. Always take extra flashes. You never know when inspiration will demand, "one more light!"

9. Learn to play nicely with the existing light.

And here's the most important philosophy/technique/advice for any photographer:

10. Get the flash off the top of your camera! Good light almost never comes from the top of the camera. It comes from angles, from behind the subject, or over the top of the subject, but rarely does it come from right over your lens.

For the do-it-yourselfer and anyone interested in saving money, there is an eleventh item that could be added to the above list:

11. Never spend money on accessories you can easily make yourself.

In the early history of cameras, manufacturers put shoes right on top of the camera because most early cameras were simple rangefinders, and if you wanted to see what your composition looked like, you needed to attach a small optical finder to squint through. The logical place to put the finder was as close to the lens as possible. Hence the "accessory" shoe. It became a "hot" shoe in the 1960s to accommodate the first generation of small, portable flashes and fostered decades of flat, unattractive photographs by millions of people who cared more about getting enough light on a scene than getting the right light on the scene. Throughout this book you'll be encouraged to get your lights off the top of your camera. The only thing that belongs in a hot shoe these days is the transmitter component of your radio flash trigger.

ALMOST EVERYTHING YOU NEED TO KNOW ABOUT LIGHT

Whatever you choose to light with, it's important to understand the basics. Light has the following properties: direction, intensity, softness or hardness (diffuse or specular), and color temperature (warmer or cooler/redder or bluer). That's it. When you learn to recognize and modify these four qualities of light you will have begun to master photographic lighting. A constant exercise of top photographers is to be aware of light in everyday situations and try to figure out a way to duplicate (and improve upon) the feeling of that light.

Direction. The dominant light in most natural scenes comes from a specific direction. Think of the downward direction of sunlight at noon or the late-afternoon sun angling up a few degrees from the horizon, providing dramatic side light. Most photographic lighting tends to emulate what we see in nature. We use large, soft wraparound light to emulate the soft, diffuse light of an overcast day. We use smaller lights a bit farther away from our subject, with a fill card to the opposite side, to emulate soft sunlight. Direction of light is an important lighting design consideration because it plays to our built-in emotional responses to different naturally occurring light effects. For example, a bright sunny day makes most people feel happier and more confident, while dark, flat, overcast days make us feel quieter and more reserved. We know these effects are real because of research done on people who become depressed when relegated to long periods of time with no bright light.

The idea of "appropriate" lighting direction is a starting point for photographers. You'll see many examples of

Direction of Light

A great way to learn how the direction of light influences the look of a photo is to take a small desk lamp, find a suitable subject, and move the light in an 180 degree arc from the far left side of your subject to the far right side. Observe the direction of the shadows and the highlights. Now raise the light so it is 45 degrees above your subject and go through the same 180 degree arc. Finally, place the light so it is slightly below the main subject and move it through the same 180 degree arc while carefully observing your subject. You'll find an amazing range of effects from this one, simple exercise.

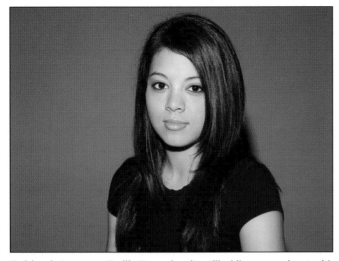

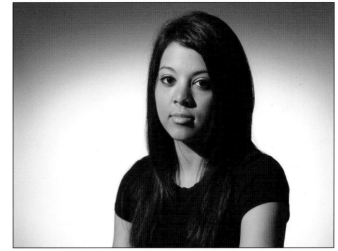

Model and stage actor Noellia Hernandez sits still while we experiment with lighting. This frame shows the effect of shooting with a flash directly on top of the camera. The gray background is about 8 feet behind the subject. Notice the hot spot on her forehead and the sharp shadow under her chin.

In this image, I've added a light to the background and moved the direct flash off to Noellia's right side. It is at a 45 degree angle to her face. Notice the very harsh shadow next to her nose and the lack of detail in her hair where she is not illuminated by the flash.

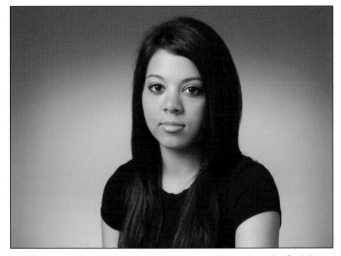

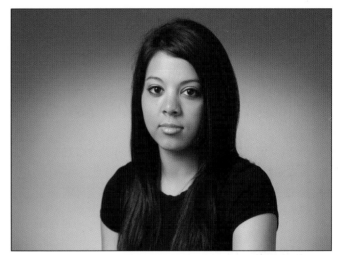

In this image we've toned the background down a bit and put the flash into a small umbrella. The larger light source gives a much nicer transition from high-light to midtone and from midtone to shadow. The deep shadows still show a total lack of detail.

Here, the lighting is exactly the same—a light illuminating the background and a flash aimed into a small, white umbrella 45 degrees to Noellia's right. We've added a large white reflector to the left side and we now have detail in the shadows and an even softer transition in all the tones.

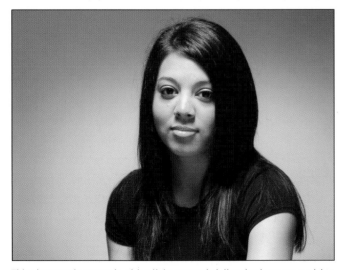

This photograph was made with a light suspended directly above our model to show the effect of top lighting. This effect is similar to bright, overhead sun-light. It's not very flattering.

This photograph was made with a light on a short stand shining up from a low angle directly in front of our model. This is the "spooky movie" or "sitting around the campfire" effect. It's certainly a different look, but not one that is especially flattering.

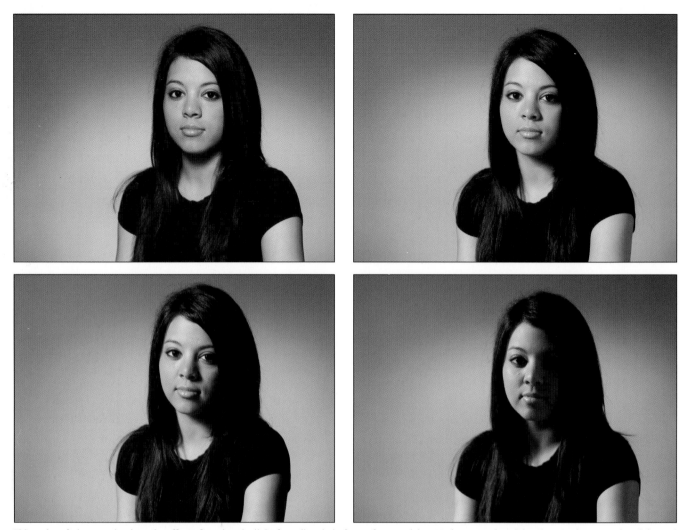

This series of photographs show the effect of moving the light from directly in front of our model to 20 degrees to her right, then 45 degrees to her right, and then a full 90 degrees to her right. In each frame the model is lit by one flash aimed into a 32-inch white satin umbrella. The first frame (top left) is flat and has no sculptural cues as to the shape of the model's face. As the light travels around in an arc more and more detail and texture is revealed.

photographs where all the preconceptions about direction of light are ignored, with great effect. But it's good to learn the basics in order to know the best way to break the rules. Millennia of human experience seems to have programmed us to interpret light in a number of ways. Light from above means "daylight." Light from below means "unnatural" or scary light. (Probably because light from below only happened at night around a campfire while just yards away was a darkness, filled with potential predators.) Flat, frontal lighting yields less contrast, which means an image with fewer cues and less apparent sharpness.

Intensity. Intensity is relative. Even a weak light is perceived as intense if it is the only light source and it is a sharp, focused beam. You can think about intensity in two ways: (1) do you have enough quantity of light to get the aperture and shutter speed you require for the shot? (2) is the intensity or quantity of light from your main source strong enough relative to the ambient light or fill light to get the visual effect you want? The intensity of your main light can be controlled by increasing or decreasing the effect of your fill light or ambient light.

In the middle pair of images on the previous page, you see a chiseled light in the first photo (middle left). It seems sharp in the absence of ambient or fill light because the ratio between light and dark is so strong. Once additional fill light is added to the scene, as in the second photo (middle right), it appears less intense. You can change the intensity (as it relates to the balance of light and dark) in your photos by changing the ratio between your main light source and the fill or ambient light in the scene.

There are a few basic rules for working with light intensity. You need enough quantity of light to give you the shutter speed and f-stop settings you want at a particular ISO setting. Since most photography depends on emulating the experience of human vision, you need to understand that the human eye can see a remarkably wide range of tones. The eye can perceive detail in strong highlight and, at the same time, can see lots of detail even in very strong shadows. As an audience for your photographs, people expect to be able to see information in both the shadows and the highlights of photographs. This means that you, as the photographer, need to condense the range of lights and darks so that they fall into a range that seems "normal" for your viewers. Usually this means adding fill to the shadows in order to reduce the ratio between light and dark areas.

You can do this in a number of ways: You can reduce the intensity of the main light relative to the existing or fill light. You can add additional fill light. You can add reflectors to "bounce" some of the main light back into the scene as additional fill light. You'll learn more about how to accomplish this control over intensity in chapter 6.

Hard and Soft. This is the quality of light that is most important to photographers. Controlling the quality of the light falling on your subject is the major difference between well-crafted photos and images that simply doc-

ument a subject. Most people refer to the differences in the quality of light by calling one extreme "hard light" and the opposite extreme "soft light." One of the photographic masters of the last century, Dean Collins, called these qualities by more scientific terms: he referred to hard light as "specular light" and soft light as "diffuse light." His point was that each light delivered an effect that could be best seen in the highlight reflections on the subject. Small, bright highlights are referred to as specular highlights; soft, large highlights that spread gently into the surrounding tones are referred to as diffuse highlights.

If you like to shoot portraits, you'll find that using a large, diffuse light source will almost always be the most flattering way to light people. The hardness or softness of the light source influences all aspects of a portrait, from the soft quality of the highlight areas, to the gradual transitions from highlight to midtone and midtones to shadows, to the soft-edged, open nature of the shadows themselves.

The same qualities are also true when it comes to product photography.

The quality of light, its "hardness" or "softness," depends entirely on some basic physics. The concepts are simple to learn and apply to minimalist lighting. They are among the most important ideas in the book.

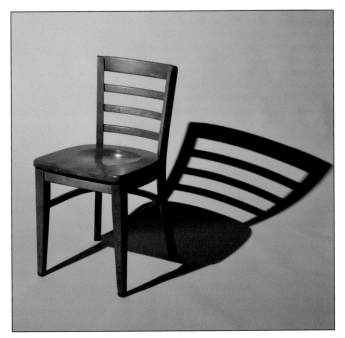

A classic example of hard light. This is light from a bare portable flash with no modifiers. Notice the deep, intense shadows with sharp edges. Fun for chairs, but not always the most flattering light for people.

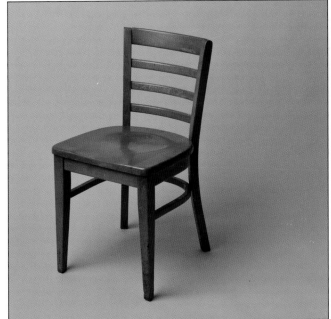

The light fixture is at the same distance as the light in above photo but it is inside a 4x6-foot softbox. Notice the soft, comfortable shadows and the bright, open feel of the chair.

This image shows the effect of lighting with a conventional 60-inch umbrella combined with a white reflector acting as a fill light. The large light source is very flattering and produces open shadows with lovely transitions.

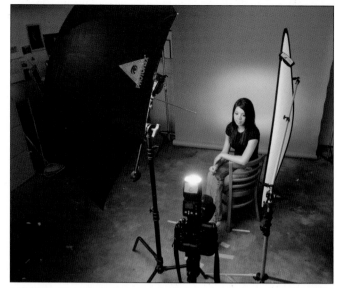

A bird's-eye view of our 60-inch umbrella portrait setup. The flash in the hot shoe was used to trigger the other flashes but did not constitute an appreciable part of the overall exposure.

This image shows the effect of lighting with the same 60-inch umbrella used in the previous photograph, but I've removed the black backing and turned the umbrella around to make it a shoot-through source. The effect is very subtle and probably lost to the foibles of the printing press. Just as in the previous image the transitions between light and dark are long and luxurious. Probably more to do with the size of both sources than anything else.

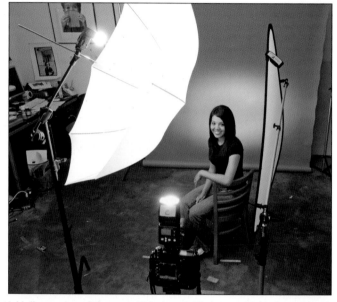

A bird's-eye view of the same 60-inch umbrella but used in a shoot-through fashion. I love big umbrellas. They are much easier to set up than softboxes, and the quality of the light can be wonderful.

Here are the rules for hard and soft light:

1. The smaller the light source, the harder the light.
2. The larger the light source, the softer the light.

Seems simple, but there are a few pitfalls of which you need to be aware. The above rules should be followed with the phrase, "everything else being equal."

The real secret is that the smaller the light source becomes, the more collimated or focused the light becomes. If the light comes from one very focused point, it cannot wrap around a subject the same way a larger and more diffuse light can.

The farther away a light source is from the subject, the more collimated or focused the light becomes and the less able it is to wrap around the edges of a subject to

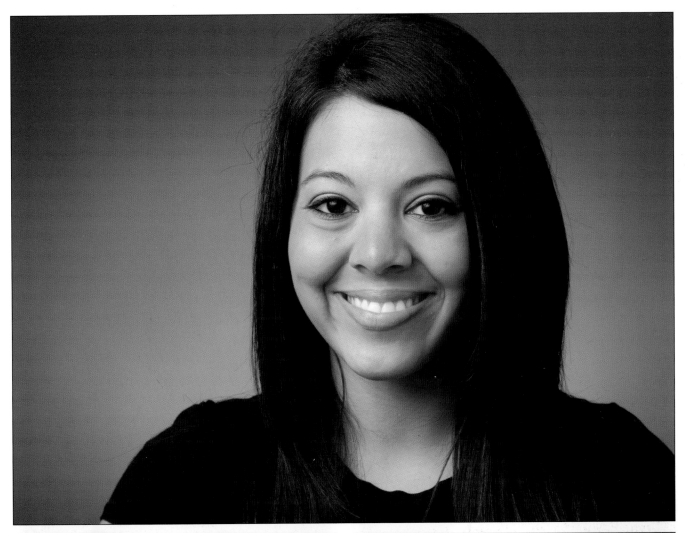

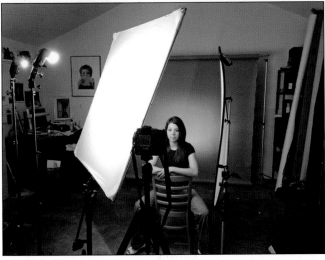

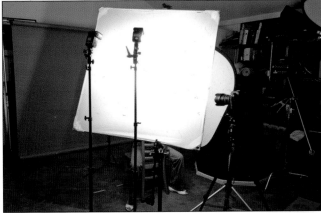

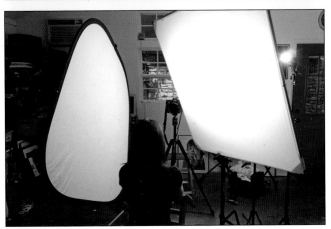

For this portrait (top) I've replaced the umbrella used in the last two shots with a Chimera panel frame covered with two layers of diffusion materials. The frame measures 48x48 inches. All other lighting details remain the same. To my eye the panel is equally soft but lacks the wraparound quality of the bigger umbrella. Above is a bird's-eye view of the same lighting setup. The images to the right show in more detail how our lights were set up for the panel shot. It is a simple lighting design that takes 10 to 15 minutes to set up on location and yields good results for a wide range of subjects.

reduce the ratio and reduce the intensity (the difference between light and dark).

Therefore, our second set of rules is:

1. The closer the light source is to the subject, the softer the light becomes.

2. The farther the light source is from the subject, the harder the light becomes.

The hardest light you can find would be a very small source from a very far distance. In the realm of lighting that we can control, that might be a spotlight from 100 feet away. The softest light would be the most diffuse light available. In practical terms, it might be a completely overcast sky as the light source. In the realm of lighting that you can control, it would be a giant sheet of translucent white material placed as close to the subject as possible with light coming evenly through every square inch of the material. Practically speaking, your range of hard to soft light in most situations would be the difference between bouncing one or more small flash units off a large white wall or white ceiling versus pointing a bare flash at the subject from across the room. However, nothing is ever so simple in the real world. The light reflected off an opposite wall reduces the contrast of the light and makes it appear softer.

We'll illustrate ways to use all the properties of light effectively in chapters 4 and 5, but first let's figure out what kind of gear you need and what kind of accessories will come in handy when you are out on location.

The image to the right shows the lighting setup for the two photographs on the facing page. I've eliminated the background light. All of our light comes from two Nikon SB flashes aimed through two layers of diffusion material. The diffusion screen measures 6x6 feet. The lights are at least eight feet from the surface of the screen to allow the light to spread out and evenly cover all the fabric. The only addition is the 48-inch white reflector panel placed on the opposite side. (Yes, the studio is usually a mess!)

On the facing page, the top image shows Noellia lit by the 6x6-foot soft diffusion screen. Even though the light sources are two small lights, emitting hard direct light, the screen becomes the light source, supplying soft even illumination, which is very flattering.

The bottom image on the facing page is lit in the same manner as above, but I've added a white reflector panel to the opposite side, which adds more detail to the shadow areas, as can be seen in Noellia's dark hair. It also bumps up the light level on her face, overall.

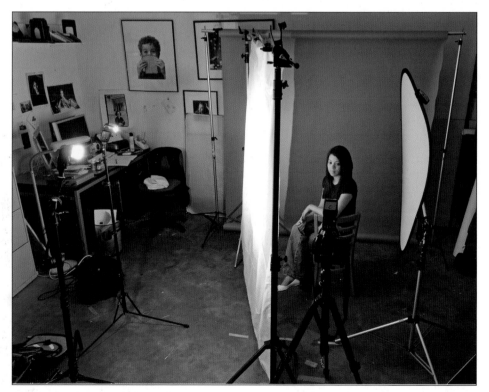

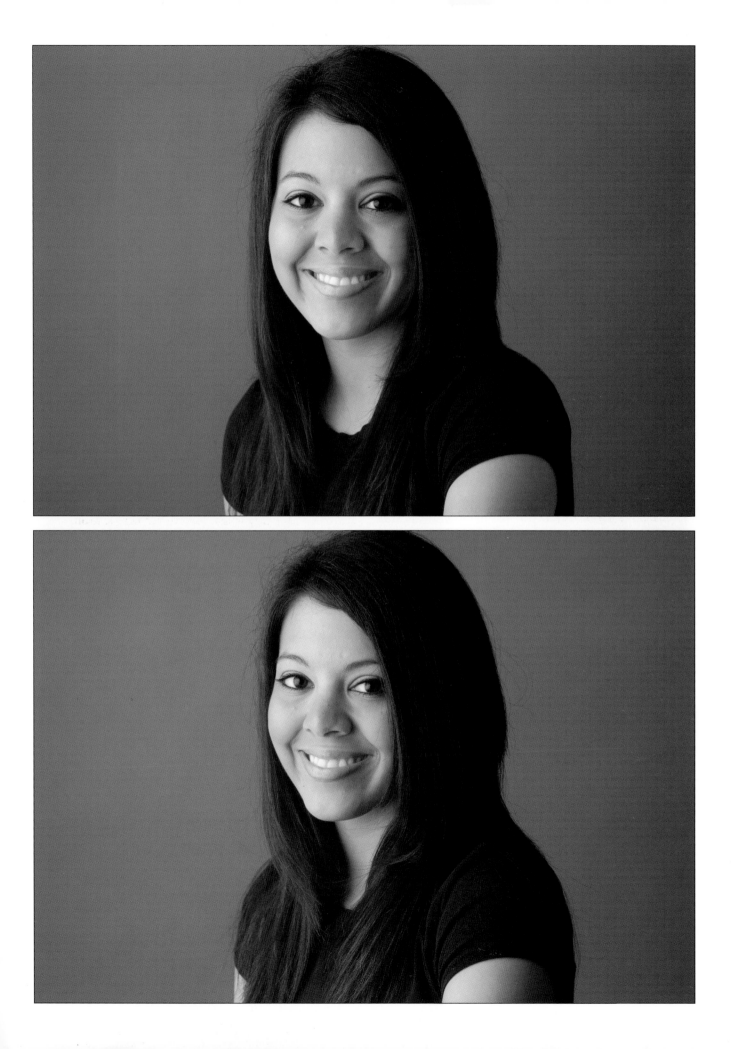

3. PUTTING TOGETHER THE RIGHT STUFF

THE RIGHT EQUIPMENT TO SHOOT JUST ABOUT ANYTHING

There is no unqualified "best portable light in the world" that works for every photographer. The lights and accessories discussed are ones that have worked well for me or have been used successfully by photographer friends and colleagues. Nikon camera owners will find certain advantages in using the latest Nikon flash units, and the same holds true for Canon owners and Canon flash units. The basic requirements for an efficient, portable flash are simple, and many new and used flashes on the market fit the bill nicely. You need to make your buying decisions based on your budget, your requirements, and just how flexible you need your lights to be. Here are the ground rules for the "basic" mimimalist flash unit:

1. Usable in a standard hot shoe. (Yes, I told you to get the flash off the camera, but the hot shoe "foot" is widely used as a point of attachment on light stand adapters as well as an interface for syncing with radio receivers and optical slaves. This requirement may rule out current Minolta and Sony flashes, as they have a proprietary flash "foot" making it a "closed system.")
2. Has a guide number of over 100. (The guide number refers to the power output of the flash. Most units that accept four AA batteries have guide numbers of at least 100.)
3. Has the ability to reduce power in manually set steps.
4. Accepts AA batteries. (This requirement yields several benefits, including the ability to switch batteries from unit to unit as well as the ability to use homemade high-yield battery packs.)

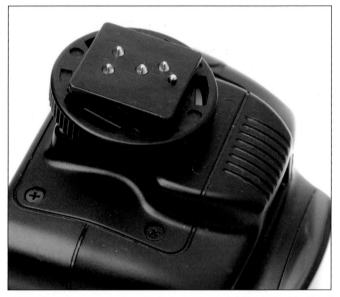

This is where the camera and the flash meet up to share information. The "foot" of a modern, dedicated flash, like this Nikon SB-28, has a number of electrical contact points that inform and control the computer in the flash. The center contact also triggers the flash.

The "shoes" of the latest Nikon flashes are made of sturdy metal to increase reliability. The center contact point is the sync trigger that detects a trigger voltage from the camera. All the other contacts relay information between the camera and the flash unit.

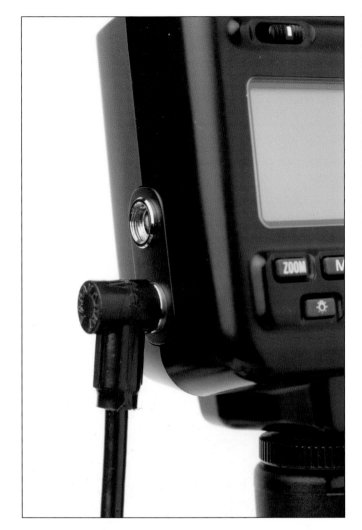

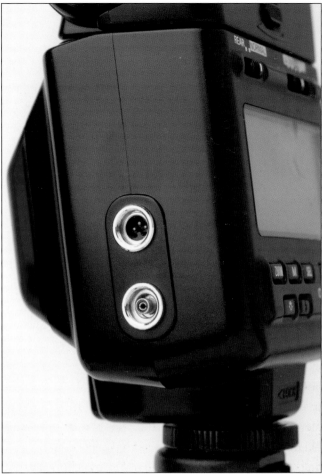

An important feature of all the professional series of flashes from Nikon is the standard PC flash connector, which allows for use with the widest range of third-party products. This close-up (top left) shows the connection of the flash to an ancient PC cord. A second view (top right) is shown without the cord.

A high-voltage battery pack from Digital Camera Battery (right). This unit, shown attached to the HV socket of a Nikon SB-28, can recycle flashes in approximately 2 seconds and has the capacity for hundreds and hundreds of full-power exposures. Be sure to read the instructions, as most battery-operated flashes can be damaged from being triggered too quickly for too many accuations. A dedicated cord is required for each brand of flash.

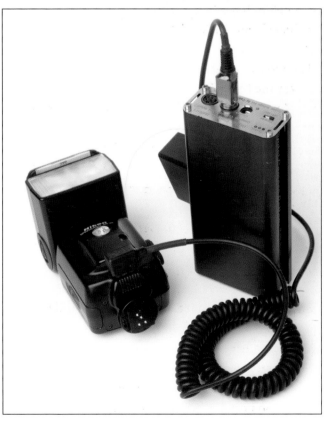

5. Finally, the unit should weigh less than two pounds with batteries.

The weight may seem inconsequential, especially if you transport your lights in a rolling case, but many of the mounting options we'll discuss use lightweight hardware or even duct tape to secure the units. If a flash unit is too heavy, you'll limit your mounting options.

The above describes the most basic model of electronic flash you'll want to use in your location lighting kit. If your requirements are more demanding and you

have the budget, you may want to consider upgrading to the next level of features.

The "step up" grade of electronic flash unit would have three features that may become more and more useful to you as you begin to explore more complex and demanding lighting situations.

1. Built-in standard PC connector (a universal plug for sync cords).
2. The ability to use high-voltage battery packs for faster flash recycling and all-day power reserves.
3. The ability to turn down the power in precise $1/3$-stop increments, all the way down to $1/128$ power. These three features can make a long and technically exacting shoot a bit easier by giving you more flexibility.

If you don't need to watch every cent and want the most advanced portable electronic flashes on the market, you might want to add the two following features, but be aware that these extra capabilities are usually only available when used in conjunction with specific cameras from Canon and Nikon or other camera manufacturers.

1. Wireless off-camera flash control. (The Nikon camera and flash combination will allow you to control up to three different groups of flashes, setting flash levels and turning groups on and off from the camera. Canon's systems are similar.)
2. FP flash capability. (The ability to be used, automatically or manually with high shutter speeds instead of the normal, limited flash synchronization for a given camera. This makes balancing the flashes with daylight easier and gives you more lighting options on bright days.) Other features such as "stroboscopic" modes are less important.

Once you've figured out the features you need and want you'll be ready to start searching for your flash units. In the following section there is more detail about various models, but it's really beyond the scope of this book to discuss every available unit. I'm a Nikon shooter so I'm more comfortable with Nikon flashes, but the capabilities of Canon and some Metz units are nearly identical.

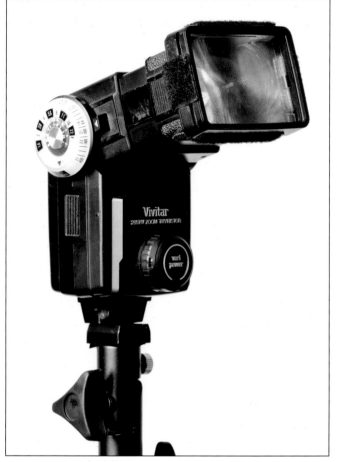

Vivitar 285 HV. This side view shows off the Vivitar 285's zoom head feature as well as the lighted white dial that allows quick automatic and manual settings. The "HV" in the name refered to its ability to be used with dedicated high-voltage, external battery packs.

The bottom line is this: to get the most out of portable location lights, you'll want to select a flash from the family of flashes sometimes called "cobra head" flashes. These fit in the hot shoe of a 35mm-style camera and articulate near the middle so that the flash head faces forward but sits up high on the camera (hence the reference to cobras). Flashes were originally designed this way to eliminate red-eye when used atop cameras. The articulated head also makes it easy to "bounce" the light from these units. If you follow the above guidelines, you'll find a wealth of new and used flashes to choose from. Some information on a few favorites follows.

THE HEROES: THE LIGHTS

Manufacturers of portable flashes seem to have hit their stride around 1972. A number of companies competed in a growing market, and each one brought out new features to differentiate their products. One company suc-

cessfully found the right combination of features and performance and quickly became the market leader. That company was Vivitar.

The grandfather of modern, hot shoe style electronic flashes was undoubtedly the Vivitar 283. This was the first "system" flash designed to actually make location shooting easy, and the designers put a lot of time and effort into figuring out what pros would like in a portable unit and how to make it work without overtaxing brain cells. The Vivitar 283 was part of a new generation of "thyristor" flashes that worked with automatic settings. The sensor on the front of the flash would sense when a scene had received enough light, and it would squelch the light output while conserving any unused power in the flash's internal capacitors. The sensor on the front was removable. It could be placed on a long, dedicated cord which attached in the sensor's place on the flash unit, providing the first simplified, off-camera flash that would retain accurate automatic exposure control. You could also remove the automatic exposure sensor and replace it with a knob that would let you "dial down" the amount of light the flash would give off, from $1/2$ power down to $1/16$ power. This is the basic flash for minimalists. If you are on a strict budget, this is the unit that meets all the minimum requirements. It's got relatively high power with lots of control. Since the Vivitar was incredibly popular, millions were made and many may still be available on the used market.

The Vivitar 283 sounds like a great solution but, unless you get the deal of a lifetime, you should pass on it and look for its replacement, the Vivitar 285 HV. This is the model that took all the best features of the 283 and supercharged them. The engineers at Vivitar added a zooming flash head that enables users to change the angle of coverage put out by the 285. The telephoto setting concentrates the light output, giving higher guide numbers for telephoto lens users. At the wide angle setting photographers can get even lighting with their 28mm lenses. A slot at the front of the flash diffuser allows for extra wide-angle diffusers or color filters. The 285 kept the removable automatic sensor, while the previously optional ratio control (power reduction knob) was built into the flash. The Vivitar 285 hit the U.S. market in the early 1980s and was (and is) so popular that it has been reintroduced

to the market just this year. If you don't need any sophisticated automatic functions, several of these flashes would make a good foundation for a basic portable lighting kit. The Vivitar 285 HV is available new at the current street price of around $89.00.

Several other flash manufacturers brought out very similar flashes to compete with Vivitar. A little research will uncover comparable flash units from Sunpak, Metz, Braun, and others. All are very usable as basic units. Just be sure to follow the "required features" guidelines at the beginning of this section.

The next revolution in hot shoe flashes came from Olympus. When they launched the Olympus OM-2 camera body, they changed the game for everyone by introducing TTL flash. The flash exposure on all other flashes had always been metered by a sensor on the front of the flash, or a sensor coupled to the flash. But the automation in these units could be tricked by filters on the camera lens, large areas of light or dark within the metering area, and other complications. Olympus changed all this by putting a flash sensor in their new camera body. During an exposure, the OM-2 camera would meter both the flash exposure and the ambient exposure right off the film itself. This served to eliminate most exposure mistakes and pioneered the evaluation of all light hitting the film, real time.

Thank goodness the minimalist lighting philosophy largely ignores TTL flash metering, favoring power ratio control for more precise and consistent results.

Soon all major manufacturers introduced their TTL flash solutions. Independent flash makers also launched TTL flashes, but their job was more complicated because each camera manufacturer came up with a different hot shoe interface and proprietary circuitry requiring the independents to play catch up and build versions of each model for each supported manufacturer. Thank goodness the minimalist lighting philosophy largely ignores TTL flash metering, favoring power ratio control for more precise and consistent results.

Nikon has been producing flashes under their brand for decades. While never achieving the market share of the Vivitar and Sunpak flashes, there are a number of

Nikon units, previous to the current SB-600 and SB-800 units, that are very desirable for minimalist lighters who choose not to use the i-TTL system available in the current Nikon digital cameras.

The SB-24 was introduced in conjunction with the F4 film camera in the early 1980s. It is a wonderful flash unit for a location lighting kit. It has zooming capability that can be set manually, and a power ratio control that drops the power in full stops from $\frac{1}{1}$ to $\frac{1}{16}$. Like all top-of-the-line Nikon flash units introduced over the last twenty years, it comes complete with an industry standard PC socket that allows the flash to be easily wired to a trig-

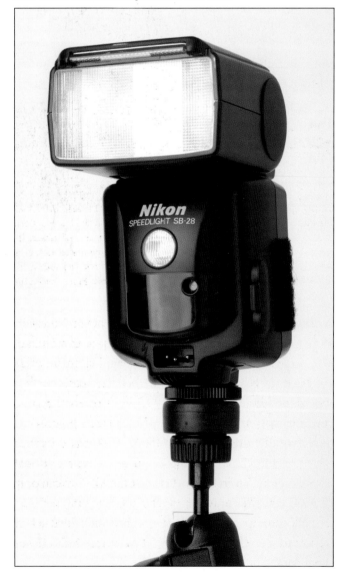

Nikon SB-28 flash. A good all-around flash for manual use. It can be ratioed down to $\frac{1}{16}$ power, has a convenient PC socket for slave device connections, and is very well made. It does not work well in TTL modes with the latest cameras from Nikon and cannot be used in the hot shoes of Canon cameras or most other camera brands featuring dedicated flash shoes.

gering device or directly synced to just about any professional camera. The SB-24 takes four standard AA batteries but also has a plug just under the red window on the front of the unit allowing a direct connection for high-voltage battery packs. The SB-24 is a bit bulkier than current models but is a great value if you can find one cheap.

Nikon followed up the SB-24 with the SB-25, which added wired multiple flash control capability (not very useful) and several small enhancements such as more advanced power management and better wide-angle coverage capabilities. The replacement for the SB-25 was the SB-26. These two flashes look very much alike, but the SB-26 was the first flash built to work in conjunction with the "3D" flash metering of the Nikon F5 camera body. The 3D flash meter used distance information from lenses to fine-tune flash exposures. The SB-26 also boasted a very elegant addition, a built-in optical slave cell. Now SB-26s could be wirelessly triggered (but not wirelessly controlled). The SB-26 was very well received, and few of them seem to surface on the used market. It has a reputation for being "indestructible" and very accurate with various Nikon film bodies.

The next wrinkle for camera manufacturers was the widespread introduction of digital SLR cameras around the turn of the century. Photographers quickly found that the flashes that had worked so well in TTL modes with their film cameras were pretty bad when used in the TTL modes on their new digital cameras. Apparently, the surface of film was relatively uniform, and its reflectance was consistent enough to supply really good exposure accuracy. Such was not the case with digital. The sensors in the cameras had a reflectance that varied depending on the angle at which light struck. The anti-aliasing filters used over the digital sensors also had reflection issues. The net result was a slew of inconsistent and unreliable exposures. Flash exposure became digital photography's Achilles' heel. Many professionals switched back to older technologies, some relying on the automation provided by the flash unit's front-mounted sensor, others went back to figuring out exposures manually.

The Nikon SB-28DX was Nikon's solution to the lighting dilemma, and while it was better, it still had its problems. The SB-28DX was the first of the Nikon flashes to use visible pre-flashes in conjunction with TTL metering to try to get closer to the optimum exposure.

Nikon called this adaptation D-TTL flash. In all other measures, the SB-28DX is a great flash. It offers almost everything one would want in a portable unit; it is smaller and lighter than the SB-24, 25, and 26 but offers the same power. Its power management (also known as the "standby") mode was more advanced, and it was more frugal with its batteries. Of course, the SB-28DX can be dialed down to $\frac{1}{16}$ power and has the front plug for direct connection with high-powered battery packs. In the last year or so, lightly used examples of this flash have come on to the used market in the $100.00 to $125.00 range. That's not a great bargain for someone determined to use them with the latest Nikon digital cameras but is a real find to location photographers who trigger their location flashes with radio triggers or optical slaves.

The next flash from Nikon was the SB80DX, a totally redesigned unit. This flash replaced the plastic "foot" of the previous models with a very sturdy metal one and also introduced a new switch to lock the flash onto the hot shoe of the camera. Older models used a round, plastic knurled knob that had a tendency to get stuck. While not much more accurate with digital cameras than the SB-28DX, the controls on the back were easier to use and, according to Nikon, the unit was more powerful and efficient with batteries. It is certainly usable for location lighting in a minimalist system but is rarely available at the bargain prices of the previous models.

The current top model from Nikon is just right. It's called the SB-800, and it offer a tremendous number of features and capabilities. This and the SB-600 are the units to own if you intend to make use of the i-TTL wireless system from Nikon. The SB-800 keeps the metal hot shoe of the SB80DX, works flawlessly in the TTL modes with the latest generation of Nikon digital cameras, and can be used as a "master" control center for up to three groups of flashes in a wireless network. The SB-800's high purchase price keeps it from being recommended as a unit to be used with radio slaves or optical triggers exclusively. It is the perfect choice for the professional who needs to use all three light triggering options from time to time and would also like to break the rules and use her flash right on top of her Nikon digital camera—in the hot shoe!

The Nikon SB-600 is a stripped-down flash that has *nearly* every feature a location lighter would like in a

The Nikon SB-800 is the current top-of-the-line flash in the Nikon system. Used in its commander mode it can control up to three groups of flashes. Its preflash system is the current champion for correct exposure control. It is smaller and more powerful than its predecessors. Shown here mounted to the new Fuji S5 Pro digital camera it provides the Fuji product with the same range and features as the Nikon cameras.

Nikon flash. It does not have a PC sync socket, however; in fact, it doesn't have any plug or interface that will accept a sync cord except for its hot foot. Nikon shooters who like to work with the i-TTL wireless flash control system like the SB-600 just the same. It offers the same controllability as its big brother, but since its power output is slightly lower it recycles more quickly, and its four batteries last 15 to 20 percent longer. One additional caveat for i-TTL wireless users is that the SB-600 can only be used in the "remote" setting and not the "master" setting. (These mysterious settings will be explained when we get to the how and why of i-TTL versus radio slaves versus optical slaves.)

Canon Speedlite 580. The 580 EX 2 is the current top of the line for Canon's line of digital ready flash units. Its closest competitor is the Nikon SB-800. Used in multiples, it represents an effective alternative to tradition AC-powered flashes for photographers who use Canon digital cameras.

Canon didn't sit around waiting for Nikon. There are two current models and three recently discontinued models that fit all of our basic parameters and embody the same kind of constant improvement shown by Nikon. The two current flash units are the 580EX and the 550EX. Feature for feature they are almost identical to their Nikon counterparts in their capabilities. Both units can be dialed down to $1/128$ power, can be used as master flashes in Canon's wireless flash system, and can be used in the FP mode. The one area in which the Canon flashes lag behind the Nikon flashes is the omission of a PC sync

socket. Canon flash users who want to connect radio slaves must use hot foot-to-PC socket adapters, which eliminates the ability to use shoe mounts on light stands.

Canon also made the 540EZ, 430EZ, and 420EZ. These units all have the basic capabilities location lighters need (with the exception of a PC socket). They differ in having slightly less power output and a good bit less weight than the latest models. Most Canon digital users will want to opt for one of the two newest models to take advantage of all the latest wireless capabilities.

The German company, Metz, makes several very good units. A recently discontinued but highly regarded unit

The Metz MZ-54 is a very well-built flash. The flash shoe of the MZ-54 can be interchanged to provide optimum integration with most of the major TTL flash systems. We use our MZ-54s with a standard shoe having only one contact on the bottom for basic triggering. The camera has a full complement of features that are desirable for minimalist lighters, including a very precise power ratio control, excellent automatic aperture operation (using the front mounted sensor instead of camera TTL), access to a full complement of high-voltage batteries, and more. They are a great value when purchased used.

was the 54 MZ 3. An interchangeable shoe module made this flash compatible with many different camera systems including the previous Nikon D-TTL system and the Canon E-TTL system. It was made obsolete in the Nikon world by the introduction of i-TTL. It is a powerful flash with a manually adjustable zooming flash reflector and the ability to dial down a manual exposure from full power to $\frac{1}{128}$ power in $\frac{1}{3}$-stop increments. Prices on these units have dropped since the introduction of the Metz 54 MZ 4. This flash is current and is offered in dedicated versions for each major camera manufacturer. Sadly, this unit does not support the wireless system for either Nikon or Canon.

HOW TO CHOOSE THE RIGHT SYSTEM

You know you're out to lighten your load, but which flash system should you buy? Good question. Before you make any decisions, let's figure out what the typical photographer will likely need to handle most projects.

Most professionals agree that three lights tends to be the magic number for most lighting setups. That means three flash units. If one flash will be used as a master or trigger flash from the hot shoe, you may want to add one additional flash to retain the real three-light flexibility you'll most likely need.

If you're on a limited budget, you'll want to look at the Vivitar 285 HVs or a similar flash from another manufacturer. When you couple these with optical slaves or the least expensive radio slaves you'll have a small, efficient lighting system that will work with any digital SLR camera on the market. Alternatives would also include any of the used Nikon flashes discussed above.

If you really like the idea of experimenting with i-TTL or e-TTL wirelessly controlled flashes, you'll need to get one master flash and two or three suitable remote flashes from the same company that makes your digital camera. For Nikon owners, that would mean purchasing one SB-800 and two or three of the SB-600s. If you find that your style of shooting really requires radio slaves, they will work well with either system. If you know from the start that you'll be using i-TTL indoors and radio slaves outdoors, you might want to purchase all SB-800s, as the built-in PC sync terminals will prove valuable when you need to mount the units on stand adapters and connect radio receivers.

The high-voltage cord for battery packs connects to the socket on the front of most Nikon professional flash units. Be sure to seat it all the way into the socket for the best connection. How do you know if your Nikon unit is "professional"? If it has an HV socket on the front and a PC sync on the side, then you've got the real deal.

Whatever direction you decide to go, be sure to consider buying three or four of the same model flash unit. Many photography assignments are done under stressful deadlines, and having exactly the same controls on all four of your flashes goes a long way toward eliminating confusion and mistakes. This is why professional photographers always try to have backup cameras that are the

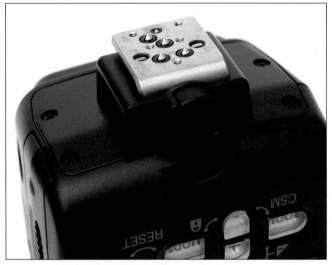

The "shoes" of the latest Nikon flashes are made of sturdy metal to increase reliability. The center contact point is the sync trigger that detects a trigger voltage from the camera. All the other contacts relay information between the camera and the flash unit.

The rear of a modern flash reveals an LCD panel with hierarchical menus that give users a tremendous range of features and a great amount of control over their flash unit. The SB-28 shown here provides lots of basic information to photographers.

same model as their primary shooting camera. Having to memorize only one menu or one set of controls is priceless when you've got one chance to pull off a great image!

At this point you've checked your piggy bank and decided on the electronic flash units that will give you the best bang for the buck. Now it's time to think about how you'll control them and what you'll use to trigger them. This is where flash photography becomes interesting.

WHOA! TRIGGER

There are four main ways to trigger multiple electronic flashes when you're out on location. The most expensive and elegant method is to use radio slaves. A transmitter sits in the hot shoe of the camera (you knew that hot shoe would come in handy for something!), and when the shutter is released, the transmitter sends a signal to all receivers operating on the same frequency. The transmitters are connected directly to portable electronic flashes. All the flashes trigger at the same time, and everything is wonderful. The second method is to trigger (and control) your lights using the built-in systems in your latest Nikon i-TTL and Canon wireless systems. Both companies use infrared pulses and pulse code modulation with faint white light pre-flashes to trigger and control multiple lights. The third method is the least expensive and the least elegant. It uses optical slaves to see the light from a wired trigger flash, and each optical slave triggers the unit to which it is attached. The fourth method is to use off-

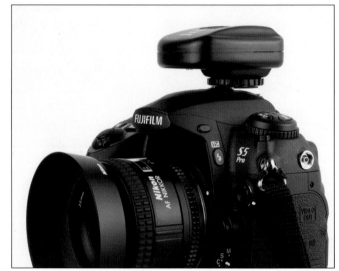

The transmitter for the radio slave systems sits in the hot shoe of any camera. When the shutter is actuated the transmitter sends a radio signal to a receiver unit and that receiver unit triggers the flash. While this transmitter is shown in the hot shoe of a camera it can also be triggered by a PC cable.

camera cords to trigger the flash. Each method has good and bad points.

Turn on the Radio. Radio slaves come with many advantages and, of course, a few disadvantages. The best radio slaves, like the very advanced ones called Pocket Wizards, are extremely reliable triggers that work well over distances of up to 400 feet! The receivers only trigger the lights when they receive a radio signal from the transmitter, so one never has to worry when working around other photographers using flash about accidental triggering of each other's lights. Another benefit of radio slaves is that of almost infinite scalability. With a big enough expenditure on receiver units, one could easily trigger hundreds or thousands of flash units from one transmitter!

The one major downside of radio transmitters is their cost. A basic set of Pocket Wizards, the gold standard of

flash triggers, is right around $500.00. Each additional receiver runs just about $250.00. For the photographer who routinely used four or five lights the costs can add up. What's a struggling photographic artist to do?

Well, you could look for less expensive brand of radio trigger. In the last two years several radio trigger systems have become available in the United States. One is distributed by RPS Corporation, but a very similar system is branded and sold by Speedotron. This species of radio

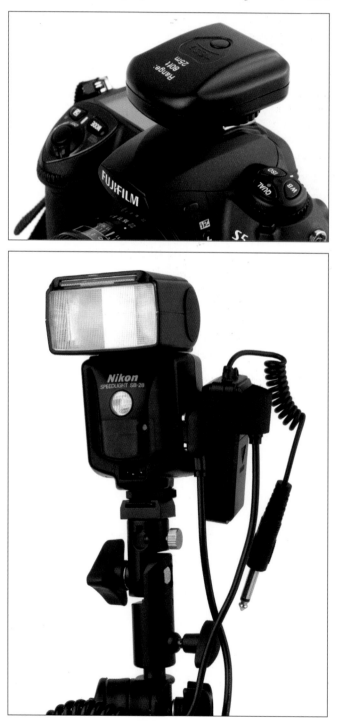

This radio transmitter (top right) is marketed by RPS, Inc. and boasts a range of up to 80 feet. The current selling price for a complete system, transmitter, and receiver is around $100.00. It can be configured to use up to sixteen different channels to prevent interference with other systems near the shooting area. In the bottom right image, the RPS radio receiver is shown velcroed to the side of an SB-28 flash unit. The large 1/4-inch "banana" plug is not used. The flash is triggered by a standard "male" PC to "male" PC sync cord. Both the Nikon flash and the slave receiver have the same connection sockets. The whole assemblage is mounted on an ALZO stand adapter. These two components shown below are the transmitter (the smaller unit with the "test" button) and the receiver of a radio slave trigger system. Made in China, they are available from a number of different companies. They are small, lightweight, and inexpensive. They are often referred to on web sites as "eBay slaves" because they were first offered directly from distributors, located in Asia, on eBay auctions.

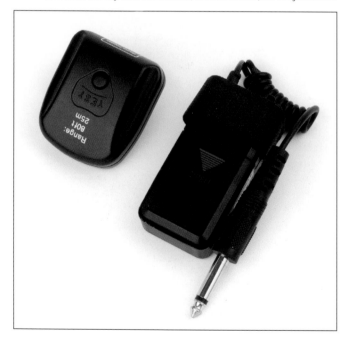

trigger is exported from China, and the basic system is right around $100.00. These radio triggers are also referred to as "eBay slaves" because one company in Hong Kong is selling the systems directly on eBay for less than $50.00 a set. Additional receivers are available for around $30.00 each.

A few photographers have had trouble getting the less expensive radio slaves to work, but many more photographers swear by them. They have about a quarter the range of the Pocket Wizards and lack a bit of the functionality, but they certainly make up for it in price.

If you need a foolproof triggering mechanism, the radio slaves are the way to go. If you are a professional on a tight schedule with once-in-a-lifetime assignments, you might want to spend a bit more and go with the Pocket Wizards. They have a spotless reputation for producing flash on demand with no excuses. If you are brave, shoot for yourself, or just don't have a lot of money to throw around, you could do a lot worse than getting a set of the eBay strobe triggers. In broad daylight and in situations when you want to place flash units somewhere other than in the line of sight, you'll find their reliability and single-minded functionality superior to the wireless infrared control of the Nikon and Canon wireless systems. In daylight conditions, they are also far superior to any of the optical slave solutions.

Untethered Control. Wouldn't it be neat if you could hang little flashes from high ceilings, put them way up on light stands and in other hard to get to places, and then be able to control them all from your camera position? Suppose you wanted one group of flashes to be a stop more powerful. Perhaps you want to turn one group off altogether. Rather than climbing a ladder to adjust your lights you could be taking advantage of Nikon or Canon's wireless flash systems to do just that. While the camera manufacturers' wireless control can't match radio transmitters and receivers for "gotta get it right every time" triggering performance, they run circles around everything else when it comes to convenience and fine control.

With either system you can designate one flash as the master flash. This one will go on top of the camera or be attached to the camera with a "smart cord." On the rear panel of the master flash you are able to control up to three different groups of flashes. Each group can have

multiple flashes, but only three groups can be controlled individually. When the camera's shutter button is pushed the master flash communicates with the "remote" flashes in each group via a series of rapid, almost invisible flashes. These "pulses" tell the remotes what settings to use and when to trigger. After the flash occurs the remote flashes can let you know they were successful with acoustic signals. They also use flashing red lights to let you know that they have recycled and are ready to fire again.

The Nikon SB-800 units are the only Nikon flashes that can be used as a master flash. When used as a slave or remote flash, they can be used in the TTL mode, the auto aperture (old style, sensor on the flash unit automatic), or in the manual mode. In any of the automatic

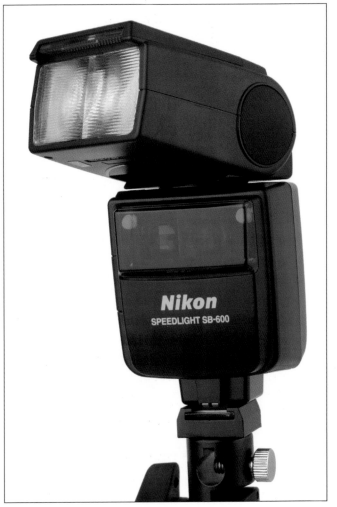

The Nikon SB-600 is a simpler and slightly less powerful version of the SB-800 flash unit. It can be used in regular modes such as TTL and manual and it can be set to work as a remote flash in the CLS system, but it lacks the ability to be used as a master flash and also lacks a few refinements such as a PC socket for sync cords and a high-voltage socket for external HV batteries. The SB-600 does feature a pair of red LEDs on the front of the flash that blink every 3 seconds to show its readiness when used in the remote mode.

modes their outputs can be adjusted in 1/3-stop increments. In the manual mode they can be set at any power level between full and 1/64 in full stops. The SB-600s can only be used in the TTL and manual modes. Photographers who embrace this wireless mode usually label each of their flashes by group to make setup and control from the camera position easier.

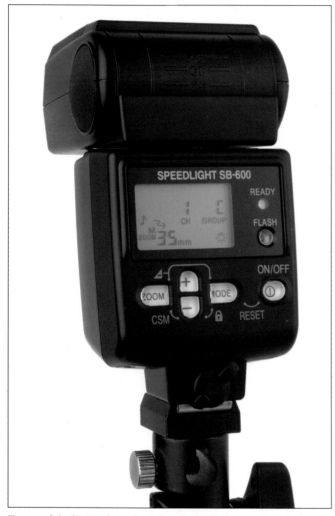

The rear of the SB-600 shows that it is a simpler flash to use than the SB-800. Though it is about 20 percent less powerful than its bigger sibling it makes up for the lack of power by having a reduced recycle time and by getting more life from its batteries. Note that this particular flash is set up in the "remote" mode.

Nikon and Canon both make dedicated wireless control modules that take the place of the master flash and can control remote flashes. A major benefit of the dedicated modules is that they use bright infrared pulses to control the remote flashes, which seems to cause fewer blinks from the subject when compared to the white light pre-flashes of the master flashes. They also free up an additional, off-camera master flash. The dedicated wireless modules seem to have better range and better performance in bright sunlight than the master flashes.

The wireless flash systems are very popular with photographers who work in a lot of interior locations. Their ability to be used in an automatic TTL mode also appeals to photographers who have to move quickly and don't have time to set each group by trial and error. Savvy wedding photographers are using more and more wireless systems because they can place lights through a large reception hall to fill in dark areas and give a better feeling of three dimensions in their finished photos. If the remote flashes were set to manual, the photographer might risk overexposures if too close to the remote flashes or underexposure if too far away. By using the remotes on the TTL setting, the camera's internal sensor constantly makes adjustments for these lights. An added benefit of the wireless camera systems are their utter indifference to other people's flashes. Each command sent out from the master flash or the dedicated infrared module is encoded, and when the other flashes are set to their remote modes, they only react when they receive the right code. No more problems with Uncle Bob's incessant picture taking draining your batteries.

One downside that must be considered when using current wireless systems is that they are essentially limited to "line of sight" and to distances of 30 meters or less. This means that the sensors on the side of the flashes want to see the master flash or the TTL module in order to work well. In a small room with white walls the flashes or infrared signals bounce all over the room and can set off the remote flashes without difficulty. When used in large, dark environments that absorb most of the light from the pulses, correct positioning becomes more critical. This also holds true for use outdoors. In open, outdoor environments there is nothing to bounce various signals from so line of sight becomes critical.

The Optical Illusion. Before radio slaves, before wireless pulse code modulation, before everything but "hardwire," there were optical slaves. They require no batteries, can be quite sensitive, and are good at triggering flashes—if all the conditions are just right. These are simple devices that came on to the market at reasonable prices in the 1960s. The 800-pound gorilla in this device market niche is a company called Wein. They make an incredible array of optical slaves for just about any purpose.

The ultimate optical slave is the Wein Ultra Slave, also known as the Model WP-SSL. These units can be used with either regular white light as a trigger or as part of a system of pulsed near infrared triggers. With a claimed range of over 100 feet and a relative nonchalance about ambient light levels, these slaves were the Tyrannosaurus Rex of the pre-radio trigger days. They are still available in several permutations

This Sunpak optical slave has been in use for over twenty years and still works. It is a very straightforward design. The only point of connection is the PC terminal on the rear of the flash. Eventually the little suction cup will submit to the ravages of Texas weather and we'll continue to use it with a liberal application of gaffer's tape to hold it in place.

From time to time I've needed simple optical slaves to trigger small flashes. I've found lots of variations, but all of them seem to work well in close quarters. Here is an example of a "store branded" unit I picked up for under $25.00 at one of our local camera stores. This unit can trigger a flash that is sitting in the hot shoe or it can trigger a flash when connected by a cord to its PC terminal. These units work best when used in a direct line-of-site mode and have a fairly limited range.

The Wein "peanut" slave was a favorite of optical slave users for many years. Officially named the Wein Micro Slave, it attached directly to a standard PC cord and could trigger just about any standard flash unit. It has two flaws: a limited range and a high sensitivity to the flicker of fluorescent lights.

An optical slave is a fairly simple device that uses a semiconductor sensor that creates a signal when it "sees" a big change in light amplitude. With no moving parts and a small form factor, these slaves are very resistant to wear and tear. They are also relatively inexpensive. You can buy a bunch of really good optical slaves for well under $25.00 each. You can also spend over $100.00 on a Wein slave that boasts a range of up to 3,000 feet!

Optical slaves, like camera manufacturer's wireless systems, work best when used in a line of sight situation. They also work better as the flash becomes more powerful relative to the existing light. Many monolights and studio generator and head electronic flash systems come with slaves built in. For studio situations these all work very well—but you want to take your stuff on the road and use smaller output flash units, so the benefits start to erode.

Against the advantages of cost and infinite scalability (you could put hundreds of slaved flashes in one room and trigger all of them with one burst of light), you'll have to weigh the fact that they can be tricked into triggering by lots of things in addition to your camera flash:

lightning, flickering fluorescent lights, other people's flashes, even people moving through the light that your optical slave sees. Many photographers have had their studio systems trigger as fast as they could recycle right up until they blew out their circuit breakers because of fluorescent light flickers. If you are on location when you encounter something like this, the only remedy is to turn off the fluorescents.

Just like radio slaves, the optical slaves make your flash dumb. If you use your flashes manually and set power ratios instead of using TTL automation, you probably don't care. The bottom line is that they work in many situations, and if they work in yours, they are an elegant and cost effective solution. Just don't expect to take them outside, put them behind a subject, and expect them to fire. They won't. That's why they make radio slaves! Consider one more thing: Optical slaves depend on a flash of fairly bright light to trigger them. If you have constructed a carefully lit image, will the flash from the camera position degrade the effect you're after? Will the frontal flash degrade the contrast you've work hard to create? Will it add extra shadows? If you work in a studio all day long, with complete control of your lighting, optical slaves are a no-brainer; put one on every light. If you venture outside, it's another story altogether.

TETHERED TO THE CAMERA OF YOUR CHOICE

Before everything else, there was the hardwire, a double strand of copper that physically connected a flash to the camera. In the photography world it is widely known as

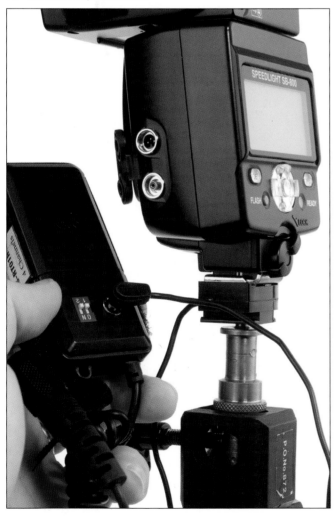

An example of a generic PC-to-hot shoe adapter being used with a radio slave to trigger an Nikon SB 800 flash. A contrived example as the SB-800 has its own dedicated PC sync connector.

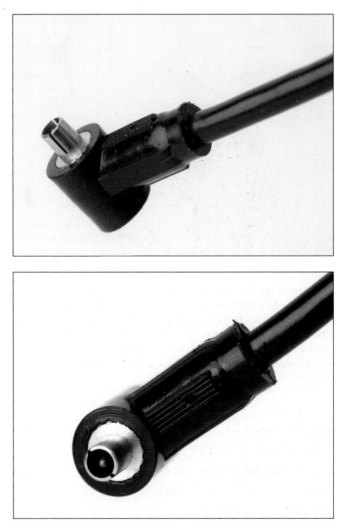

The PC connector and PC termination are relics that have survived since the 1940s. PC stands for Prontor/Compur, the manufacturer of shutters for view camera lenses. It has become the de facto standard through the process of attrition as many other solutions for connecting cameras to flash units have come and gone. PC connections are notoriously unreliable. They can easily become loose and fail to make good connections.

a sync cord. In its simplest manifestation it is two wires that send the message, "fire the flash." In its most modern appearance it can be a bundle of small wires within a coiled cable that has terminations at one end that match the little pins in the shoe of your modern camera and a matching foot at the other end. These are meant to be used with TTL-enabled camera and flash systems and retain all of the automation you would expect when using your flash on the hot shoe. Nikon's SC-29 cord even preserves the autofocus light at the camera position via a

small infrared light that forms part of the plug that fits into the hot shoe of the camera.

The off-camera cords work very well, but they are very much a "one flash, one camera" proposition. They are further limited by their length. Off-camera cords are

One standard in all professional-caliber digital and film cameras is the inclusion of a standard PC socket for studio flash connection. Shown here is the PC socket on the latest Fuji S5 Pro camera.

It's no secret that I like fully dedicated, off-camera cords like the Nikon SC-17. This is the same one I've had for a long time. They never seem to wear out. There are similar cords available to fit all brands of cameras that offer dedicated flash systems. These cables allow you to use all the features that are available to you when using the flash in a dedicated hot shoe.

The successor to the SC-17 cable from Nikon is the new SC-29, which adds a neat feature. The component that sits in the dedicated hot shoe of the camera comes with its own infrared focus assist light so that no matter which direction your flash is pointed the AF illumination is always aimed at whatever your lens is aimed. Nice touch!

Above is the camera end of the Nikon SC-29 dedicated flash cable. Notice the red plastic window that covers the near infrared autofocus illuminator. This addition to the classic off-camera cable will help your camera focus under the most adverse conditions. Cool.

To the right is the camera end of the Nikon SC-29 dedicated, off-camera cable. Note the control on the front. This allows you to turn the autofocus illuminator light on the other end of the cable on or off. Why would you want to turn it off? Maybe you're trying to photograph surreptitiously and the blast of red light from the front of your camera isn't the most subtle greeting.

useful for situations where one flash will suffice and the flash need only be moved a short distance off camera for more pleasing light. They can also be combined with some of the triggering methods described above. An obvious use would be to trigger a main flash near the camera position, which would then trigger other flashes outfitted with optical slaves. Used this way background lights could be set at a specific manual power setting and the main flash could be used either in a manual power setting or with TTL automation.

MIX AND MATCH

As you work through various photographic projects with your new lights and triggers you'll notice that some methods work well in some instances, but not everything works for every situation. Most photographers mix and match triggering technologies from the above list. Some combine techniques in almost every shoot. Once you get the hang of it you'll know instinctively which set of slaves or cords to grab. It's as easy as falling off a bicycle.

HAULING AROUND THE PHOTON GENERATORS: FROM CARAVAN TO CARRY-ON

Let's take a break from thinking about flashes, slaves, triggers, and cords and focus on how you're going to get this gear from one location to another. You could emulate the early career of famous photographic artist Duane Michaels and carry all of your cameras and lights in a conventional shopping bag, complete with the little twine loops for handles. However, this approach is no longer recommended as you'll be carrying a bit more than his one camera and two lenses, plus a few boxes of film. Paper shopping bags tend to fall apart quickly, and they're not much good after a light rain. Forget the traditional photographer's shoulder bags—they're hell on your back and not big enough to carry all your cool, new stuff . . . and they are sooooo last century.

The smart money these days is on rolling cases. The newest generation of soft-sided rolling cases uses in-line skate wheels for a smooth roll, has configurable dividers to customize their interiors, and holds a good amount of

Below is the Think Tank Airport Security case as supplied. Not shown are an assortment of included straps and the thoughtful rain cover. Love the in-line skate wheels.

This rolling case from Think Tank Photo (top right) is called Airport Security. It's a staple on every shoot, in town or out of town. As you can see it holds flashes, controllers, and batteries as well our primary cameras and lenses. We use it like an equipment cabinet on location and it's ready to roll to the next location in seconds. Even comes with its own rain cover! Here's how I have it pack for a typical day's shoot.

The Think Tank Airport Security case closed up and ready to roll (bottom right). Notice the complement of three Manfrotto stands and two Westcott umbrellas in the front pocket and our Velbon carbon fiber tripod lashed to the side. If we need more gear, we just pile it on top and keep rolling.

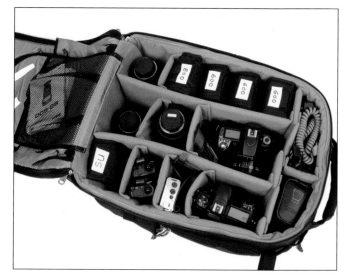

camera gear with enough space left over for four flashes and a handful of radio slaves. Being able to roll a case along, with an extendable handle, takes most of the physical burden off the photographer and lets you arrive on location relaxed and ready for action. The rolling cases are available from traditional bag manufacturers such as Lowepro, Tamrac, Lightware, and others. The current "hot" rolling bags are from a new company called Think Tank Photo. They make a smart-looking roller bag called Airport Security, which fits neatly into a domestic airline's overhead rack and comes with locks for both main zippers as well as a sturdy built-in cable that is used to lock the entire bag to any convenient, immovable object. It might not stop a dedicated thief with time on his hands, but when cabled to the plumbing in your hotel room, it might serve to discourage crimes of opportunity.

Think Tank also makes a version called the Airport International Roller. Its claim to fame is a set of measurements that allow it to fit in the overhead compartments or under the seats of international carriers.

Whether you go with the Airport Security from Think Tank Photo, Lowepro's Pro Roller, or the Tamrac Rolling Strongbox, you'll find them superb cases from which to work. Additionally, all of them have large external pockets capable of holding small light stands and side straps to secure tripods and other accessories.

If you have a good camera store close by, it's a good idea to drive on over with all of your gear and see which case really fits the stuff you use. Everyone's idea of the ideal case is different, and it's hard to tell from catalog photographs how everything fits.

It's the consensus of most experienced photographers that one way or another you'll end up with a rolling case. The only question is, will you get one before or after you ruin your back?

GETTING YOUR LIGHTS TO STAY WHERE YOU NEED THEM

Getting small flashes positioned properly reminds one of the television show, *MacGyver*, where the hero could make just about anything out of common household objects. On one show he would use a lawnmower, a few umbrellas, and a hollow core door to make an airplane, while on another show he used chewing gum, lightbulbs, and popsicle sticks to defuse a nuclear bomb. (Okay, these are exaggerations, but you get the point.) Photographers

Everyone needs a good flash-to-light stand adapter, and I've been through enough of them. This is an inexpensive Chinese product that I've turned into a "Frankendapter" by adding a cheap ball head with a built-in "cold" shoe for flashes. This stand adapter is in competition with the Photoflex adapter for the "accessory with the most knobs" award. In its defense, it is both sturdy and able to tackle just about any task.

start to feel like MacGyver when they begin to master the art of rigging their lights. There's something about the ability to put a light just about anywhere that makes you feel a bit like a superhero.

It all starts with light stands. The light stand is a perfectly rational choice for holding lights. That's what it's designed to do. But most light stands are designed to be used with studio lights that have built-in mounting brackets that fit neatly on the tops of the stands. Your flash units are designed to fit on the tops of cameras, so a little bit of customization is called for. You'll need stand adapters with accessory shoes on top of them. Above and on the next page are two photo examples of stand adapters from various manufacturers. You'll notice that the best ones serve two purposes: (1) they have an acces-

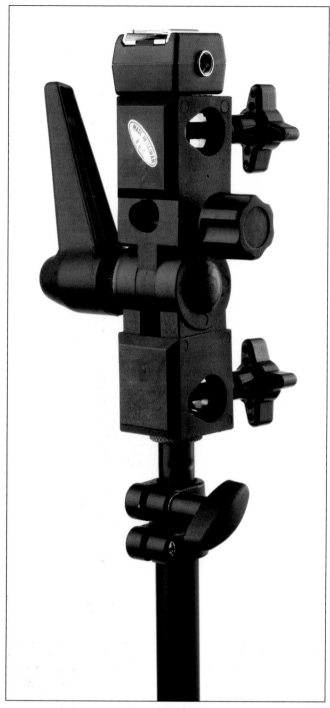

Every bit of flexibility comes in handy when it comes to correctly positioning your lights.

Customization is the name of the game. Occasionally, you can find cheap ball heads that, with a small adapter, allow you to mount a light and then position it quite eas-

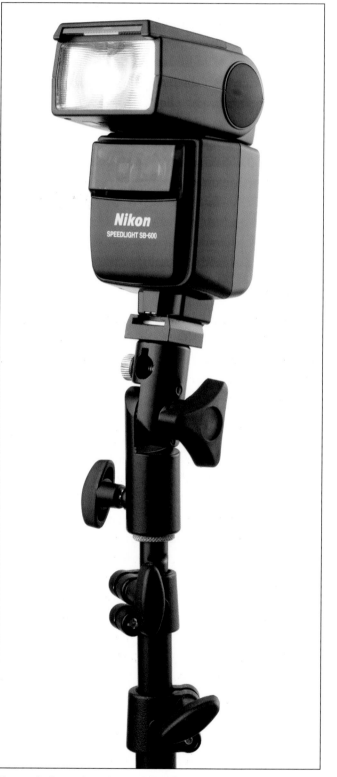

Photoflex markets this composite constructed stand-to-flash adapter for a bit less than $20.00. They come with little metal cold shoes, but after I lost mine I replaced it with a spare part from a previous generation Nikon flash system. This gives me a "cold" shoe for my flash without having to worry about shorting the connectors on the bottom of the flash. While there are way too many knobs on this adapter it can handle umbrellas and just about anything with a $^5/_8$-inch stud.

sory shoe at the top to hold your flash; and (2) they have a hole in the top section that will hold the shaft of a photographic umbrella. Notice the lever or knob that allows the top half of the stand adapter to be tilted up or down.

Alzo stand adapter shown in use with a Nikon SB series flash unit.

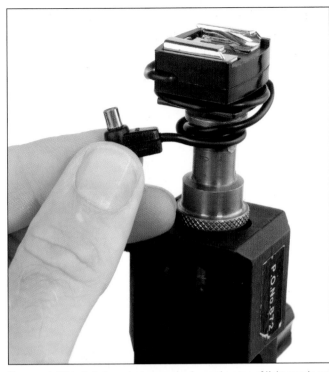

The generic PC-to-hot shoe adapter can also be used on top of light stands and tripod equipped with 1/4-inch screw thread as a stand adapter for attaching flash units.

The Manfrotto 3373 light stand is one accessory I never leave at home. It extends to a good usable height and is my first choice for a lightweight, packable stand. I like black because it doesn't reflect as much in shiny objects.

ily. There are no hard-and-fast rules, so even duct tape is a legitimate tool. In fact some photographers have even successfully mounted small flashes to bare walls with nothing but an adapter and some handy tape.

Various adapters are available from Alzo, Lastolite, Promaster, and others. The ones you want have a shoe mount on the top. That's the whole reason to buy the stand adapter. Make sure yours comes with one!

Hold Still Right There! Now that you have your stand adapters, it's time to pick some stands to go under them. Dave Hobby, famous minimalist photographer and originator of the Strobist.com web site, makes a good case that the ultimate light stand, for those committed to reducing their lighting load, is the famous Manfrotto 3373 five-section light stand. It's a favorite for many reasons, but the most germane are these: (1) it folds up to a small 19 inches, allowing it to fit into smaller bags; (2) for a stand with such a small "footprint" in its dormant state, it extends up to an impressive 75 inches; (3) Though it is sturdy and well built it weighs a mere 2 pounds; and (4) in deference to the black finish of most cameras and photographic luggage, they are available in a black finish as well as the traditional shiny metal. (Although if you shoot outside in the Southwestern United States, you might

want to consider the regular metal finish as it won't absorb heat to the same degree the black finish will. It's never fun to burn your hands when putting away your gear.)

Another favorite is the Pic 4707 Featherlite light stand. It extends to 7 feet, folds up to 18 inches, and weighs only 1 pound, 13 ounces. It is crafted from aluminum and stands up well to general wear and tear.

Traditional light stands are made to support ten- or fifteen-pound studio flash heads and engineered to be

sturdy, not for convenient travel. Some light stands tip the scales at 18 pounds, probably more than all your lights and camera equipment combined! You may need taller stands for some shots, but the Manfrotto 3373 will serve you well 90 percent of the time. Since the 3373's legs fold down in their unique way it's easy to anchor the stand for safety or wind resistance by putting heavy objects on the legs when they are parallel to the ground.

A Weighty Subject

If you set up light stands in an office or a public place, you should weight them down so they don't tip over and hurt someone or damage property. Photoflex makes heavy-duty plastic bags with a connecting hook that are made to be filled with water and used in place of sandbags. You can fill them from any source, and when you've finished your shoot you can drain them, fold them, and stick them in the front pocket of your rolling case. At less than $20.00, they are right in line with the minimalist philosophy of traveling light, but they allow you to do high-quality work once you've reached your location.

It's important to keep your light stands stablilized. The last thing you want is a five- or ten-pound light crashing down on someone's head. Photoflex makes it easy on location photographers by offering these plastic "sand bags." When you get to your location you simply fill up the bag with water and hang it onto your light stand. When the shoot is over you can drain out the water and fold the bag up for convenient storage.

Going Beyond the Light Stand. Light stands are all good and well, but one of the fun things about truly portable lights is the range of options you have for un-

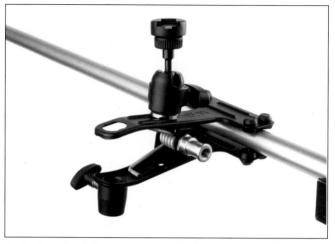

The Manfrotto Justin Clamp. A great example of a company responding to a new market, this clamp is quite versatile, incorporating a ball head with a flash shoe and a separate $5/8$-inch stud for easy attachment of a stand adapter. It's perfect for positioning a flash on a door, chair, or fence.

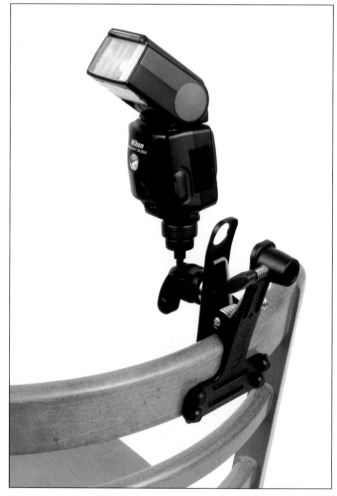

The Manfrotto Justin Clamp allows for very resourceful light placement. Here it is shown attaching a Nikon SB series flash to a chair.

conventional rigging. Have you given any thought to using them with a simple clamp instead of a light stand? Manfrotto makes a simple, sturdy spring clamp called the Clip Clamp with a mounting stud bolted on it that's perfect for clamping flashes to doors, the blades of ceiling fans, bookshelves, chairs, and just about anything else that fits. These clamps are easy to carry along and come in handy for positioning a light in just the right spot. The mounting stud on the clamp allows you to use the same stand adapters you use on your light stands. Manfrotto has gone one step further and added a product they call a Justin Clamp. It's exactly like the Clip Clamp but comes with a small ball head with its own accessory shoe in place of the usual threaded screw meant for cameras.

Sometimes your spring clamp comes in handy when you need more power. How can you get more power with a spring clamp? Easy. Use it to quickly double the

number of flashes you have mounted to one stand in order to increase the power of your light by 1 stop. Spring clamps make improvising a lot more fun!

Have you ever wished there was a way to mount your flash from one of those ubiquitous tile dropped ceilings you see in every office and school in the world? A spring

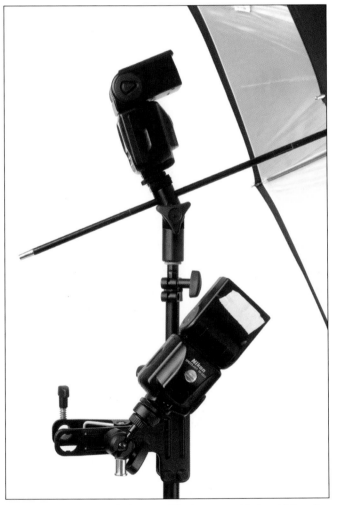

You can boost the power of a light modifier by 1 stop with the addition of an equivalent flash unit. We often use a Manfrotto Justin Clamp to add a bit more light to a light modifier.

The Lowell Scissor Clamp attaches to the rails that hold drop ceiling tiles in place. When properly attached it provides a secure stud from which to hang small lights. Its $5/8$-inch stud works with all stand adapters. It's the perfect device for putting lights in a room when light stands are inappropriate or will show in a shot.

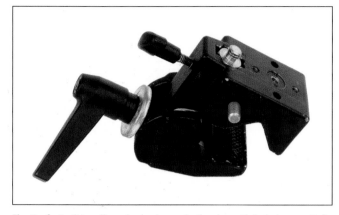

The Manfrotto Super Clamp is also known in the cinematic industry as a Mafer clamp. It is rugged and can be used to position heavy lighting units and accessories. We have successfully used two of these clamps to hang a hammock for a photo shoot. They easily handled the 120 pounds of our model.

clamp is a bit unwieldy in this situation, but a company called Lowell has just what you need, it's called a Scissor Clamp and was invented by the lighting guys in the movie industry for hanging fixtures from these kinds of ceilings. These clamps can be lifesavers when you need to put a light right over your subject (for effect), right behind your subject (for a hair light), or to put a splash of light on the back wall and you can't use a light stand because it will be visible in the frame.

Heavy-Duty Clamp Champ. Several companies sell versions of the Manfrotto Super Clamp (lighting guys in the film and video industry call them Mafer clamps). The Super Clamp redefines the term "heavy duty." Properly attached to a strong surface they can hold the weight of a fully grown photographer. As you can see in the image above, these clamps come with an inset for various kinds of studs. The insert is there because the Super Clamp is part of a very cool and very well-designed system that includes articulated arms and other gadgets. This system allows you to mount a clamp somewhere, then use one of several articulated arms to position your flash up to 2 feet away in various positions. The king of the articulated arms is the Magic Arm, which has heavy-duty clamping mechanisms at every articulated point. Many photographers use these in conjunction with their tripods when they need to shoot straight down on a scene or a still life.

The Super Clamp/Magic Arm combination is unbeatable for mounting any number of things. This combo, mounted to the top of a conventional door, becomes an extra tall tripod or an impromptu light stand with a tall maximum extension. The downside of the

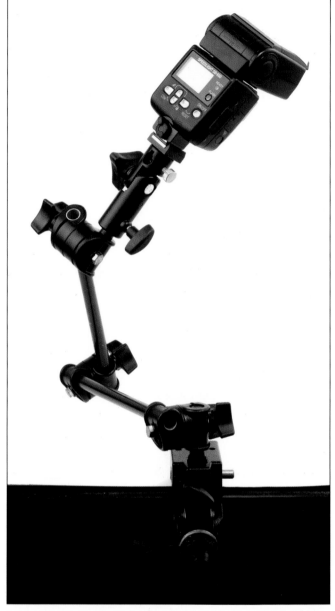

A Super Clamp holds an articulated arm to a tabletop. The articulated arm can be used to precisely position lighting units for still life photography and it can hold light blockers and other accessories. Here it is used in conjunction with an Alzo stand adapter and an SB-600 flash.

Super Clamp/Magic Arm combination is the weight and bulk it adds to your location kit.

The Ultimate Portable Light Stand? While most of the equipment choices and techniques in this book emphasize self-reliance over surrounding yourself with staff, you can always press human beings into service as light stands. In many situations you'll find people hanging around watching your shoot who would be happy to hold a small light in "just the right position" for a "few minutes." After ten minutes of human light stand experience,

you'll quickly understand why real light stands were invented. The human version tends to drift out of position rather quickly. When apprised of their drift, they tend to always "overcorrect," repeatedly placing your much needed light in the wrong position. The human light stand bores easily and is not understanding of your need to shoot "variations," to "bracket," and so on. The human light stand also has a tendency to shift their "flash mount" position and sometimes covers up important sensors or slave triggers.

When your back is against the wall, human light stands are better than nothing. Here's one way to improve the aiming accuracy of your human light stand (or HLS): tape a number two pencil to the top of the flash head and have your HLS use the pencil to "sight" on the place you want the light directed. Another way to improve their performance is to leave the flash on a stand adapter so that your HLS has a grip to hold onto that keeps them from inadvertently pushing any of the buttons or covering any of the sensors on the flash unit.

You'll soon find the care, feeding, and continuing instruction of the HLS stand overwhelming and will rush to get a set of Manfrotto 3373s to replace them.

TWO FINAL VITAL ACCESSORIES

The last two things you need to add to your kit are vital to your lighting success in all kinds of light. They are the voodoo that makes minimalist location lighting work like magic, and they are fantastically cheap. You need a roll of gaffer's tape and a pouch full of color correction filters.

Gaffer's Tape. Gaffer's tape is used for just about everything photographic. You'll use it to tape color correction filters to your flash, secure things to stands, and tape things to walls. The reasons you want real gaffer's tape (a cloth-based tape made for the movie and video professions) are that it tears cleanly, leaves little or no residue when removed from objects, is remarkably strong, and it feels so cool to use a professional tape product instead of icky, sticky duct tape. It's available in white and black, and it's always handy to have a roll of each.

Color Correction Filters. The other vital accessory is your envelope or pouch full of color correction filters. These are not the hard glass filters that come in metal rings and screw onto your camera lens, they are filters available in large, flexible sheets that can be cut to size

The Nikon AS 19 flash adapter is a useful little stand that comes packed with every new SB-600 and SB-800. It provides a handy and stable base for free-standing flashes.

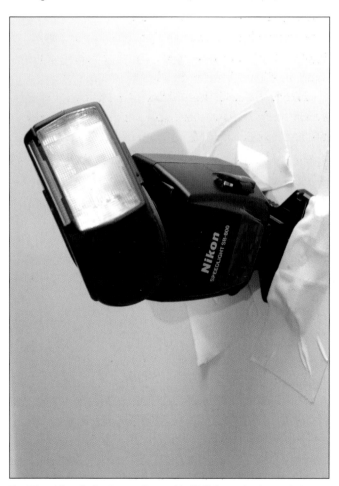

The Nikon AS 19 flash adapter offers a wide "lip" that makes it practical to attach a flash unit to just about any flat surface. Shown here anchoring an SB-800 to a door with a liberal application of gaffer's tape.

These books contain small samples of every filter gel and light modifying material made by each of the major filter manufacturers. Rosco also provides sample books. Write to the companies and ask for a free sample book. The filters are cut to the perfect size for fitting over the business end of most portable flashes.

and placed over any sort of light source. You can order a sample book from a company called Rosco. They've been providing the movie industry with a huge assortment of color filters for many decades. They'll send you a sample book with hundreds of different filters. You'll most likely just need three or four different colored filters, but once you start using them you won't dream of going on location without them.

You'll find a list of filter suppliers in the Resources section in the back of this book. Here's what you'll want in order to master any mixed lighting situation:

Full CTO. This is an orange-colored filter that converts daylight color temperatures to match the temperature of tungsten movie lights. It's also close enough to get your flashes into the same color range as bright, household lights. This is one you'll use on interior locations every day and on exterior locations for special effects.

Half CTO. This gives you half the correction of the full CTO and is very useful in getting color temperatures closer to each other while still providing some color contrast.

Plus Green. This is a green filter that is approximately 30 points green on the mired scale. It's used when you encounter a scene totally illuminated by fluorescent light fixtures and you need to get close to the color they are

emitting. You'll place this filter over your flash and set your camera to one of its fluorescent white balance settings. This gives you an approximate correction for many interior locations.

Various Filters. You might want to put together a mix of warming and cooling filters for various effects. Some photographers carry a range of full, one-half, and one-quarter CTOs as well as several strengths and variations of plus greens to use in fine-tuning shots.

Whatever you decide to buy, you'll want to use a sharp pair of scissors to cut them into rectangles that are slightly larger than the front on your flashes. It's a good idea to have enough of each filter type to cover all of your flashes because you'll want all the colors to match when every light is pressed into service.

Once you've got your filters you'll need to really look at the light in each location and figure out what flavor the dominant light source is. In an office or manufacturing situation you'll most often encounter fluorescent lights. In a situation like this you'll want to tape on your plus green filters, set the camera to your fluorescent setting, or make a custom white balance and start shooting. Be sure to avoid shooting with windows showing or you'll have to deal with a magenta contamination. In a gallery or home you'll usually encounter tungsten track lighting or regular incandescent lightbulbs. If these are

Left, able minimalist assistant, Ben, holds up a sample of CTO gel. This is the filter that will convert your flash to a tungsten-balanced instrument. You'll be able to match colors with standard tungsten halogen lightbulbs, unless they are on dimmers. On the right is a standard application of CTO to a Nikon flash. Cut the filter into 2x4-inch strips, slap a couple of pieces of gaffer's tape to your equipment case, and you'll be ready to make a quick conversion between two of the most ubiquitous color temperatures in the photo world.

the dominant light source, you want to reach for a CTO filter for your flashes. Again, avoid window light in your shot unless you're a fan of bright blue contamination.

Once you've filtered your lights to match the main light source in your scene you'll be able to use slower shutter speeds to introduce more available fill light for your flash exposures.

It's important to get your head around the whole concept of color temperature. This is another one of those "make it or break it" issues in doing photography with lights. Just to review, every light source emits light at a specific color temperature. This ranges from the deep red of a burning log to the very blue light of the sun at high altitudes. For most situations you'll encounter in day-to-day photography the light will range from the cool blue light of an overcast day to the very warm glow of candle-light at a wedding or some other interior location.

In a mixed lighting situation two or more different color temperature light sources exist within a scene. Though the human eye blends the sources together and automatically neutralizes (white balances) most mixed light situations, digital cameras and film cameras don't have the same capabilities. For any exposure the photographer must choose one white balance. A classic worst-case lighting scenario might be an interior location with lots of windows (daylight balance = 5500K), track light-

ing on the art on every wall, and several fluorescent "worklights" in bookcases, under shelves, and in ceiling fixtures. If the photographer chooses to balance for the fluorescents, the light through the windows will show as a purplish-magenta light while the track lights will be a

Ben holds up a sheet of plus green gel filter material, which is commonly used on flash units to convert their color spectrum to more closely match that of most fluorescent bulbs. Plus green is available in most cinema supply stores. We cut the gel into dozens of 2x4-inch strips, which can be taped to the front of our portable flash units. The gel can also be used over windows to convert daylight to fluorescent.

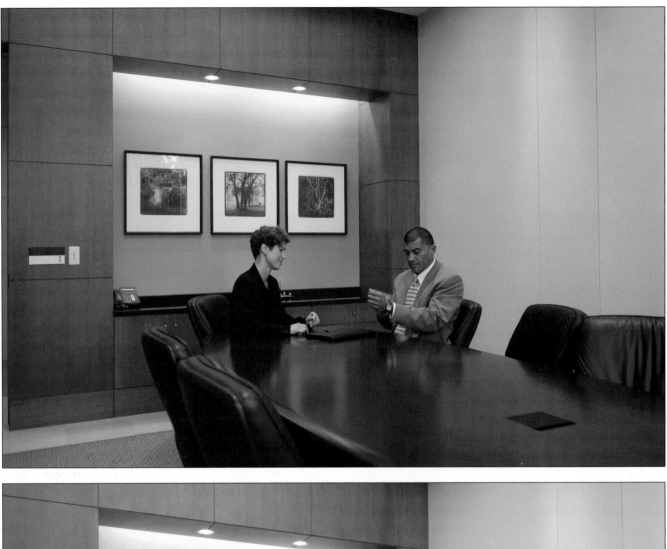

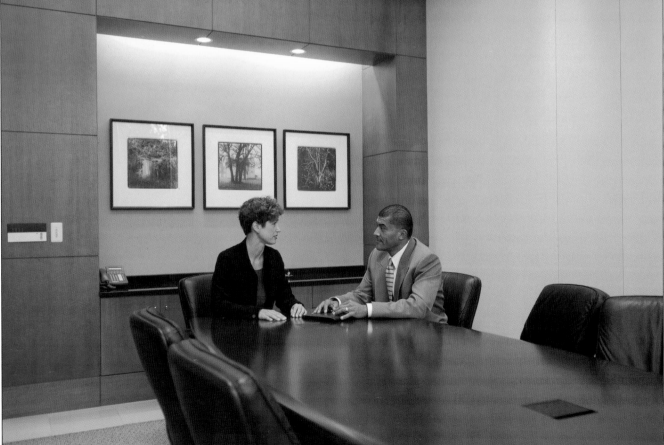

The images on the facing page were taken for a real estate project. In the top image, only the ambient daylight from windows outside the frame was used. For the bottom image, I set up several flashes bouncing off the ceiling to clean up the light and integrate the overall lighting more closely with the tungsten lighting used within the room.

warm orange-yellow. If the photographer chooses to balance for the tungsten track lights, the fluorescents will show as a deep, icky, greenish brown while the light from the windows will show as a deep blue. Correct for the daylight streaming through the windows and the track lights will show as orange while the fluorescents will glow a vivid green.

What you're doing with your filters is converting your flashes to match (relatively) the dominant light source of the scene. If your scene contains two different light sources that compete, you'll have to find a way to convert the second existing light source to match the first one or you'll have to eliminate the secondary light source entirely.

The feature film industry has been doing this for years. Imagine shooting a scene in a giant newsroom for a movie about a reporter. You might have five or ten thousand square feet of open office space filled with fluorescent ceiling lighting. The entire office might be ringed with big windows. The director of photography (the per-

son responsible for designing the lighting for movies) has to make a decision: Will he filter every window with large sheets of plus green gel, thereby converting the daylight coming through the windows to match the interior light source? Or, will he choose to wrap every one of the fluorescent tubes with a 30 magenta gel in order to convert the interior lights to match the daylight balance? The budget film director would immediately say, "The hell with the daylight, we'll change the script, shoot at night, balance our camera to the fluorescents, and save thousands of dollars!"

> It's virtually impossible to replicate the look of an office of that size with lights on stands. The light falloff across the room would be insurmountable.

The only option they would not consider is trying to overwhelm all of the other lighting sources and light the scene from scratch with movie lights. It's virtually impossible to replicate the look of an office of that size with lights on stands. The light falloff across the room would be insurmountable. In effect, directors of photography are constrained to using the same techniques (on a grander scale) as minimalist location lighters!

4. THE ELECTROMAGNETIC SPECTRUM HITS THE ROAD

MODIFYING THE PHOTONS

Now you have lights, a place to put them, and the technology to attach them, as well as the magic filters to make everything match. In this chapter, we'll learn how to modify the quality of the light so we can get on to the coolest part: making photographs!

In chapter 2, we covered the quality of light. You learned about direction, soft/hard light, color temperature, and intensity. Now it's time to put these ideas into practice by learning how to modify light and make it do what you have in mind so you can "make" photographs instead of just "taking" photographs.

If you don't want to doom yourself to re-inventing your lighting every day you'll want to start keeping a journal. I use these little notebooks from Moleskine to make lighting diagrams and notes about each commercial shoot. If I need to replicate a lighting design these notes give me a good starting point. This page is about a shoot with Trilogy CEO, Joe Liemandt.

Joe Liemandt is the CEO of Trilogy, Inc. in Austin, Texas. For his shoot, and for every other executive shoot, we keep a log of how we've set up the lights, what camera we've used and the general settings for all the gear. That way, when a client says, "More, just like last time" we don't have to stumble around trying to re-invent the lighting. We just stumble over to the right notebook and get busy.

Whether you want your light hard and contrasty or soft and enveloping you'll want to be in control and understand how you got a great effect. Repeatability is the key. You don't want to be in the position of having taken a photograph that's so spectacular it deserves to be in a museum, but you've forgotten the magic formula. Take notes. Make yourself little diagrams as you work through various examples so that you end up with a "cookbook" of lighting tips and techniques that you can fall back on, like favorite recipes. Many photographers keep a journal with descriptions and sketches of their lighting and shooting positions for each important shoot. Often clients will come back and request a new shot that matches the look and feel of a previous shot. These journals knock hours off the time required to make a good match.

THE BOUNCE

This is a technique you can try even if you are afraid to take your flash off the hot shoe of your camera. Photographers call it bouncing. The idea is to point the front of your flash toward a big white ceiling and literally bounce the light off the ceiling and back down onto your subject. As the light travels from your flash to the reflective surface of the ceiling it spreads out and covers an area hundreds of times bigger than your flash tube with its tiny reflector. You'll remember that the larger the light source is, the softer the light. If the flash reflector of your flash unit is 1.5x3 inches, you have a light source that is 4.5x4.5 inches in size. If the light spreads across the ceiling it may cover an area that is 4x6 feet, which equals 24 square feet of surface area! The light that bounces off the

ceiling covers much more of your subject, reducing contrast and softening the effect of the light.

You could also bounce your light off a white side wall with the same effect. In this example, bouncing from a wall gives your light a more interesting feeling of direction. It's all a matter of control. You can bounce either off the ceiling or off a wall without taking the flash off the camera, but you gain even more control by moving the flash off camera.

The only thing you lose when bouncing is power. And with digital cameras providing clean files at up to 800 ISO, it's a simple matter to turn up the ISO setting to compensate for the lower power.

The most important thing to understand about crafting your own lighting is this: the light source of a light

that is bounced or modified is actually the surface of the modifier (or the last thing the light touches before it registers on your camera's film or sensor), not the original light "generator." In the example above, the ceiling and the wall become your light sources because they dictate how the light will look to the camera. This is important to understand because it means that the size of the light you use to generate the primary burst of light doesn't matter. Whether you use a small shoe mount flash or a big, fancy studio electronic flash, the size of the final surface dictates the quality of the light. When you assimilate

We'd be lost without a bunch of pop-up reflectors and light modifiers. This one is made by SP Systems and is called a Five-In-One. When you flip it open you have a choice of a white reflective side or a black subtractive side. Unzip the outside cover, turn it inside out, place it back on the wire circle, and you have a choice between a silver surface or a gold surface. Take off the cover altogether and you'll find a round translucent modifier that makes a great light diffuser. The pop-up modifiers can be folded down to ¼ of their regular size. There are a tremendous variety on the market from SP, Westcott, Photoflex, and more.

this idea you will be freed to use just about any source of light that can be modified.

Bouncing is the "down and dirty" method of light control. It's used constantly by photojournalists, wedding photographers, and other professionals who have to move quickly and be assured that the lighting on their subject is decent. You will come across situations where it's not possible to bounce. Many shops and restaurants have ceilings that are painted black. A black ceiling is like a light sponge, soaking up all your flash's photons without returning enough bounce. And it's impossible to bounce light from a side wall if you need to be in the middle of a big room.

Just remember that the white walls and the white ceilings are nothing more than stationary light panels, and you can bounce flash off any light panel. You can bring your own or you can find suitable "panels" on location. A light panel could be several large pieces of foamcore board held in place by light stands, a white bedsheet clamped between two light stands, or a folding reflector from a camera store. All will do an equally good job of bouncing and diffusing the light.

Several manufacturers such as Lightforms, Chimera, and Slim Jim, make rectangular metal or plastic frames to which you can attach different types of cloth reflectors that modify light. The Chimera frames fold down small for packing and offer about sixteen square feet of surface area when set up. Each of these vendors offer a range of surfaces including metallic silver and gold. The most used and appreciated cloth is bright white on one side and dull black on the other. The same kinds of surfaces are also available from Photek and Westcott in their lines of pop-up reflectors. These are handy and quick to set up, but they don't pack down as small as some of the metal framed systems.

Add a Reflector

Additional foamcore boards or other reflectors can be used as a second light source if they are placed opposite the lighted reflector. The second board catches light going past the subject and reflects it back toward the subject without creating any secondary shadows. Any large piece of white material works well.

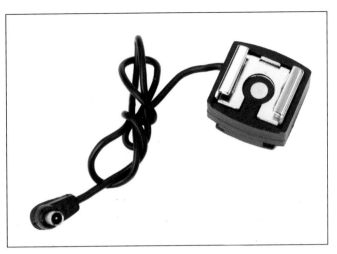

This is a generic accessory called a PC-to-hot shoe adapter, available at most photo retailers, that allows you to connect a radio slave or any other PC socket–terminated device to a flash that lacks a PC socket.

The metal frame systems are an adaptation of equipment made for the movie industry. Our pop-up reflectors are theoretically the equivalent of cinematographer's bounce boards, just smaller and much lighter. Many frugal photographers make due with pieces of foamcore and, indeed, foamcore forms the basis of reflected light for studio photographers across the country.

Using a big reflector couldn't be simpler. Attach the foamcore to a stand with a clamp or attach two pieces of full-size (approximately 4x6 feet) foamcore together on the long side and set up as a V-shaped, self-supporting bounce wall. Figure out what angle you want to have the light strike your subject, then point your flash unit into the board.

ALL STRUNG OUT

A major tenet of minimalist lighting is the mandate to move your light away from the camera. Moving the light makes it easier to bounce it from a wide variety of surfaces. The simplest way is to find a long sync cord with the proper terminations on both ends. Plug one end into your camera's flash sync terminal and the other end into your portable flash's sync connector. Now you can extend the distance between your camera and flash and still trigger everything reliably.

(What? Your new digital camera doesn't have a PC socket? No big deal. There are a number of companies that sell adapters made to fit into the hot shoe of your camera and provide an easily accessible, standard PC socket. Nikon users will probably end up getting an AS-

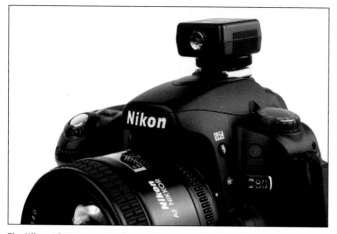

The Nikon AS-15 connector is an adapter that sits in the hot shoe of a camera and provides a standard PC sync socket for cameras that lack them. It can be used with all popular brands and models of cameras with the exception of the Sony and Minolta lines of SLRs. Those cameras use a proprietary hot shoe design.

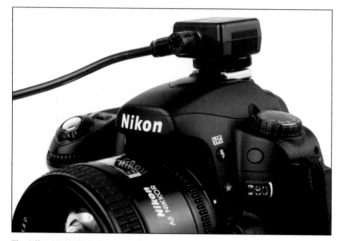

The Nikon D80 digital camera is a model that lacks a built-in PC connection. The D80 is shown here with the Nikon AS-15 hot shoe-to-PC accessory connected to a standard synchronization cable.

15 from their local dealer. It works on any brand of camera except the incredibly idiosyncratic Sony/Minolta digital SLR products, which use a totally nonstandard shoe configuration.)

The lowly sync cord works well as long as you don't mind using your flash in its most manual configuration. The sync cord just transmits the basic firing current; there is no two-way communication between camera and flash. Most photographers start out holding the flash at arm's length and trying to control their camera with their free hand. It's certainly one way to get the flash off the lens axis, but for long periods of work you'll find that your arm starts to get tired.

At some point you'll want to get the flash off the camera *and* be able to use some of those automatic features you've paid for. That's why the dedicated off-camera cable was invented. These cables have a connector at one end that provides a dedicated shoe for your portable flash and a dedicated foot for your camera's hot shoe. Each connector has the right number of contacts, in the right configuration, to allow your Nikon brand flash to communicate fully with your Nikon brand camera or your Canon flash to communicate fully with your Canon camera. The most sophisticated cords will allow fully automatic TTL metering, distance measuring "pre-flashes," and even trigger infrared, autofocus assistance lights built into the camera connector area of the cord.

Minimalists who crave full automation and good looking light will love the speed and flexibility offered by the off-camera cord. Many Nikon users successfully link two or more cables together to gain distance from the flash. While electrical resistance will eventually cause erratic performance, the use of two interconnected cables is a tried-and-true application. There's no reason why this wouldn't be true for other brands as well.

Whether you use a dedicated cord or a simple sync cord your lighting will improve by moving your flash to one side and raising it up. It will more closely resemble light that we might see in the natural world.

The next step is to modify the quality of the light itself. At this point you'll want to think about ways to modify your small light source to make it act and light like a much larger source. Your choices are simple: either bounce your light off a larger white object or shoot through a semitranslucent material. Either way you'll find your highlight to shadow transitions softened and your subject illuminated in a much more flattering way.

Go one step further and add a reflector to the opposite side of your subject to fill in the shadows and lower the ratio between highlights and shadows. Your camera will be better able to capture detail in both the highlights and the shadows as you assist by reducing the lighting "ratio."

SMOOTH AS SILK

The inverse of the reflector is the scrim or "silk." A silk is any cloth or material that you push light through instead of reflecting it. We call these materials *translucent*. We've nicknamed them silks because their progenitors in the movie industry used real silk, in various thicknesses, to

create these kinds of light modifiers. Saying, "I need to push this light through a half-stop silk" sounds so cool that still photographers have held on to the name. Take the same frame upon which you stretched your reflecting fabric, change the fabric to a "translucent" one (any material that allows light to go through its surface), and you have a "silk."

While the light is similar to that of a reflector you can vary the quality of the light by choosing cloths that allow more or less light through. The more opaque your "silk" is, the less light goes through. The trade-off is that the light that comes through the surface of a more opaque silk is very soft and diffuse. As the diffusion materials, or silks, get thinner and allow more light through, the quality of the light becomes less and less soft and diffuse. The range from soft to hard and from diffuse to less diffuse gives you more control over the look of the light. One benefit of using light through a diffuser versus bouncing it off a board is that the diffusing surface can be placed much closer to the subject being lit. This gives you a softer, yet more dramatic photograph.

Many times you need to block or partially block an annoying fixture just over your subject's head. In a large office you won't be able to turn off just one light in a large bank of lights, but you need to lessen its effect to enhance the look you are creating with your small lights. Lightweight reflectors are perfect when pressed into use as "light blockers."

SINGING IN THE RAIN?

Photographic umbrellas are just nonlinear reflectors. They pack down smaller than most reflectors and set up very quickly. You can find gold and silver versions, but the most practical for most situations are those made of bright white material. The stand adapters you've chosen most likely have a hole in them that allow them to accept the shaft of an umbrella and lock it into place. If you get an umbrella with a removable black cover, you can remove the cover and shoot through the umbrella giving you a nicely portable "silk." Two favorites of working pros are the Photoflex 60-inch umbrella (with removable black cover) and the Photek Softlighter 60-inch umbrella. The Photek has the same kind of removable black cover but also includes a translucent white diffuser panel. The light bounces off of the reflective surface of the umbrella

and is then further softened as it diffuses through the front panel. It gives a lighting effect that is very close to that from the same sized softbox.

Umbrellas are available in a variety of sizes from as small as 14 inches across to over 84 inches in diameter. All things being equal, the smaller the umbrella, the harder the light, and the larger the umbrella, the softer the light. You can never have too many choices.

Umbrellas, folding round reflectors, and frame and cloth reflectors are all available with a variety of materials. The two most common bounce surfaces are white and

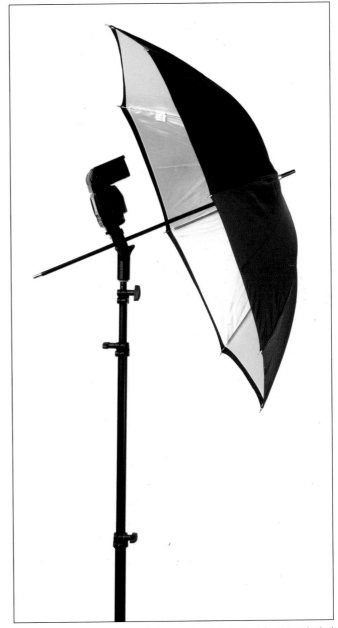

One of our favorite location tools is a 32-inch Westcott style #2012 Optical white satin umbrella with black backing. It softens light well and is impressively efficient. It also packs down well for travel.

ital camera) by changing the white balance on your camera or in postproduction.

THE HARD FACTS ABOUT SOFTBOXES

For the last thirty years the realm of light modifiers has been dominated by softboxes. These devices are used to produce very soft light. They have been preferred over umbrellas and panels for two simple reasons: (1) all the light from the strobe is directed to the front diffusion panel, and no light spills out the back or spreads around the room. This gives studio photographers more control. Less light spilling out into the set means better control of image contrast; and (2) they can be used with the front surface very close to your subject, giving a soft, enveloping wraparound lighting and also taking advantage of the inverse square law to give you a much quicker falloff of light from one side of your subject to the other.

There are a number of softboxes available from manufacturers such as Photoflex, Chimera, Calumet, Elinchrome, Westcott, and others. They range in size from 6x9 inches for use on a hot shoe flash to huge 6x10-foot softboxes used to photograph enormous products like cars. Most photographers have a selection of boxes ranging from 16x20 inches up to 48x72 inches. The large boxes are great for evenly lighting full-length portraits or small groups, and the smaller boxes are great for close in work and situations where you might want a look with more contrast.

Nearly every softbox on the market is made to accept adapters for various studio flash heads. It can take a bit of ingenuity to use them with small, portable flashes. Most photographers mount a stand adapter to a speed ring. (The speed ring is the inset that holds the rods of the softbox and attaches to the studio flash head.) The stand adapter holds the softbox on the light stand, and then the photographer cobbles together a way to get the flash in position through the center of the speed ring.

The mounting need not be precise—especially if the portable flash is equipped with a diffusion dome that spreads light out evenly. There have been reports of desperate photographers using duct tape, rubber bands, and baling wire to position their flashes. The images on the facing page show more elegant methods.

Softboxes are great from a purist standpoint since they allow more precise control of light than comparably sized

silver. The white surface gives off a softer light that is more diffuse, and the metallic silver finish is harder and more specular. If you decide on one type of umbrella, you'll find the white is easier to use well and provides almost as much efficiency as the silver.

Most location photographers will find that umbrellas with a black backing, to keep light from spilling in every direction, are the best bet. You might consider picking up four umbrellas. Two small 20-inch umbrellas are great for spreading soft even light across a background. They can also be pressed into service as main lights for portraits. The next umbrella to pick up is a 40-inch diameter model, which provides a softer light for portrait work. While you might be stretching to include a 60-inch umbrella in your location kit you will find that, used as a translucent, shoot-through modifier, they have a look all their own. One large umbrella and a reflector to the other side may be all you need for a very flattering portrait.

Unless you have a real desire to mess up the color balance of your photos, stay away from gold reflective umbrellas, reflectors, or boards. If you need to warm up a scene, you'll find it much easier to do (when using a dig-

This is the way our Nikon flashes are typically mounted in softboxes. The speedring and adapter are from Photoflex and should work with any medium softbox.

When we're in a hurry and can't find a Photoflex adapter like the one shown at the top of the page, we often resort to the use of an articulated arm. The articulated arm is mounted to the light stand with a Bogen Super Clamp while an accessory platform and a cold shoe connector hold the flash in place. When set up for actual use the flash is inserted deeper into the softbox opening.

umbrellas or reflector panels. From a location photographer's point of view, the larger the box, the more of a nuisance it is. It is time-consuming to set up most boxes and, when larger ones are used, they put all the weight onto one side of their light stands, requiring the use of sandbags or water bags to keep the whole assembly from falling over.

The biggest softbox location pros normally consider is 24x36 inches. It's easy to love the look given by softboxes when used in the studio. It's easier to love the ease of use of umbrellas and reflectors on location. Your mileage may vary.

There are plenty of other light modifiers on the market, not to mention an almost infinite number of designs you can dream up and build on your own, but keep in mind that what most people end up using has withstood the test of time and been found effective. Experiment to your heart's content, but try not to get too wrapped up in reinventing the wheel.

CRITICAL ATTACHMENTS

Most of the light modifiers discussed so far are used to make the small surface of the flash reflector much bigger, thereby softening the light and creating a new light source with different characteristics than the hard light produced by the unadorned flash. There are plenty of times when you'll want an accessory to block or shape the beam of light from your portable flash. Think of the control movie makers get from optical spotlights, capable of producing a sharp, thin beam of light that can be directed into just the right spot. Think of the barndoors on most movie lights that allow lighting designers to block part of a light's beam from hitting parts of a scene that need to stay dark.

You want to be portable and minimalist, but you don't want to give up control either. There's some stuff you've probably got sitting around the house that will give you more control over your direct lights. The next time you run out of toilet paper be sure to save the cardboard core. Save the cardboard from your paper towels as well. These two free resources will be the basis of your new collection of snoots.

Snoots are tubes that channel light into a narrower beam. They fit right over the front of your flash and allow you to put a spot of light just where you want it. They are great for accents and for focusing attention on the most important part of your composition.

Here's how to use your new snoots: Get a piece of white foamcore and cut out a rectangle that's just a little larger than the front reflector of your shoe mount flash. Put the cardboard toilet paper or towel core on the foamcore and trace a circle onto the face of the foamcore. Cut out a hole in the foamcore and fit the cardboard core into the circle. Now tape it into place with duct tape or gaffer's tape so that it's secure. Now you can tape the whole assemblage onto the front of your flash. If you'll be

Black Wrap is heavy-duty, matte black aluminum foil that can be shaped easily and is totally opaque. We use it to block stray light, cover windows, and much more. Available at most cinema supply houses.

This is an example of Black Foil being used to make an impromptu snoot for an SB-600. It is held in place by one small piece of gaffer's tape. A snoot concentrates light and keeps it from spreading outside its intended area.

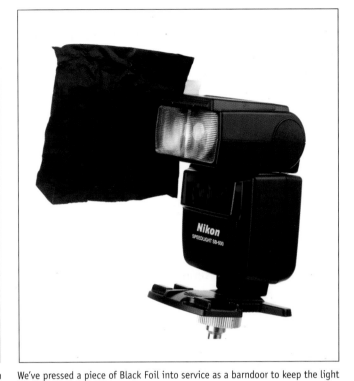

We've pressed a piece of Black Foil into service as a barndoor to keep the light corralled. This prevents spurious shadows and flare in camera lenses.

using it in front of paying clients, you might want to spray paint the outside of the assemblage matte black, just for show.

Another way to make quick snoots and barndoors is by using a miracle product called Black Foil. This is heavy-duty, matte black aluminum foil that photographers and movie crews use for just about everything. Mold it into a cylinder and tape it to your portable flash to make a quick snoot; you can even change the shape and size of the front opening to match the subject you are lighting. Small pieces of the foil, taped to the sides or the top and bottom of your flash work just light barndoors to block unwanted light spills, keeping your beam of light just where you want it. Keep a couple folded sheets of Black Wrap in your roller case because it's just what you want for blocking flare-producing light striking the front of your camera lens, blocking unwanted reflections in your still life work, and subtracting fill light when used opposite your main light source.

David Hobby, a great photographer and total lighting minimalist, even makes lighting control devices out of empty cereal boxes, tape, and tracing paper. If you get the theory, you can make the most out of just about any materials you have at hand. See his site: www.strobist

.blogspot.com to see some of the incredible improvisation he uses to get really great newspaper images for his employer, the *Baltimore Sun*.

THE SIMPLEST USE OF MINIMAL LIGHTING

Back in chapter 2, I made a big point about moving the flash off the top of the camera. Everything I said was true, but there is an exception—there always is. The simplest way to use flash with our digital cameras is to mount the unit right on top of the flash and use it as a convenient way to add some frontal fill light to a scene that is already fairly well lit by natural light but might need a little extra boost to look just right. The goal here is to choose a flash power that is at least 2 stops less powerful than the natural light that's providing the bulk of lighting for your subject. This is largely a matter of taste. I prefer to dial my light down far enough so that it is not producing any telltale shadows or hot spots on the subject.

THE NEXT STEP: SEPARATION ANXIETY

The next step in your lighting journey is to move the flash off the camera. Use a sync cord, a dedicated flash cable, or even a radio slave, but whatever you use, make sure you move the flash off the top of the camera and extend

it several feet from the camera location, minimum. The standard pose of photojournalists is to hold the camera up to your eye with the right hand and extend the flash out to your left, in your left hand. Practice pointing the flash toward your subject, and fire away.

You'll notice that your light now has a feeling of direction. It will start to become interesting.

With the addition of light modifiers to increase the perceived size of the light source and reflectors to control how much light gets bounced into the shadows, you'll be pleasantly surprised at just how much you can do with one light.

To gain a little leverage in your one-light setup, you'll want to add a tripod. This will allow you to hold the camera steady enough to use some of the existing light. Com-

bine the existing light with your flash and you have a lot of control over the intensity of the light in the scene. You can also create more of a sense of reality to the location.

DOUBLE YOUR PLEASURE

Once you master one-light setups you'll be amazed at how much depth a second lighting unit can add to your photographs. I'm convinced that lighting your background adds a great amount of depth to your compositions by effectively separating the foreground subject. A revealing test would be for you to set up a typical one-light setup that you're comfortable with and then add a spot of light to the background. Second lights can also be a useful and utilitarian addition to your lighting design. If you are lighting a group of two or more people, you

We often use wirelessly controlled lights bounced from white ceilings to provide a soft even fill light for interior locations. Shown are two Nikon SB-600 units. All of our Nikon flashes have been assigned specific groups. Notice the letter C on the gaffer's tape. Both of these flashes are controlled by a master flash.

can use one light on either side of your camera to provide an even wash of light for the group. If you are working in a room with a white ceiling, you can bounce both the lights off the ceiling for a soft, even illumination that can be very flattering.

THE THIRD DIMENSION

Adding a third light gives you so many options. You can go "classical" in setting up a portrait. Put one flash to the left of your camera and up. Dedicate a second flash to the background to provide separation, and then add the third flash, aimed back at the subject, as a hair or rim light.

The third light gives you the option to extend light out into more space and with more control. If you were photographing a group of people seated at a conference room table, you could space your lights evenly through a room, bounced off the ceiling, and be able to produce a photograph that convincingly says "real life."

LIGHTING IN PLANES

We're not necessarily talking about lighting in airplanes here, we're talking about lighting in geometric planes. Now that you've got lights and stands and modifiers you need to understand the simple concept of "lighting in planes" in order to leverage the advantages of small lights on location.

Here's a simple example: You're lighting a subject in a very large room. You're using a short telephoto lens for a tight head-and-shoulders shot. The subject is 6 feet from your lens and 40 feet from the background. You could try lighting up the whole room, but it would take thousands of watt-seconds of light. Or, you could put one light close to your subject to light them adequately and then, with a second light, you could light just the part of the back wall that shows in the final frame. The rest of the room can be totally dark. As long as the two "planes" the camera sees are well lit, the impression of the viewer is that the photo has been lit.

The bottom line is that you only need to light the things that the camera sees. Anything more is a waste of photons and battery power. Lighting in planes also allows you more control. If you are shooting a portrait in a white room and you light up the entire room, so much light will spill back onto your subject that you'll never be

able to introduce enough of a ratio to make an interesting photograph. If you light just the portion of the back wall that shows in your frame and then light your portrait subject separately, you will be able to control the contrast across the portrait subject's face.

Studio photographers, who tend to be real control freaks, want a huge space to work in—not necessarily because they think the space is impressive to clients, but because they want to light in separate "compartments." A rather esoteric technique is to place your subject as far as you can from a background and ensure that absolutely no light from the background comes all the way forward to your subject's position. In this way the light on the subject can be meticulously composed and implemented. If you work on location, you'll rarely have the luxury of

> The bottom line is that you only need to light the things that the camera sees. Anything more is a waste of photons and battery power.

fifty or sixty linear feet to play with, but the theory is the same. See portraits by Albert Watson for wonderful examples of this technique.

If you work in the studio frequently, you might consider painting the walls, and especially the ceiling, with a flat black paint. Not having to worry about spurious reflections will give you more control. The lesson for location lighters is this: Carry several large, lightweight pieces of black, opaque cloth with you. If you find yourself in a bright, bouncy location you can always build a black tent around your subject and allow only the light you want to enter your construction. This can give you a good portion of the control studio photographers have at their fingertips.

On a location shoot "lighting in planes" can become a relative thing. If your subject is a chef in a kitchen, the size of the kitchen will influence your lighting, but you can still control where your light goes and how much bounces back to the detriment of your image. In the scene on the next page, I was assigned to photograph the chef of a restaurant. I wanted to show him in front of the stoves and other industrial appliances, but all of them were clad in shiny metal. If I lit him with a strobe in an umbrella to one side without modifying my lighting, I

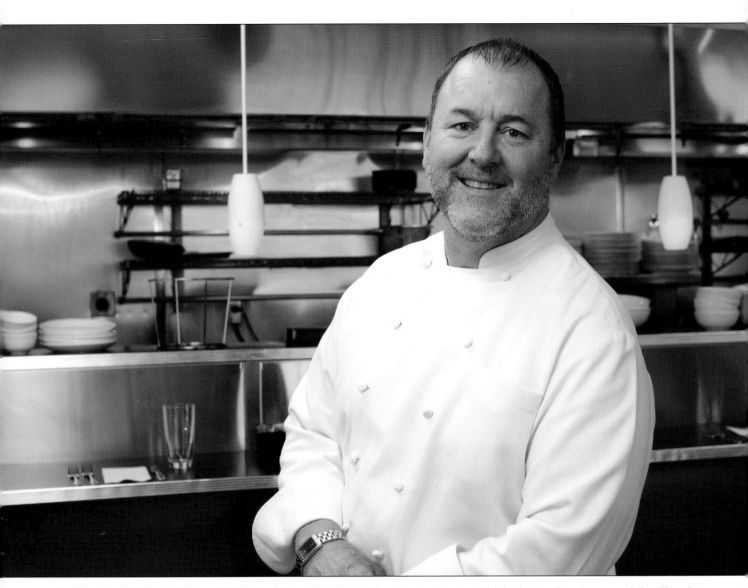

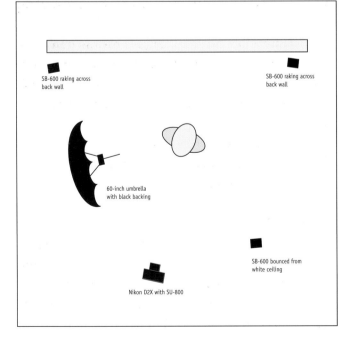

SB-600 raking across back wall

SB-600 raking across back wall

60-inch umbrella with black backing

SB-600 bounced from white ceiling

Nikon D2X with SU-800

On a location shoot "lighting in planes" can become a relative thing—but you can still control where your light goes and how much bounces back to the detriment of your image. Check the diagram to the left to see how this portrait of a chef in his kitchen was lit.

would end up with a large white specular highlight on the equipment, which would draw attention from the main subject. I also wanted the background to go a little darker than the foreground, and the highlight would have scuttled that. I set up one of my black-covered light frames to block the light from the umbrella to the ovens. This kept the light on the chef without contaminating the background. That's an example of just lighting the plane that the chef is on. After I got the light on the chef the way I wanted it I found that I wanted to bring up the levels on the background just a bit. I used two separate strobes with radio slaves to add just a little splash of light without causing any glare or obtrusive highlights.

DESIGNING THE LIGHT IS YOUR MAIN JOB— EVERYTHING ELSE IS JUST HUMAN INTERACTION

The key to every successful photograph is the background. The subtle factor that separates a great photograph from all the rest of the images floating around is the amount of attention paid to the background. When you begin the process of photographing a scientist or an executive for a magazine or a corporate marketing piece, the first thing you should do is to start scouting for good backgrounds. Do they make sense? Is there room for your subject to get far enough in front of the background to get the effect you'll need? Does the background "inform" the image or detract from it? Can the background be lit effectively? Does it offer the right contrast to the main subject? Does it make sense? Should the background be in focus? Should it be out of focus, and if so, by how much? Decisions, decisions.

You could have the greatest technique for lighting a face that the world has ever seen, but the factor that holds the photo together is definitely the way you handle the background. Even if you have the option of using a long lens to put the background totally out of focus, your choice of background will determine the tones and shapes that make up the de-focused image.

After you've selected the background and figured out how you want it lit you can move your subject (or a stand-in) into position and carefully work out their relationship to the background. You will find people a lot easier to move than most backgrounds and you'll have the precise control you need to establish the correct relative positions. Once you have the subject positioned relative to the background you can start lighting in earnest with the assurance that you probably won't have to do any repositioning later. Once you've decided on the background/subject relationship, the rest of your lighting job should be a piece of cake.

So, you found a perfect background and you've figured out how you want to see it in relation to your main subject. With a stand-in at the subject position, you've decided that you'll need an aperture of f/5.6 to ensure sharp focus on your subject while rendering the background soft enough to keep from making it a second center of attention. Let's go ahead and figure out a two-light setup with some fill light from a reflector card. Let's build the photograph one step at a time. First we'll get the background light set exactly where we want it and use the power control on your background flash to dial the power up or (more likely) down until you determine, with a flash meter or the histogram on the LCD panel of your camera, that the tone and exposure are correct for the background. Take a good look and make sure that the unmodified flash isn't casting too sharp a shadow. If it is, now is the time to tape on some diffusion material or use a light modifier such as a small umbrella or softbox.

Take a good look and make sure that the unmodified flash isn't casting too sharp a shadow. If it is, now is the time to tape on some diffusion material . . .

Once you've got the background nailed down you can move on to lighting your main subject. A popular (quick and easy) method is to use a large umbrella or softbox to the left or right of the subject. Much has been written about precisely where to put the softbox, but the consensus seems to be 45 degrees off the line from the camera to the subject and a few feet above the subject's head position and tilted down at a 45 degree angle. The reflector fill gets placed 90 degrees off the line from the camera to the subject opposite the main light. You can move the fill card or reflector farther from or closer to the subject in order to lighten or darken the fill side of the subject's face.

Congratulations on producing a hard-core minimalist location portrait with nothing more than two shoe mount flashes, three small light stands, and a few modifiers. Now you can pack it in and move on to the next shot.

Now that you've mastered the two-light shot in an interior location let's take your show on the road for a nice two-light exterior shot.

TAKE IT OUTSIDE!

The main difference between an interior shot and an exterior shot is the way you deal with the ambient light. Most interiors have a somewhat controllable amount of light. Outdoors you need to work around the quantity and quality of available light and the limitation of your

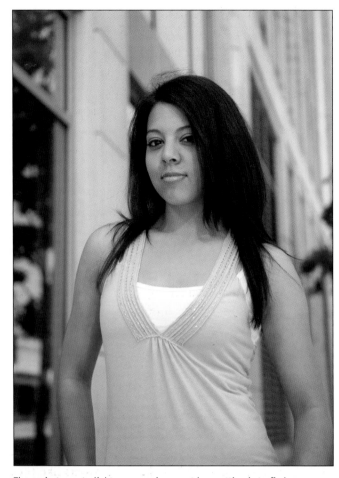

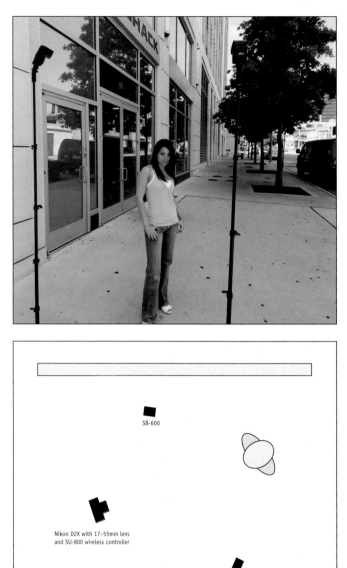

The easiest way to light someone in an outdoor setting is to find some open shade. Anywhere direct light is blocked by a building or other large structure you'll find soft even light with no direction. This image was created using a very simple lighting setup. We're using two flashes, one to either side of the subject for frontal fill light. The flashes are set for an exposure about 1 stop less than the ambient exposure, but as you can see, the flashes add a bit of sculpting to Noellia's face while warming up her skin tone and helping to separate her, via color palette, from the background.

camera's flash sync speed. You're probably aware that most digital camera shutters can only synchronize with flash at shutter speeds of up to $\frac{1}{250}$ second. Some cameras can only synchronize with flash up to $\frac{1}{60}$ or $\frac{1}{125}$ second, so you'll want to read your owner's manual to be certain.

The highest shutter speed at which you can sync your flash establishes one parameter in your overall exposure. Let's assume your Canon or Nikon DSLR can sync at $\frac{1}{250}$ second. With your ISO set at 100 you'll have the following exposure combination in direct sunlight: f/11 at $\frac{1}{250}$. Your direct flash probably puts out enough power used directly to give you about f/8 at 10 feet. But you aren't really interested in taking a photograph with the sun directly overhead and your subject squinting miserably. In fact, you actually want to cut some of the light falling on

your subject so that you have more control over the quality and direction of your lighting. You'll also want to use a modifier in front of the flash in order to give a soft quality to the light.

Here's how you design for an outdoor shoot:

1. Find the background and the composition for the background that works best for your image, then figure out the optimum exposure, taking into consideration the need to synchronize your flash. Your top shutter speed with most DSLRs will be around $\frac{1}{250}$, so you'll need to modify your aperture and your flash-to-subject distance to totally control your exposure. Also remember that with your digital camera you can change the

ISO setting up or down to fine-tune the exposure settings. If you need a wider aperture, try setting your ISO to a lower number. Several Canon cameras can be set at ISO 50, which is very handy. (*Tip:* Green foliage soaks up a lot of light before burning out the highlights and can be a good medium-toned background, even in direct sunlight!)

2. Position your subject in the correct visual relationship to your chosen background. It's easiest to determine your background first and then have your subject move closer to or farther from the camera as you look through the finder. Remember that a wide angle setting will give you lots of background area, and a telephoto setting will narrow down the amount of backdrop that shows. The telephoto setting also compresses the apparent distance between the subject and the background, while the opposite effect is true of wide angle lenses.

3. Use a reflector or a silk (or a chunk of cardboard or foamcore) to block the direct sunlight hitting your subject. If the sun is directly overhead, you'll need a light stand that extends up at least a foot higher than your subject. Alternately, you could find an area of open shade in which to place your subject. Now add the light you need to make the portrait. You can usually get away with a slightly harder light than you might use in an interior location as all the ambient light bouncing around makes for a strong fill light. In effect you've created a two-light setup using your own light as your main light and the sun or ambient light as your fill and background light.

The success of your shot depends on a number of variables, such as the quality of the existing light and its angle. Certain "looks" call for making the flash light on your subject brighter than the existing light. This is easy to do on an overcast winter day but a bit harder to achieve on a bright summer day between 10:00AM and 6:00PM. You may need to double up the number of flashes you're using in your main light source or you may need to move your lighting rig much closer to your subject. In extreme conditions you will probably end up doing both!

If you are using one of the more sophisticated flash and camera systems, you should also know about a nifty feature that can be helpful for shooting in sunlight with your flash. It's called "FP" flash, and it works like this: With your camera and flash set to handle FP (which stands for focal plane flash and is based on a technique

This is a simple setup to use when you want to photograph in bright daylight and end up with a moody image with deep, saturated colors. I used a square black Chimera panel over Noellia's head to block any direct sunlight. I placed a strobe directly in front of her, gelled with a CTO gel. The camera white balance was set for tungsten. I used the FP mode on the flash and camera in order to shoot at very high shutter speeds.

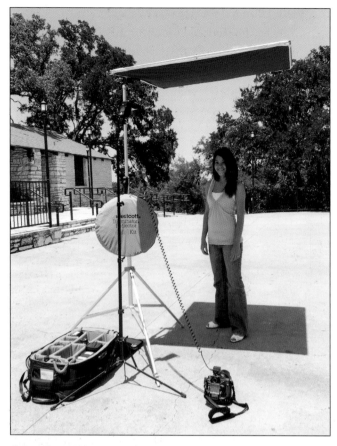

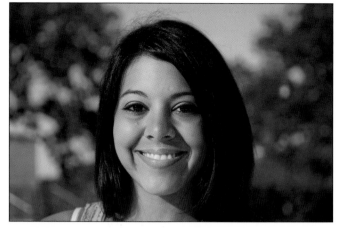

To the left in the the setup for our midday tungsten white balance technique. As seen above, this causes the background to become a deeply saturated blue while maintaining a mostly accurate foreground color palette.

This is the same lighting setup as above, using the same exposure settings. However, we've shot it without any filtration or light balance changes in order to show the difference in the look and the amount of saturation.

from the 1950s that allowed photographers to use faster shutter speeds than the fully open flash sync speed by relying on certain flashbulbs having longer burn times. Certain bulbs could sustain a "burn" that would last through the curtain travel of a focal plane shutter at higher speeds), choose a shutter speed and aperture combination that works with the ambient light and the flash will actually pulse consistently enough to light the camera sensor evenly as the shutter opening travels from side to side or from top to bottom. This technique is best used to supply a bit of fill flash when you are using a fast lens near its widest aperture to blur a background. Since the flash must pulse instead of unloading one big burst of light the output is much lower. In order to use this technique with multiple flashes all of the flashes must be "FP" capable and used with the camera manufacturer's lighting control system. (Think i-TTL with Nikon or e-TTL with Canon.) It's a method that calls for a bit of practice to get a feel for the distance ranges and exposure settings that are optimal.

One of the best times to light on location is right around sundown as the last direct light of the sun falls behind the horizon. Movie makers call this time "the magic hour," which is a bit of a misnomer as the window of good shooting illumination is really only twenty minutes wide in most locales. You'll want to have your shot planned and set up before the light starts to change. The best plan is to use the glow of the sunset behind your subject as a background while using your lighting unit as a main light to the front (or 45 degrees to the side). Once the sun is over the horizon the light levels drop quickly, which means you'll need less light from your flashes to compensate. You'll also find your ambient exposure dropping with every passing minute.

On cloudy days the challenge is not overcoming the light but adding some sort of excitement to the flat lighting via your own lighting design. Though an overcast day allows you to use less power and to overwhelm the available daylight with your flash, the background can be dull

and lifeless. Here is a technique that you might find very useful:

Cover your flash (or flashes) with a gel filter that converts the daylight color temperature of the flash (5600K) to the color temperature of tungsten lights (3200K). Set the white balance (WB) of your digital camera to tungsten (usually represented by a lightbulb icon). When you do this your camera and flash are set to render anything lit by your flash with accurate color. Now set your camera's exposure settings so that the ambient light is being

The first of a series of images showing how to handle flat, dreary lighting. This shot is made without any artificial light. Just the cold, gray ambient light of a winter afternoon. The sky is ugly and the entire effect is unflattering.

Here our model is lit by an off camera flash. We used two Nikon SB-800's in one 24x36-inch softbox placed approximately ten feet from the model. This is the typical flash amplified shot. A big improvement from the first shot, but it lacks snap and contrast.

Here our model is lit by the same flash combination but we've covered the flashes with a full CTO gel and have set the color balance setting on our Nikon D300 camera to "tungsten." The flash color is balanced to the color setting of the camera so our model's flesh tones are nicely neutral but the very blue color balance of the underexposed sky creates a great saturated background that makes our final image much more exciting.

underexposed by about 2 stops. When you take the photograph you'll discover that any part of the scene lit by the flash is nice and neutral, while anything lit by the ambient light is very blue. It can be a very dramatic effect.

When the ambient light is flat and gray you might also want to consider adding a few effect lights to give more life to your image. After you've composed the shot and set an exposure that takes into consideration both your main (flash) light and the ambient light, go ahead and add an additional light behind the subject to help separate the subject from the background. The effect should be a subtle bright edge around your subject that gives the image a bit of extra pop. It's also good to remember that you can experiment with filter gels. Try placing a warming gel over the backlight to add some color contrast to your frame.

Using backlighting wisely will also help the shots you take during magic hour. The soft, wraparound nature of magic hour lighting has a tendency to obscure the edges between the background and your intended subject. One or more well-placed backlights can create an important separation.

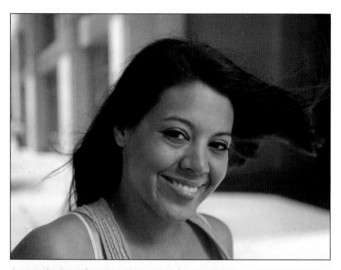

I often find myself using the technique of filtering my flash and camera to tungsten WB while shooting in daylight. I really like the contrast between the warm foreground colors and the cool backgrounds. The image that appears to the left shows the very simple lighting setup I used for the next two shots. The shade, and having Noellia's back to the sun both helped to ensure I had enough flash power for a correct exposure even with a CTO filter over the flash. The second photo (below) shows the effect of the added filtration and white balance setting adjustment.

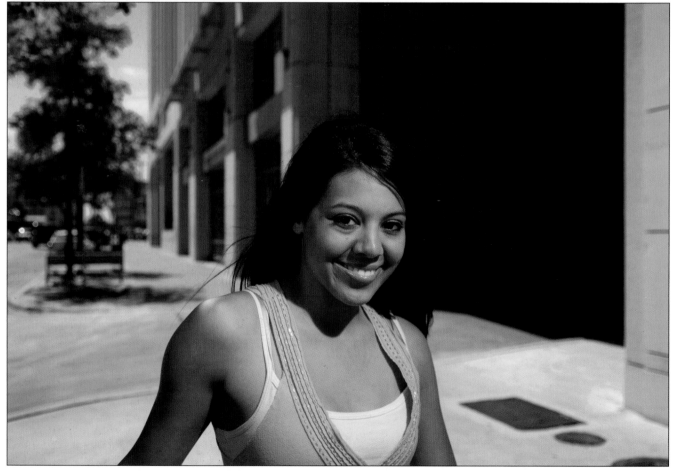

With a little practice and some help from the instant feedback of your digital camera's LCD screen you'll soon be able to accurately predict the effects you'll get as you add flashes to a standard outdoor setup.

PRACTICAL APPLICATIONS

Lighting a Group in a Conference Room. For some reason businesses like to show off teams of their employees in conference rooms. Perhaps they want to show off the fact that they have physical "bricks and mortar" facilities and to prove they are not just "virtual" companies. At any rate it's a shot that gets done a lot. The easiest way to shoot this scenario is to go with bounce lighting. Most conference rooms have white ceilings, making the technique a natural. Frame your shot to eliminate the ceiling, then place three lights on stands outside the frame area. The three lights ensure an even distribution across the whole group of people.

If you have time, you'll find that one soft umbrella light from either side of the camera fills in the faces nicely, eliminating one of the few issues with bounce lighting. Just keep the umbrella fill at ½ or full stop lower than the light from the ceiling bounces. You want to make sure that your fill from your umbrella doesn't create shadows on the back wall or overpower the feel of the top light bouncing from the ceiling.

If you have the time to do a more extensive "prelighting" of the room, you might want to use several Scissor Clamps to hang two lights from either corner of the room, backlighting your portrait subjects. You could use a Scissor Clamp and one additional light to light the back wall with a broad spot of light.

Shooting in Rugged or Messy Conditions. Most photographers pack up and go home when the clouds open up and the rain starts pouring down, but the intrepid minimalist sees inclement weather as just another opportunity to create more interesting photographs. And what could be more interesting than a portrait created in the soaking rain, partially lit by off-camera flashes?

This was not a concept that photographers could get their heads around in the good old days of studio strobes. Basically, the typical studio strobe pack and head combination, added to a good rain, is potential death. What you basically have is a machine that's function is to take safe, grounded, electricity from an A/C socket and ramp it up in voltage and intensity so that it can deliver one big bang of high-amperage power every few seconds. None of the studio strobes are sealed to keep out moisture, and all the connections between pack and head are equally unprotected. You might as well take your toaster out in the rain.

Enter the slave-triggered portable flash. You can use them in the most intense downpour if you use a couple of dollars' worth of widely available portable flash waterproof housings. These housings are also better known as Ziploc bags. The most flexible in daily use is the one-gallon freezer bag. Every well-prepared photographer should stash a little cache of these bags in their roller cases "just in case."

Here's the way you use them. While you are still under some sort of shelter go ahead and set all the flash settings you plan to use—the zoom setting, power ratio, automatic settings and, of course, attach your choice of slave trigger. Place it on your favorite stand adapter and then secure the bottom of the bag with a rubber band or, in a pinch, a piece of gaffer's tape or duct tape. With all the electronics safely secured in waterproof bag you are

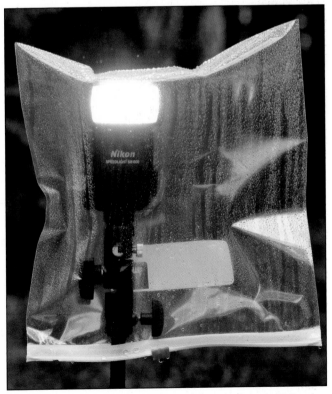

Splashproofing your flash. The handy one-gallon-sized plastic kitchen bag makes a perfect raincoat for flashes that can be triggered either by infrared or via radio remote. No reason to stop shooting in a light rain. But I'd never risk shooting an A/C powered strobe under rain conditions!

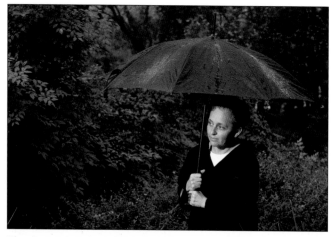

When it starts to rain or drizzle the light can be very interesting. Often a little bit of off camera flash is just what is needed to bring a photo to life.

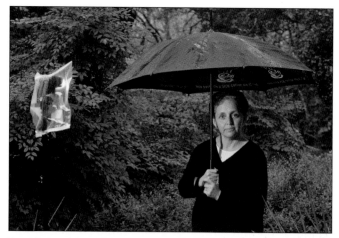

My patient model standing in a rain soaked garden. Note the flash in the very professional Ziploc plastic bag. The flash not only fills in the shadows, it also gives direction to the light.

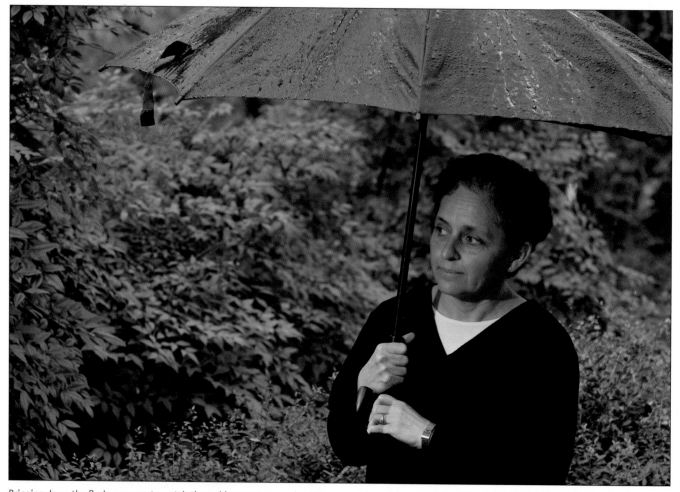

Bringing down the flash exposure to match the ambient exposure makes the scene look more natural while adding needed fill light under a black umbrella.

now ready to attach the ensemble to a stand and get shooting.

You should also cover your slave trigger or radio trigger with a similar plastic bag. If your camera is not one of the professional "weather sealed" versions, you'll also want to make sure that your camera is under a good umbrella or a plastic rain cover. None of these transparent covers will impede the signal from your trigger device. If you need to change flash batteries, you'll need to come in from the rain. Warning: Any high-voltage battery system

is potentially as dangerous as an A/C power pack. Leave these at home and depend on the lower-powered, less dangerous AA battery for wet condition flash work!

When shooting in the rain you'll find that side lighting and backlighting accentuate the visual effect of the rain and add definition to the raindrops. In most cases you'll want to underexpose your background just a bit in order to get the directional effect of your main lighting.

High-Magnification Images. I never thought of including a section about using minimalist location lighting techniques for a specialized field like high-magnification technical photography, but I was recently assigned to photograph a proprietary chip die (the inside guts of a microchip) that measured less than 2x3mm. We do this kind of work frequently for chip makers like Freescale Semiconductor.

The marketing director in charge of this product needed me to shoot this particular chip die in their facil-

ity. I would need to take all of my specialized macro gear, a digital camera with a high-density sensor chip, and anything else I needed to do the job. Here's what I took and why: (1) A copy stand. It provides a sturdy way to anchor the camera/bellows/subject stage combination while allowing the whole apparatus to be raise or lowered to a comfortable working position. (2) The Nikon D2x digital camera. It has one of the highest densities of sensors giving great fine detail rendering, and its 1.5x magnification (when compared to full-frame digital or 35mm film cameras) allows for higher magnification at any particular bellows extension. (3) The 35mm macro lens for the Olympus $\frac{4}{3}$ digital camera system. The wider angle of view gives a high magnification with less bellows draw than more traditional Nikon macro lenses such as the 55mm or 60mm macros while giving a very sharp image when used wide open. The easiest way to attach this lens to the Nikon PB-4 bellows is by using a BR reverse ring

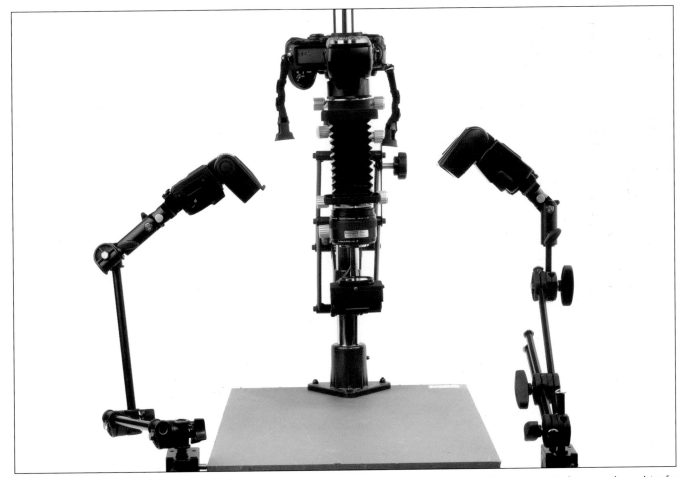

Macro rig with TTL lighting control. My business often is called on to document tiny products from the high-tech business segment. Our macro rig consists of a PB-4 bellows, an Olympus 35mm macro lens, a PS-4 slide stage, and a copy stand. Our lighting comes from two SB-600s triggered by an SU-800 flash controller mounted on a Nikon D2x. I need to be able to precisely position our lights and then leave them in position for a long time. I depend on articulated arms coupled with Alzo stand adapters secured to the tabletop with Manfrotto Super Clamps.

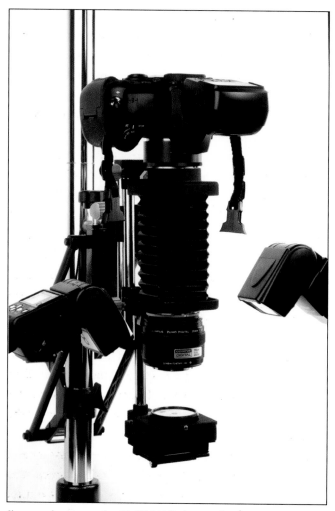

Close-up of my macro rig with SU-800 flash controller providing wireless TTL flash in conjunction with my D2x camera. This combination of camera and lens can shoot at up to 10x life size on my reduced-size sensor.

era's viewfinder becomes way too dark for focus unless you add a bright focusing light source. Using a continuous light source to take the actual photograph is problematic because the length of the exposure makes the whole assembly vulnerable to vibration and seriously degrades the sharpness of the image. Even the tiniest vibration, like the travel of the shutter curtains, is magnified tremendously! The very short flash duration of the SB-600s prevents any lack of sharpness from movement.

Once I arrived on location we found a solid tabletop and set up our macro rig. I used the flashes close in and at angles, which had worked well on past projects of this nature. The hardest part of the assignment is handling such a tiny specimen, securing it on our stage, and then composing the shot. Once the product is centered under the lens and the focus has been carefully checked I take a test shot. Getting the right exposure is an iterative process that requires shooting a test and then using the SU-800 to control the power of the two flashes. Once the right exposure is determined I shoot a few shots at that setting and then bracket a bit by increasing and decreasing the flash power in small increments with the SU-800.

The automated flash system is very compact and works flawlessly when shooting tiny objects. Traditional studio lights would be too powerful, and the physical size of the flash heads would make exact placement very difficult.

and mounting the lens in a reverse position so that the part of the lens that usually faces the camera sensor actually faces the subject. (4) A Nikon 25mm extension tube allows the Nikon D2x to be attached to the bellows assembly without the camera's protruding "chin" fouling the edge of the bellows rail assembly. (5) A pair of Nikon SB-600 flashes attached to clamps, which are then attached to the "arms" of two century stands. The SB-600s are set up as remote flashes. They will be controlled by a "master" module from the camera position. Both flashes are set up for TTL operation. (6) A Nikon SU-800 infrared flash controller will be placed in the hot shoe of the D2x to trigger and control the two flashes. (7) Finally, I brought a tungsten spotlight to provide a strong, continuous light for focusing and composition. When working with a bellows extended far enough to provide between 8x and 10x magnification from life size the cam-

ENERGY SOURCES: BATTERIES AND BEYOND

Batteries are crucial part of minimalist lighting. You've got to love batteries—they are supremely portable and let us light stuff miles away from A/C power.

Alkaline Batteries. AA batteries come in many different types. Within the nonrechargeable category there are carbon/zinc batteries (often called heavy-duty batteries) and alkalines. The so-called heavy-duty carbon/zinc batteries are anything but heavy duty. Their sole advantage is their cheap initial purchase price. Avoid these as they represent a false economy that combines a short working life with low capacity. The best choice in nonrechargeables are called alkalines. If you don't want to mess with chargers and having to remember to put your batteries on a charger before and after every shoot, just go to a warehouse retailer like Costco and buy the store brand of AA alkalines. These batteries will last for around

Our favorite nonrechargable AA alkaline batteries are available in boxes of 40 at Costco. They hold a charge for years and are ready to go for fast-breaking assignments.

one hundred full-power flashes in most professional flashes. The current price (2007) for a box of forty AA Kirkland (Costco store brand) batteries is around $12.00. This works out to around $1.20 per total change out of batteries in a four-battery flash.

Once the recycle time in your flash unit becomes too long and you're ready to change out batteries, you'll find that while the alkalines can no longer muster the oompf to recycle your power-hungry flashes, they'll still do a great job in your electric toothbrush, your kid's hand-held game devices, small toys, things that make noise, and other low-power appliances. Keep two plastic battery boxes in your house or studio. One is for batteries that no longer have what it takes to keep your flash flashing but are still good for other stuff. The second box is for totally dead batteries. Once you've accumulated enough you'll want to find a local source for recycling.

No question about it, remembering to buy batteries to feed your flash habit can be a real pain. Professionals will want to start every shoot with a fresh set of alkalines so they don't keep clients waiting during an unexpected,

mid-shoot battery change. And, if you are using four flashes in most of your shoots, in situations where they are firing at or near full power, the $4.80 change out can get expensive. It is at this point that most photographers turn to rechargeable battery power.

Rechargeable Batteries. In previous decades the nickel cadmium (NiCad) rechargeable was the battery to have. They generate a higher current than alkalines, so they recycle flashes quicker. NiCads had a few foibles that made them less than perfect. Even the best of the breed only had between 50 and 75 percent of the total power capacity of same size alkalines. This means they have to be changed out more frequently during a shoot. Alkalines also die a more "graceful" death, meaning that they slowly run down, gradually giving longer and longer recycling times, which lets a photographer know that their time with said batteries is limited. NiCads are more dramatic. NiCads keep shooting right up to the point of exhaustion and then, within the space of three or four flash recycles, they just give up and die completely. No matter how long you wait, the little red flash ready light on the back of your flash never comes back.

Another shortcoming of NiCads is a phenomenon called "memory effect," which basically means that NiCads remember how much of a duty cycle they output before you recharge them and they have difficulty ever getting a deeper charge. What does this mean? Suppose your NiCads are rated to give you fifty full-power flashes in your favorite four-battery flash. You fully charge your batteries and then go out and shoot only twenty-five shots. Next week you have another shoot and you want to make sure the batteries are fully loaded before you leave the house so you throw them on the charger. Eventually the charger indicates that the batteries are recharged and you toss them into the flash and go. To your surprise, the batteries remember the amount of power you used in the last cycle and refuse to work past the first twenty-five full-power flashes. You've just been stung by the "memory effect." NiCads need to be used until they are almost totally depleted before being recharged.

In years past photographers devised many methodologies to counteract this effect. Most annoying to spouses was the practice of sitting on the couch in front of the TV popping flash after flash to wear the batteries

Rechargable NiMH batteries provide much greater reserves of power than non-rechargable batteries. They also reduce flash recycling times.

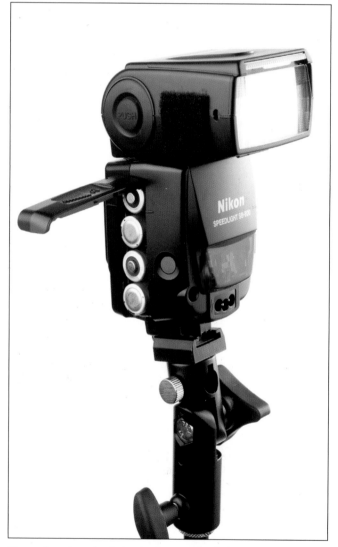

When we're not moving fast and we're not using flash as our dominant light source we're usually more than happy with the performance we get from four good recycleable batteries.

down to their lowest point before putting them on the charger. In answer to the need to deplete the remaining charge in NiCads before recharging, battery manufacturers made complex rechargers with available "reconditioning" cyclers meant to restore batteries afflicted with "memory effect" to their former health.

The turn of the century saw the widespread introduction of a new battery technology based on nickel metal hydride (NiMH) compositions. NiMH batteries combined the high capacity of alkalines with the ample current of the NiCads to produce a new generation of super batteries. These are rechargeable batteries that have dropped in price, displaced NiCads almost entirely, and do not suffer from "memory effect." The only downside of NiMH batteries is that they do not hold their charge over time. From the moment you take them off their chargers they start to slowly dissipate their charge. After a week, depending on their storage conditions and their age, they may lose up to half their power.

This is not a real issue for photographers who work every day because they get into the habit of charging their NiMH batteries at the end of each workday. It's a little fuzzier for less prolific photographers as they may reach for a flash while running out the door only to find that the batteries they installed several weeks ago are a shadow of their former selves. If you have the time, you can just throw the batteries on a fast charger, and fifteen minutes later you'll have a fully charged set.

So, which should you choose for your minimalist lighting kit? Well, these decisions are never really binary. There is no right or wrong way to go. Most photographers work with NiMH batteries because of their positive properties, but they always hedge their bets by bringing along a few four packs of alkalines, just in case. If you use multiple sets of NiMH batteries, it's a good idea to mark them with small color dots so that you keep them in sets or families. NiMHs tend to lose capacity over time and should always be used with batteries that are in similar condition. You don't want to mix new and old batteries because your battery system within a flash is only as good as the weakest link. According to the manufacturers most NiMH batteries will last for up to five hundred "use and recycle" cycles; your mileage may vary.

External Power Plants. At some point you may want your flash to recycle more quickly than it does with just

the four AA batteries in its belly. You may also be on day-long shoots that require lots and lots of flashes, and you might want a solution that keeps you flashing, without stopping to reload, for long periods of time. Now you're in the market for an external, high-capacity battery pack.

Most of the flashes recommended for the minimalist lighter can be powered in two different ways. The familiar approach is the four AA batteries inserted into the body of the flash, but if you give your flash a careful "once over," you'll probably find a two- or three-pin socket that's marked "HV."

In its normal configuration (with internal batteries) a flash works like this:

1. 6-volt current from the batteries is supplied to an internal circuit that increases the voltage to 330 volts.
2. This higher voltage current is fed to a set of capacitors that store up the high-voltage energy over a short amount of time until there is enough power in the capacitors to supply a full charge to the flash tube. At this point the flash has fully recycled.
3. The flash is triggered and the power flows from the capacitors into the flash tube to create a bright burst of light. When fired at less than full power the flash shuts off before the capacitors are fully depleted. This allows for the shorter recycle time at lower power settings as a certain amount of reserve is left in the capacitors.

The limitations of this configuration are that the batteries can only supply a certain current over time, their power is not instantaneously available to the voltage increasing circuitry. The voltage increasing circuitry is not 100 percent efficient so a certain percentage of power is lost as heat. Since the batteries can only recharge as fast as their current capacity allows them, it takes time to refill the capacitors for the next flash. What if the flash could circumvent the limitations of the batteries and the less efficient voltage conversion circuitry and have high-voltage power delivered directly to the capacitors? That is precisely what high-voltage battery packs are designed to do. By feeding raw power at exactly the required voltage directly to the flash's capacitors the recycle time can be re-

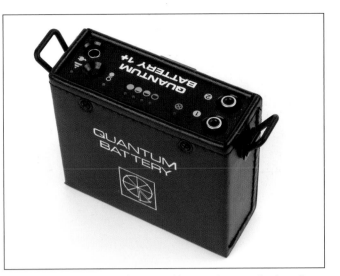

The Quantum Battery One has been around in one guise or another for well over twenty years. It is not a high-voltage battery. It is a 6-volt battery that's perfect for powering most shoe mount flashes available today. It boasts about three times the capacity of most rechargable AA batteries and can be recharged and reused for years. This low-voltage source speeds up flash recycle and is highly reliable.

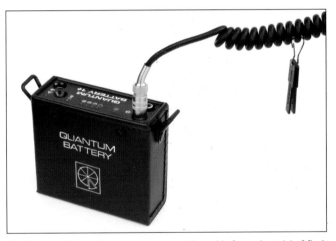

The Quantum Battery One requires a connecting cable for each model of flash you want to use with it. The connector for the battery side of the connection is based on an RCA plug and has a twist lock to secure it in place.

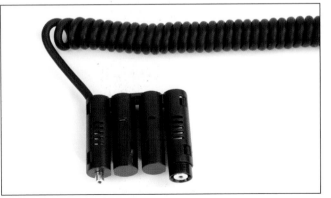

The flash end of a Quantum Battery One is configured to match the battery chamber of the selected flash. This shows the connection for the SB-800, 28, 28dx, SB-80dx, 26, 25, and SB-24 flashes from Nikon. Inside the battery compartment, there is a screw that holds the cable and its termination in place.

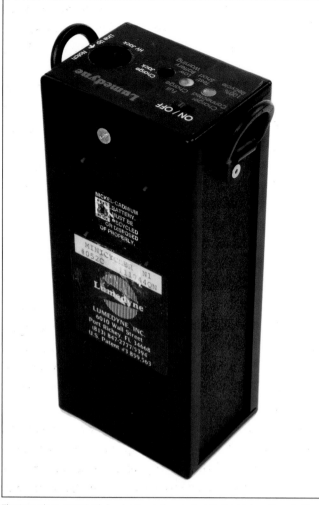

The Lumedyne #052C Minicycler is another variant in the high-voltage battery field. It uses heavy-duty NiCad batteries as its power source. It is similar in performance to the Digital Camera Battery product but is a bit bulkier. It uses Quantum Turbo Modules to connect with various flashes.

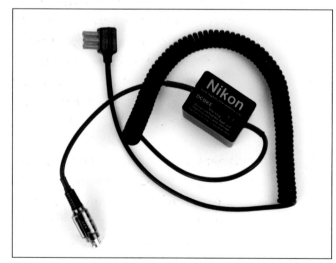

This is a specialized connecting cord for mating a DCB HV battery module with the high-voltage socket of a Nikon SB series flash. The small box on the connecting cord contains electronics that limit the recycle speed to ensure that the flash doesn't overheat and get destroyed. I've used one for three years without losing a single flash unit.

duced from 8 seconds (with alkalines) to less than a second with an external power pack.

The capacity of external battery packs is only limited by the amount of weight you are willing to carry around. One company, Digital Camera Battery, makes a series of rechargeable NiMH batteries with capacities ranging from 30 watt-hours to 180 watt-hours. This is enough capacity to power your flash for thousands and thousands of full-power flashes. There are a number of companies making high-voltage power packs for hot shoe flash units.

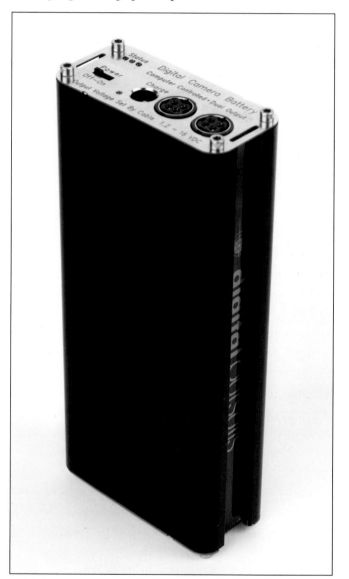

A Digital Camera Battery DCB-40 external battery pack. This high-voltage battery supplies 320 volts and plugs into the HV ports of most professional flash units. It can recycle most flashes at nearly 1 fps. The company supplies cords for several flashes that slow down the recycle times to keep from burning out the flash unit's tube or electronics. The advantage over a lower voltage pack is speed, speed, speed. The HV port of most flashes bypasses the charging circuitry and applies power directly to the capacitors. If you use a high-voltage battery pack with your TTL flash, you'll still need to use the internal AA batteries to run the exposure electronics!

The best known is Quantum, which offers a number of configurations that they call "Turbo" packs. HV packs are also provided by Lumedyne and Sunpak.

Some of the systems use new NiCad technologies, and others use NiMH configurations, but all of the packs include heavy-duty circuitry to supply a strong and steady source of 330 volts to flashes. Digital Camera Battery has also introduced a new line using lithium battery technology, which is much lighter than competing technologies, has no memory, and holds its charge for a long period of time.

There are two problems with external HV battery packs. The first problem is that most portable flashes are not designed to withstand the strain of fast, repeated flashes at full power. The capacitors heat up, the flash tubes heat up, and there is no effective way to dissipate the heat. Eventually the systems burn out completely and, in some instances, die a dramatic and smoky death. Digital Camera Battery supplies a cable for Nikon flashes that slows down the recycle rate on some flashes to 2.5 seconds, while most manufacturers caution you not to exceed ten fast flashes in a row without letting your flash cool for several minutes before taking the next fast series.

If you look at studio flashes made for fast recycling (and mostly used by fashion photographers), you'll find very heavy, fan-cooled flash generator packs and flash heads with multiple flash tubes cooled with high-speed cooling fans. There's no way that a plastic cased, unventilated, battery-operated flash system can compete!

The configuration of HV sockets on cameras is different for each brand. This is the flash end connector for Nikon flash units.

The second problem with the commercially available HV power packs is the sheer cost. Most solutions range in price from around $300.00 for the smallest units up to nearly $1,000.00 for the highest-capacity lithium units. Most are more expensive than the flashes they are meant to power. Putting one bare bones HV pack into service for each of your three or four portable flashes will set you back over $1,200.00, and that's before you buy the required connecting cables. If you need this kind of high-voltage/fast recycling, you probably need one or

> There is no effective way to dissipate the heat. Eventually the systems burn out completely and, in some instances, die a dramatic and smoky death.

more of these packs, but if you are like most photographers, what you are really looking for is just a way to increase the total number of flashes you can get with your flash unit without having to constantly replenish the internal batteries.

If that's the case, you might be more interested in a less expensive (and less risky) approach to providing a nonstop source of power to your flash units. This approach substitutes the internal batteries with an external, high-capacity power pack of the same total voltage (usually 6 volts). The most trouble free of these power packs are the lead acid, rechargeable battery packs. Lead acid batteries (the kind used in cars and motorcycles) are relatively trouble free, but they love to be charged immediately after each use. Since there is no circuitry required to increase voltage the designs are simplified, and since no high voltages are used these battery packs are safer for humans and safer for your flashes. Lead acid batteries use trickle chargers that take between six and twelve hours to fully recharge.

Quantum is the most prominent of the manufacturers for these kinds of batteries although there are some independent manufacturers such as Al Jacobson that provide great products at lower prices. If these are of interest to you, take the time to look at the Underdog batteries as well.

Though these lower-voltage battery packs do a good job providing high capacity and a reduced recycle time they are still fairly expensive. Expect to spend between

The battery holder available from Frye's, Radio Shack, and other electronics stores holds four D batteries. Used by hobbyists and experimenters, its average cost is about $3.00.

An RCA connector is soldered onto the end of a standard dual-channel lamp cord. It will be the interface for a quantum cable or a home-made connection to the flash unit.

The lamp cord is soldered to the two leads on the end of the battery pack. Check your polarity!

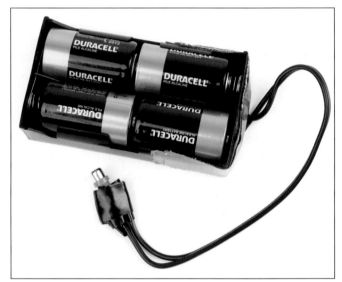

The fully assembled battery pack stocked with fresh D batteries. This should give between five hundred and one thousand full-power flashes. Note the RCA connector.

Packed neatly in a protective sleeve, this is a high-capacity battery that you can make at home for chump change.

two and three hundred dollars for a battery pack and the necessary cable to attach it.

Now your appetite is whetted for a high-capacity battery, but there's no way you can justify spending $1200.00+ to equip your entire system of portable flashes? Would you be interested in a high-capacity power pack that replaces your internal batteries for about $10.00? Most photographers would.

Here's how you make one. Go to a good electronics supply store like Frye's or Radio Shack and find a plastic battery holder that holds four "D" cell batteries securely. We bought a couple of them for about $3.00 each. On one end of the battery holder are two metal lugs. Solder a flexible wire to each lug and then solder the other ends of the wires to the connectors on a standard RCA female plug. These are available for less than $2.00 each. Now secure the solder connections with an ample supply of electrical tape so that they don't accidentally "short" against any metal and, congratulations! you've just built your own low-voltage, high-capacity power pack. The only thing left to do is buy (or build) a connector cable to attach the new battery pack to the flash's internal battery contacts and install four D cells.

Your custom-made battery pack won't recycle any quicker than using AA cells in the flash because the current is relatively constant, but you will easily gain five hundred to a thousand full-power flashes with this configuration. If you want to increase the performance of your new pack, try using high-capacity NiMH or NiCad D batteries. The higher supplied current of these batteries will cut your recycling times to less than half that of standard alkaline D cells.

The most readily available cables are the Quantum cables available for most popular flashes.

CHEATING: BLENDING THE MINIMALIST APPROACH WITH HIGHER POWER

The intention of this book is to show how useful and efficient small, portable flashes can be in the hands of an informed photographer. You can do just about anything with small portable flashes, but in some cases you can do the same thing with greater ease using a hybrid flash system. These flash systems are a hybrid. They use separate flash heads attached to a pack, but the pack is really a combination of a large lead acid battery and a flash generator. These packs are capable of popping out up to 1200 watt-seconds of flash power (compared to the 120 watt-seconds in the most powerful shoe mount portable flashes) for up to 100 flashes per battery charge. They also come with comfort features such as built-in cooling fans, flash heads with modeling lights, and built-in compatibility with speed rings, removable reflectors, and other accessories.

You can do just about anything with small portable flashes, but in some cases you can do the same thing with greater ease using a hybrid flash system.

These units are available from some of the big manufacturers of prestige studio lighting equipment like Profoto, Broncolor, Elinchrome, and Hensel. The common denominators between all these manufacturers are high purchase price and lots of power. Several of the systems have price tags of nearly $5,000.00. Why should you be interested in these lights?

There are styles of photography, especially outdoor fashion in full sunlight, where there is a compelling need to overpower ambient sunlight, while using lights in large modifiers such as softboxes. In these situations the most practical solution is one of the hybrid light sources. They meet certain parameters the minimalist craves, such as freedom from the need for A/C power, and a measure of portability, while satisfying the need for raw power. Sure, it's possible to stick ten Vivitar 285s or Nikon SBs in a softbox, each connected to a radio slave, and each one tethered to a high-voltage battery pack, but at this point the logistics of shoe mount flash methodology get a bit cumbersome.

Most professionals have a real need for this kind of raw power on location relatively infrequently and they find it easier to rent the needed units from one of the rental houses listed in resources at the end of this book.

Now that you know about the "hybrids," you'll know what to rent when *Sports Illustrated* calls to book you for the annual swimsuit edition.

Before we get back to pure minimalism you should also know about another recent development in location lighting. It's the use of a combination of battery/inverter

assemblages and A/C monolights from several sources. While not the most elegant, the most popular is the Vagabond pack from a flash manufacturer called Alien-Bees. The Vagabond (and most similar packs) uses a large, lead/acid motorcycle battery connected to a power inverter. Inverters take low-voltage DC power from the batteries and convert it into 120 volt, 60 cycle A/C power. You plug your A/C powered monolight or monolights directly into an A/C household plug on the inverter, turn on the power, and you are ready to shoot.

A Vagabond power pack will provide enough A/C power to recycle AlienBees' midsized 320 watt-second flash hundreds of times. The system will handle higher-powered AlienBees' flashes or multiples of AlienBees flashes, but the trade-off is slower recycle times. The Vagabond pack weighs in at 15 pounds and takes about six hours to fully charge. While there are a few trade-offs the system is pretty compelling given its relatively low purchase price.

AlienBees B 400 monolight shown with optional high-capacity battery pack. Invaluable for those rare occasions when you require more power on a remote location. The Vagabond battery pack works with all sizes of AlienBees flash units including their new ring light, the ABR 800.

Many photographers use the Vagabond packs and AlienBees monolights for their location shoots when necessary and also find that a portable source of A/C power is great for powering critical "on shoot" appliances such as laptop computers or, in a pinch, small fluorescent work lights. Work lights come in handy when it gets dark and you're trying to pack up and get home.

THE MOST VALUABLE NON-LIGHT TOOL FOR CREATING FLAWLESS PHOTOGRAPHS

There is one vital tool that any location lighter should not be without and that's a good tripod. Tripods come in all sizes and in a variety of price ranges, and choosing one can be downright overwhelming—but choose one you must. A tripod is required to provide a steady enough base for many of the shots you'll do that require using subdued ambient light as a basis for your overall lighting design. Trying to handhold a camera at any shutter speed below $\frac{1}{125}$ second is sheer folly. Even if the image looks okay on your digital camera's LCD monitor, you'll quickly find that it's less than optimal when viewed on a high-resolution computer monitor and even less adequate in a large print.

Getting into the habit of using a good tripod ensures good composition, and holding the camera steady gives you twice or more the resolution compared to hand-holding. You pay a lot of money for extra resolution when you buy camera bodies; it just makes sense to get your money's worth by providing a steady enough base to re-solve what all those pixels are capable of capturing!

Though companies like Gitzo make incredibly sturdy tripods designed to hold massive 8x10 view cameras, you probably won't need that level of design, engineering, and sheer mass to adequately support your digital SLR. Though you can spend thousands of dollars on a tripod you should be able to get a perfectly adequate one in the range of $150.00 to $500.00. The trade-off in price is pretty simple: the lightest, sturdiest tripods are made out of the most expensive materials. Carbon fiber is the current king of strength coupled with light weight. Good carbon fiber tripods range from $350.00 to $700.00. You pay more up front than on a conventionally built model, but you haul less weight with you on every shoot. The less expensive units just use heavier materials. In actual use the well-built $150.00 metal tripod and the incredi-

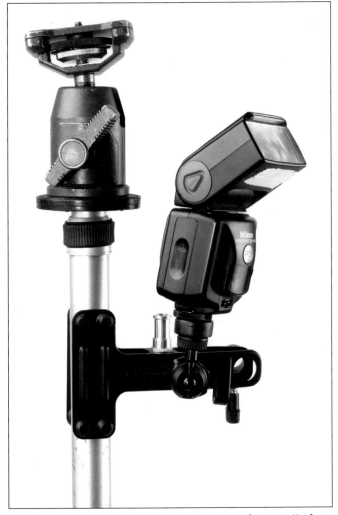

A tripod can be pressed into service as a light stand. We often use a Manfrotto Justin Clamp to fix a small flash to our Gitzo tripod. The ball head allows for easy flash positioning.

bly well-built $700.00 carbon fiber tripod do the same job, supporting the camera without moving, equally well. The real difference is in carrying the tripods.

The less expensive, steel tripods generally weigh more than twice as much as their carbon fiber counterparts, making the higher initial investment in carbon fiber very sensible for a minimalist location lighter. Studio guys can buy the sturdiest, heaviest unit on the market, but they never have to haul it more than a couple of feet per day. A fast-moving location specialist may clock several miles with gear in tow in a typical day of shooting. The pounds and the miles add up.

Besides weight and steadiness you'll want a tripod with legs that extend up to your eye level without having to extend the center column. You'll probably want a model with a removable head so you can customize your

tripod with a pan head or ball head that suits your style of shooting, and you'll want legs that can be extended at different angles to help you on uneven ground or when you want to get very low to the ground.

Gitzo, Velbon, and Manfrotto all make carbon fiber models that fit that description. The initial purchase price will leave you breathless when compared to more pedestrian models, but your back will thank you for years to come and your images will be as sharp as they can be. Using a tripod is essential for ultimate technical quality. And essential for many of the techniques you'll want to use.

In addition to using a tripod for camera support photographers regularly press these sturdy three-legged accessories into service as impromptu light stands!

USING NIKON SB-600s AND 800s IN THE REMOTE MODE

Many users are justifiably confused about using multiple Nikon flashes in the wireless mode. Unfortunately, the owner's manual is more confusing than it is revealing. So here is a quick course in using one of the best features of the SB-600 and the SB-800.

It all starts at the back of the flash. Image 1 shows the panel of an SB-800 mounted on a current Nikon digital camera. You'll make almost all of your selections using the four-way switch in the center. It's the white illuminated button that says SEL in the middle. To get started, push straight down on the SEL button and hold it for 4

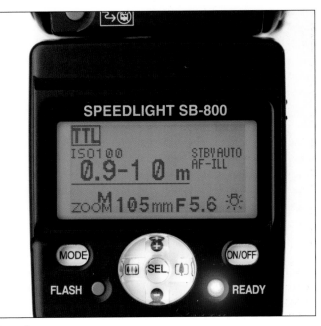

Image 1.

seconds. Be sure you are pushing directly in the middle and not applying pressure up and down or to the left or right sides of the button. Four seconds can seem like a long time if you're in a hurry.

If you've pushed the button correctly and you've held it down for 4 seconds, the screen will change and you'll see a screen that looks something like the one shown in image 2. Actually the top-left box will be the one grayed out. Press the center selector to the right (toward the lone tree pictogram) and you'll see the screen in our illustration.

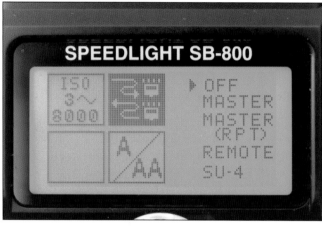

Image 2.

Push the center button (SEL) once for just a second and you'll see this screen. The word OFF will be illuminated (image 3). You're on the right track.

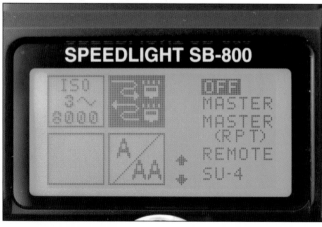

Image 3.

Now press the selector button down and you'll see the screen shown in image 4. If you want to use your SB-800 as your master flash, you can stop here and press the center button for just a second. Now your SB-800 is ready to be used as a master flash, which will control

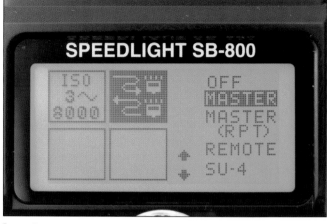

Image 4.

other groups of SB-600s and SB-800s provided they are set up as "remotes." If you are using this SB-800 as a remote, in conjunction with an SU-800 flash controller or the control of a D-200 or D-80 with built-in flash control, you'll want to skip the previous step of hitting the SEL button and just keep scrolling down the flash menu to select "remote."

Once you've decided whether you want to set the flash as a master or a remote push the power on button for just a second and you'll go to one of two screens. Let's assume you selected remote. Once you push the power button you'll see this screen:

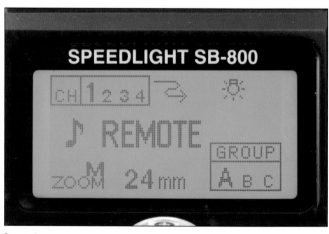

Image 5.

Now you'll be able to set this flash to be part of group a, b, or c, and you'll be able to select different control channel, which can be quite helpful if you are shooting at an event where other photographers are using the same wireless flash control. From this point on your remote flash will be controlled and triggered by the master flash or the SU-800 controller.

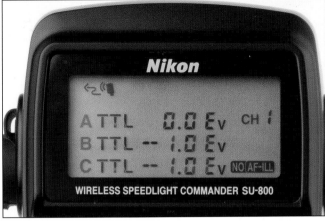

Image 6.

If you choose "master" for your flash setting you'll see a screen on the back of your flash that is similar to that of the SU-800 screen (image 6). In this menu you can select modes, exposure compensations, and on/off for each of three groups of flashes set as remotes. To make your selections you'll use the center SEL button as your command center and the Mode button to set modes.

Image 7.

At this juncture (image 7) it's as easy as point and shoot.

A Great Accessory

The Nikon SU-800 Wireless Speedlight Commander is a great accessory. It controls multiple flash groups, just like the SB-800 flash when set to "Master," but it does so without sending out visible pre-flashes. We've found that some subjects are susceptible to blinking when we use pre-flashes. Not so with the SU-800, which controls and triggers remote flashes with nearly visible infrared pulses. It also frees up an SB-800 to be used off camera. (My only gripe about the SU-800 is the use of CR-123 batteries, which are expensive and not always easy to find. Maybe next time Nikon will consider using a couple of AA batteries.)

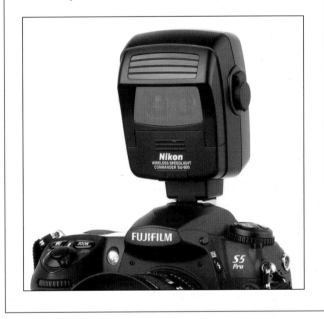

5. MINIMALIST LIGHTING CASE STUDIES

CASE STUDY 1:
KEVIN ROLLINS, CEO OF DELL, INC.

My assignment was to photograph Dell's President and CEO, Kevin Rollins. The photographs needed to have an informal feel and were intended to be used in internal communications to Dell employees. Having photographed in various locations around Dell's Round Rock, Texas campus I knew that we'd have the best results in the executive area of the company's headquarters. The added benefit was that Mr. Rollins would only need to travel a few dozen yards from his office to our chosen location. Using a friendly person from Dell's marketing department as a stand-in I quickly chose a background I liked and then moved my camera forward and backward to find just the right spot to put my subject in.

Then I started to figure out how I wanted to light the scene. There is a white wall to Mr. Rollins' right side, which provided a convenient reflector fill for the shadow side of his face. I didn't want the ceiling-mounted fluorescent light to affect the light on my subject so I put a round reflector/light blocker on a stand and placed it between the light bank and my subject's head. I placed my main light, a medium-sized softbox powered by an SB-800 Nikon flash, set at $\frac{1}{2}$ power, at a 45 degree angle to my subject, approximately a foot higher than his head and tilted down to light his face.

I wanted to separate my subject from the background so I placed another light in a small (12x16 inch) softbox to the subject's left side, approximately twenty-five feet behind him and just out of the frame. This was powered by an SB-28 Nikon flash, also at $\frac{1}{2}$ power. All that was left was to place direct flashes in each of the offices in the background, set to illuminate the glass brick walls from

the inside. I used two SB-24 Nikon flashes, each set to $\frac{1}{4}$ power. All the lights were equipped with inexpensive radio triggers. All of the flashes were powered by NiMH AA batteries, except for the main flash, which was powered by a Digital Camera Battery.

Each of the flashes were covered with Rosco plus green filters to convert their color to match the spectrum of the fluorescent fixtures that dominated the area. The

On the facing page is a portrait of Kevin Rollins, taken during his tenure as CEO of Dell, Inc. The diagram below shows how the image was lit.

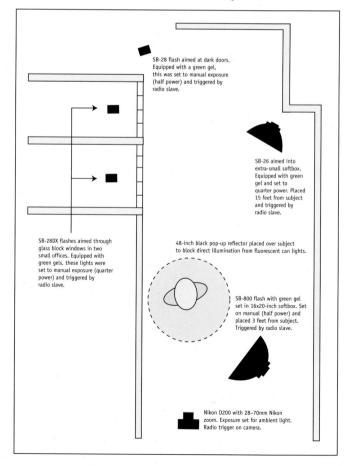

SB-28 flash aimed at dark doors. Equipped with a green gel, this was set to manual exposure (half power) and triggered by radio slave.

SB-26 aimed into extra-small softbox. Equipped with green gel and set to quarter power. Placed 15 feet from subject and triggered by radio slave.

SB-28DX flashes aimed through glass block windows in two small offices. Equipped with green gels, these lights were set to manual exposure (quarter power) and triggered by radio slave.

48-inch black pop-up reflector placed over subject to block direct illumination from fluorescent can lights.

SB-800 flash with green gel set in 16x20-inch softbox. Set on manual (half power) and placed 3 feet from subject. Triggered by radio slave.

Nikon D200 with 28–70mm Nikon zoom. Exposure set for ambient light. Radio trigger on camera.

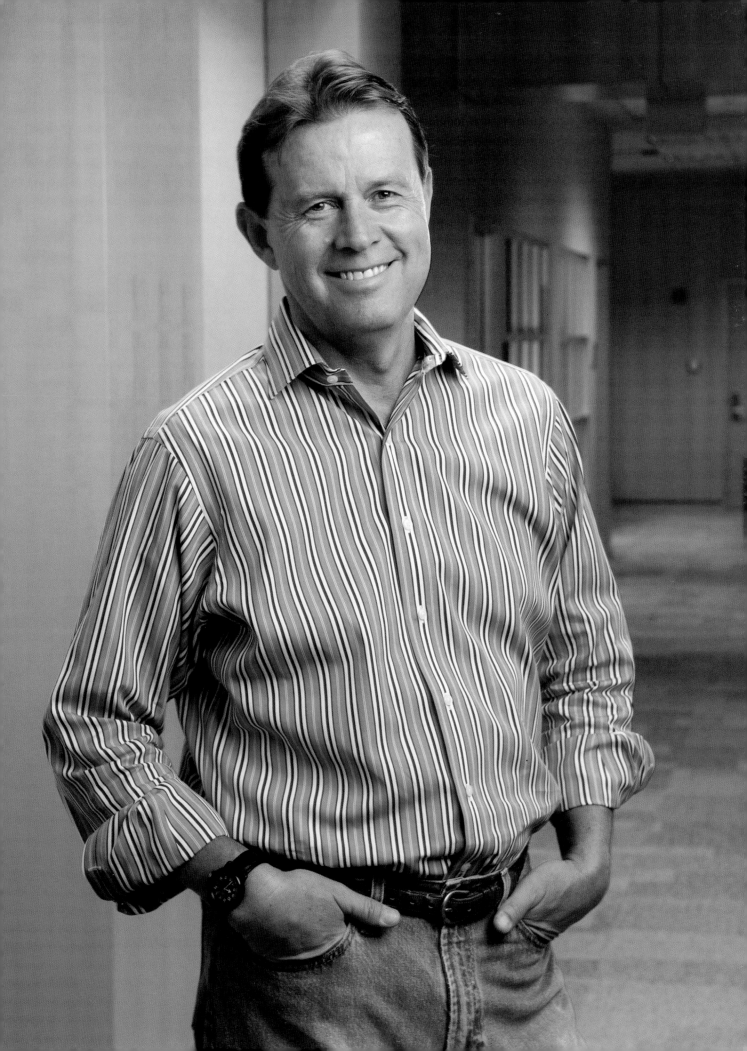

Nikon D200 I used to make the photograph was set to automatic white balance, and the images were made using the raw setting. This would allow me to make the final color adjustments back at the studio when converting from the raw files to the finished JPEGs (or TIFFs).

I thought I was done at this point, but a final test shot revealed that the back wall at the extreme rear of the shot was too dark and would subtly degrade the credibility of the shot. I quickly added one more light in the back office, snooted with Black Wrap to create a spot of light on the office doors and back wall. I looked at the test and knew we were ready. Mr. Rollins stepped onto the "X" I'd taped on the floor and posed like the consummate pro he is. Seven minutes later we had forty or fifty great variations of this pose. Mr. Rollins left and I started the process of packing everything back into my rolling case. My total time on site for this project was ninety minutes.

One piece that was critical for this project, that isn't always in my kit, was a tall enough stand to hold my round reflector up over Mr. Rollin's head at about eight feet. I add the taller stand and the arm that holds my round flex reflector when I know I will be shooting in locations with fluorescent light banks in the ceiling. I prefer to control the light on my subject rather than be controlled by it!

CASE STUDY 2:
PAT PALTA, AMD EMPLOYEE

One of my favorite clients is AMD's *Accelerate* magazine, which is published by Ziff Davis. I often get assignments to photograph AMD employees, clients, and partners for timely articles about the company's cutting-edge technologies. In this case I was assigned to photograph a gentleman named Pat Patla. The parameters of the assignment were straightforward: I would need to photograph Pat in the building where he had his office. I would have one hour to scout, set up, and photograph. I was to avoid showing any technology or logos. And, finally, I was to make an interesting image.

Once I checked in through security I quickly walked around the entire building. I was quickly drawn to the long, windowed corridor just off the main reception area. I really liked the background and I spent a while figuring

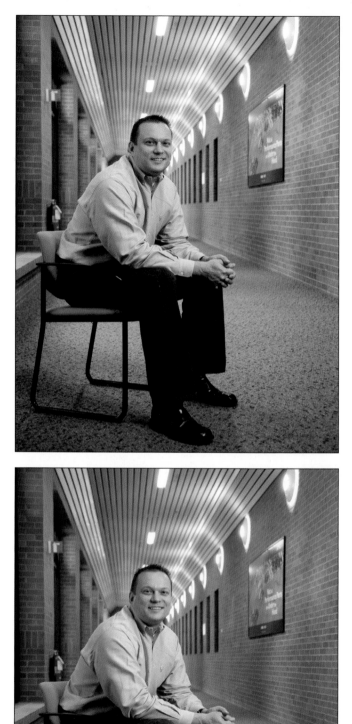

Here we see Pat Patla, an AMD employee. In the top image, the basic composition is in place but no color correction and no extra light has been used. In the bottom image, we see the basic composition with a global color correction.

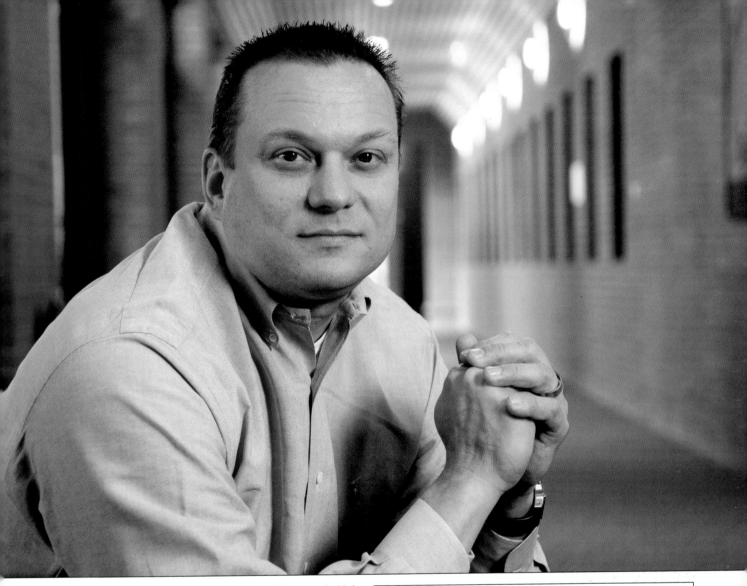

Finished image with global color correction and one light with green gel added to camera right.

out how to place Mr. Patla into the scene while keeping the feel of the receding hallway.

Once my camera position and the position of the subject were set I did a quick search for a chair that wouldn't call attention to itself and then I set about lighting the scene. The hallway was over one hundred feet long, and I knew for sure there was no way I'd be able to overpower the ambient illumination and keep the feeling of the space. I determined that I would need to light Mr. Patla and then balance my light with the warm, incandescent fixtures spaced along the walls. The photograph was taken late on a winter afternoon, and the light through the heavily tinted windows was minimal. I taped a CTO filter over an SB-800 flash to match its output to the ambient sources, set it to ¼ power, and placed it in a medium-sized softbox just to Mr. Patla's right.

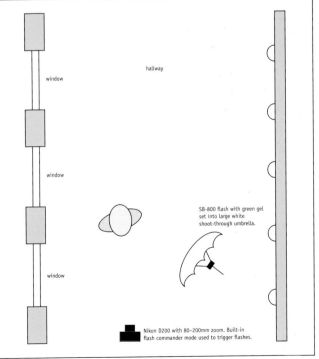

hallway

window

window

window

window

SB-800 flash with green gel set into large white shoot-through umbrella.

Nikon D200 with 80–200mm zoom. Built-in flash commander mode used to trigger flashes.

I wanted to shoot at an aperture of f/4 to drop the background out of focus, and I wanted to set my camera ISO no higher than 200, so I used the power ratio control on the flash to fine-tune the actual exposure. The total time, from setup to walking back out the door, was just under one hour!

CASE STUDY 3:
VALERIE KANE, AMD EMPLOYEE

This photograph of Valerie Kane was also taken for AMD's *Accelerate* magazine. My assignment was fairly open-ended, and I made arrangements to arrive at the facility at 10:00AM with the idea that we would scout, and set up, from 10:00AM until 11:00AM, at which time Ms. Kane would arrive and we'd begin photographing. In this case we had a little glitch: AMD's security people had not yet approved our paperwork for bringing a camera into one of their secure locations. I wouldn't be able to bring any of my gear past the lobby and into the main building. The AMD public relations person working with me rushed to her office to try to remedy the problem and I began to make a "plan B," just in case.

I walked out the front of the building and saw a great stand of trees right across the road. It was a nice spring day in Austin, TX, with temperatures in the 70s, a gentle breeze, and low humidity. I'd found a great background for my shot. Just in case.

Ms. Kane arrived promptly at 11:00AM and I explained our situation. She didn't miss a beat. We walked across the street, found a nice shady spot, and designed the shot with the perfect balance between my subject and the background. With the camera and subject position set I started to work on the lighting. All that was really needed was one main light, placed to Ms. Kane's right. The light was a Nikon SB-800, set at ½ power and used in the remote mode. An SU-800 wireless controller was used on the camera. The SB-800 flash was aimed into a 32-inch white umbrella. As the sunlight came in and out of the clouds and haze I was able to make quick corrections from the camera position, dialing the flash power

A security glitch turned this indoor shoot into an outdoor session—requiring a little quick thinking!

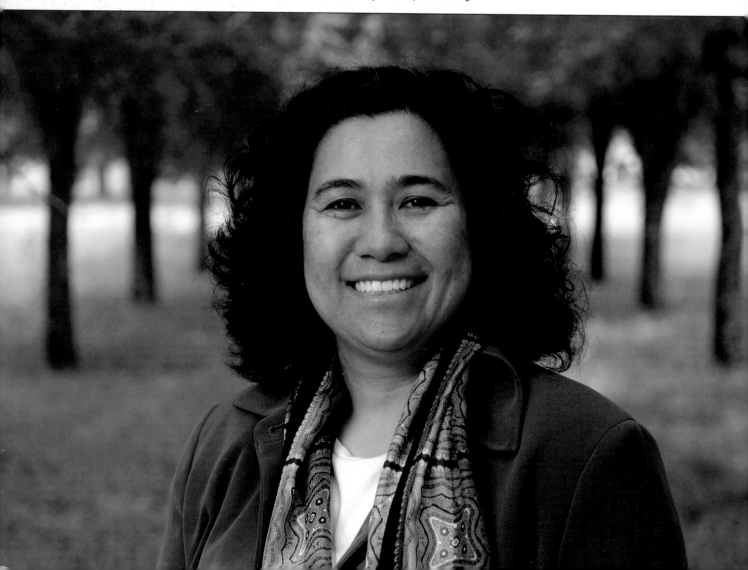

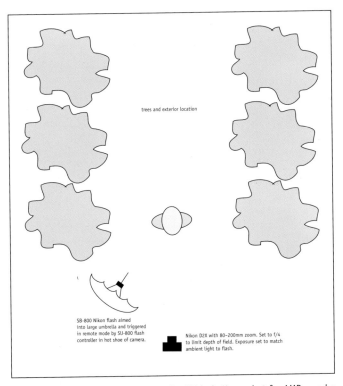

trees and exterior location

SB-800 Nikon flash aimed into large umbrella and triggered in remote mode by SU-800 flash controller in hot shoe of camera.

Nikon D2X with 80–200mm zoom. Set to f/4 to limit depth of field. Exposure set to match ambient light to flash.

Here is another variation of our portrait of Valerie Kane, shot for AMD—and a diagram showing the lighting setup.

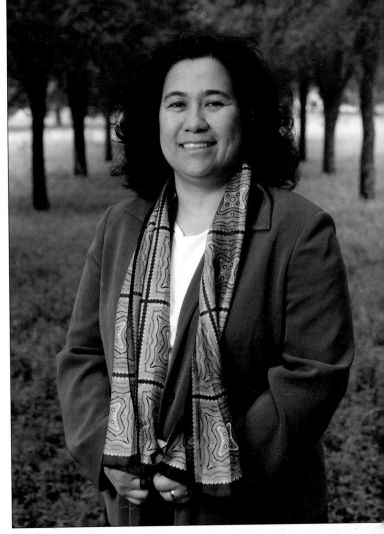

up and down to match the ambient, outdoor light. We used a Fuji S5 digital camera with a Nikon 17–55mm f/2.8 lens and took advantage of the camera's "dynamic range" control to provide an image file with a much longer tonal range that helped ensure detail in the highlights and the shadows. We just finished up our session when the public relations person arrived with our permission to enter the building. After reviewing the images we'd made, she agreed that our improvisation was very successful. Sometimes simple setups and a calm approach to problem solving yield the best results.

CASE STUDY 4:
DR. ELIZABETH MOOREHEAD, RADIOLOGIST

This photograph of Dr. Elizabeth Moorehead was taken on an assignment from Austin Radiological Associates. I was working with their marketing department taking photographs at a number of their facilities for use in their marketing materials and on their web site. At the end of

a long day we arrived at St. David's Hospital, in Austin, TX, to take a few photographs of ARA radiologists who worked there. Most radiology reading rooms in hospitals are small because space is always at a premium. Dr. Moorehead was reading images in a room not much bigger than a walk-in closet, and the room was very plain. I knew that her rapt attention to her work would make the best image so I started to set up my lights. My first intention was to put three Nikon SB flashes on light stands and bounce them off the white ceiling, yielding a soft flat light throughout the room. I set up the lights and did a test, but I was really disappointed. The additional light totally changed the feel of the scene. I turned one of the lights off and the image looked better.

Finally I realized that the main light should be the daylight-balanced, flat-panel screen directly in front of Dr. Moorehead. I shut off the second flash and dialed the power down in the third flash. That did the trick! The third flash was in the back corner, bouncing off the ceil-

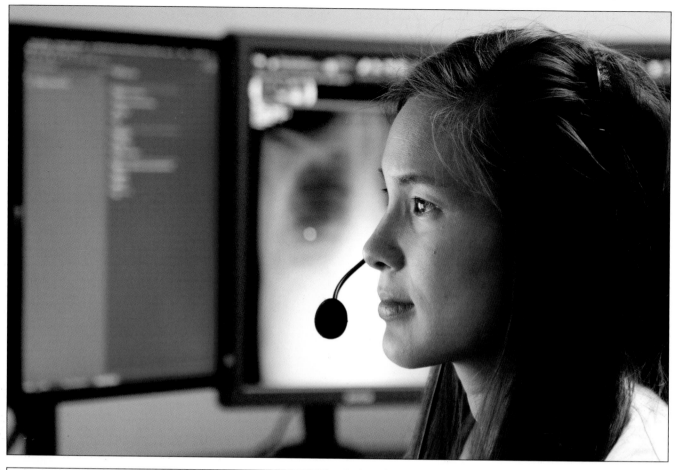

Dr. Moorehead, a radiologist in Austin, TX, is illuminated by a flat-screen monitor directly in front of her face.

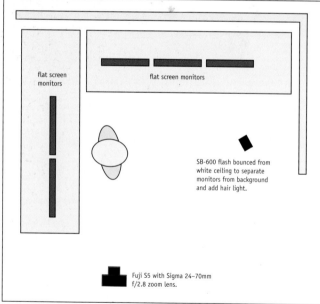

flat screen monitors

flat screen monitors

SB-600 flash bounced from white ceiling to separate monitors from background and add hair light.

Fuji S5 with Sigma 24–70mm f/2.8 zoom lens.

pod, which allowed for a very sharp image even though the shutter speed was 1/40 second. The various screens in the room provide most of the light while the Nikon flash effectively fills in the shadows and provides a few crucial accents.

This was an instance where too many lights destroyed the image while just the right amount of light, blended with the ambient light (the light from the screens), was just right. I think many images are overlit. Try to make each lighting situation as efficient as possible.

CASE STUDY 5:
RIBS AND SLAW, TRIBEZA MAGAZINE

This photograph came from an assignment for an Austin magazine called *Tribeza*. I was asked to photograph various BBQ dishes at three different restaurants. Lamberts is known for their incredible pork ribs and their jicama cole slaw. The assignment was pretty open-ended; the art director just gave me a laundry list of subjects and left the

ing and providing just enough light to illuminate the wall behind the monitors in the background, and produced a little bit of backlighting and a hair light for Dr. Moorehead. I used a Fuji S5 set at 400 ISO and an f-stop of f/3.5 with a Sigma 24–70mm f/2.8 zoom lens set at 70mm. The camera was mounted on my carbon fiber tri-

styling and direction up to me and the chef at the restaurant. I had never been to Lamberts before, so I had no preconceptions of how the images should look.

When I walked into the restaurant in the middle of an overcast afternoon, I was immediately attracted to the soft green material that covered the banquets. I decided to use that background for my image of the jicama cole slaw in a simple white bowl. The chef prepared his signature dish and delivered it to me. After trying several compositions I felt that an extreme close-up was the best way to show the blend of unusual ingredients.

I used a manual focus, 55mm Micro Nikkor lens on a Nikon D2x, setting the ISO at 100 and the white balance at 5000K. I used a 42-inch translucent, flexible Westcott

At the bottom of this page is the final beauty shot of the jicama slaw at Lambert's Restaurant in Austin, TX. The the right is a wider variation. Below is a diagram showing how the lighting effect was achieved.

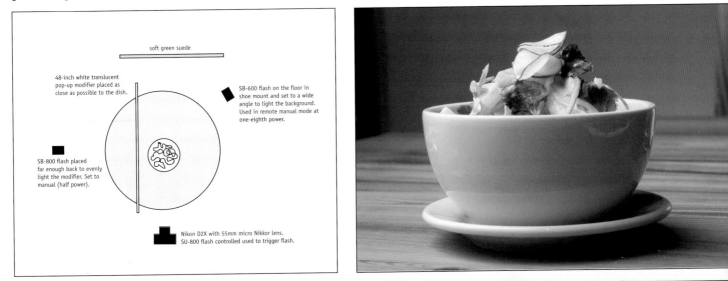

light modifier directly to the left of the camera, diffusing the light from a Nikon SB-800 flash, set at ½ power. I placed the diffusion surface as close to the bowl of slaw as I could without it being in the camera's view. I placed the SB-800 about four feet from the other side of the diffuser to make sure that the light struck the entire diffuser evenly.

A second light, a Nikon SB-600, was placed on the floor, behind the table, on the supplied foot adapter, to illuminate the green material that covered the back of a booth. The SB-600 was set up to provide 24mm coverage and was set at ⅛ power. Both of the flashes were controlled and triggered by an SU-800 wireless controller, sitting in the hot shoe of the camera. The ambient light was metered and an exposure was set that gave 2 stops more exposure from the flashes.

The shot of the ribs was made using a similar lighting setup. Instead of using the flexible light modifier as a diffuser I placed it a bit farther back from the ribs and aimed the SB-800 into the front of the modifier, using it as a reflector. I did this because I wanted the main light on the ribs to have slightly more contrast. The light is just to the left of the camera and is centered approximately two feet above the ribs, and angled down. A second light, a Nikon

SB-600, was used to light the chef in the background. The SB-600 was placed, with its supplier foot adapter, right on the counter, next to the plate of ribs, and aimed directly toward the chef. Used directly, the SB-600's power had to be dialed down to 1/16 power. Again, both of the lights were controlled and triggered by the SU-800 wireless controller, from the camera position.

The shot of the ribs was the opening shot, running full page, for the BBQ article.

Below is a rack of ribs shot for a restaurant review in *Tribeza* magazine. To the right is a diagram showing how the image was lit.

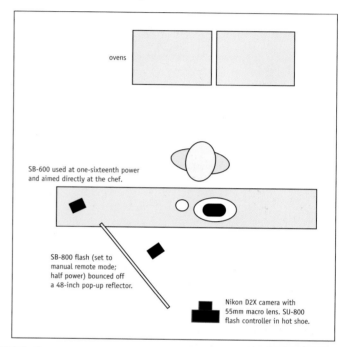

ovens

SB-600 used at one-sixteenth power and aimed directly at the chef.

SB-800 flash (set to manual remote mode; half power) bounced off a 48-inch pop-up reflector.

Nikon D2X camera with 55mm macro lens. SU-800 flash controller in hot shoe.

These three shots show the evolution of a feature photograph for a lifestyle magazine. We describe the lighting fully in the text of the case study. After the lighting was set we continued to experiment with additional props and compositional effects until we wound up with a frame (above) that really showed the ambiance of Asti Trattoria.

CASE STUDY 6:
ASTI TRATTORIA

A shooting day at Asti. Another magazine assignment sent me to one of my family's favorite Austin restaurants. We were working on an article about buying and enjoying wine in the Hyde Park neighborhood.

The first shot is a still life showing a bottle of wine on the counter with the bar stools going off into the distance. I wanted to preserve the feeling of the light-filled dining room while filling in the shadows and cleaning up the color casts in the ambient illumination. I used three Nikon SB-600s set on tables with their heads pointed toward the white ceiling. They were all set up as remote flashes. I needed to use three in order to get an even light pattern from the front to the back of the shot. The fore-

ground was lit with a Nikon SB-800 in the commander mode, set at ¼ power and bounced off the ceiling to the left of the camera position. I used an 80–200mm zoom lens set to 100mm with the aperture nearly wide open.

The second shot is a food still life. I wanted to use the front window of the restaurant as a background because I like the word "espresso" showing backward, through the almost transparent curtain. The first photograph

These images show an entrée at Asti Trattoria. The first image (right) is illuminated just by the daylight from the window. The second image (above) is lit with one light bounced from the white ceiling and a second light bounced into a 48-inch white reflector panel.

A corkscrew at Asti as a symbol for fine dining and an exercise in minimalist lighting (left).

Two variations from a wine tasting at Asti Trattoria (facing page).

shows the effect of the natural light alone. The second photograph was enhanced by adding an SB-800 aimed through a pop-up diffuser, coming from above and to the right of the camera. A second SB-800 was bounced off the white ceiling. Each flash was set to ¼ power. I varied the shutter speed until I found an exposure combination that worked well with the outside light.

No restaurant story feels complete without a portrait of the executive chef. The owner of Asti, Emmett Fox, happened to be in the restaurant and agreed to pose. For the final image, which appears on page 66 with an accompanying diagram showing the lighting, I started with a straight ahead shot of Fox. He was lit by an SB-800 flash aimed into a 48-inch pop-up diffuser positioned to the left of the camera. The center of the diffuser was placed just above his head. The SB-800 was set at ½ power. I used two SB-600 flashes placed at either end of the bar and aimed back into the kitchen.

I was happy with the first shot but wanted to try something a bit different, so I moved Fox back to the bar stools and had him hold a cup of espresso. The lighting was much the same as the first shot.

In addition to the final portrait (see page 66), here are two variations of a portrait featuring executive chef and owner of Asti and Fino Restaurants, Emmett Fox. The image was created on location at Asti in Austin, TX. The lighting used in this image was basically the same as that shown for the portrait on page 66.

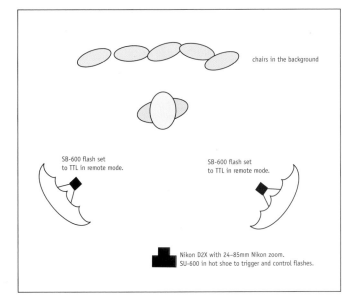

chairs in the background

SB-600 flash set
to TTL in remote mode.

SB-600 flash set
to TTL in remote mode.

Nikon D2X with 24–85mm Nikon zoom.
SU-600 in hot shoe to trigger and control flashes.

Jessica Ortiz-Price, owner of Austin Deep Tissue Therapy, was photographed outside her studio (above and top right) with two portable lights. The interior portraits of Jessica (right center and bottom) were lit by two lights and the soft glow of the room lights.

CASE STUDY 7:
JESSICA ORTIZ-PRICE, OWNER OF AUSTIN DEEP

One of our favorite web design shops called and asked me to make a series of photographs at a business called Austin Deep. The owner, Jessica Ortiz-Price, is an expert in a massage method that involves deep tissue work and is favored by top athletes. Our first photograph was to be a straightforward portrait of Jessica sitting in a little garden just to the side of her studio. She is sitting in a pink plastic chair, and the garden is generally illuminated by open shade. I added small umbrellas with SB-600 flashes to either side of my camera position so they were lighting Jessica at 45 degree angles for a soft, even fill.

Next we decided to do a more formal portrait in the reception area with Jessica sitting on a sofa. I used a straightforward two-light setup. One light came from an SB-600 on a light stand with a small umbrella set about five feet to the left of the camera and aimed at Jessica. A second light, also an SB-600, was placed about five feet to the right of the camera. I used a larger (48-inch) white, shoot-through umbrella on this light. The right light, the main light, was set at $\frac{1}{2}$ power and the left light, acting as a fill light, was set at $\frac{1}{4}$ power. Both lights were triggered by an SU-800 in the hot shoe of my camera. The flash exposure was set to be about 2 stops brighter than the ambient light exposure.

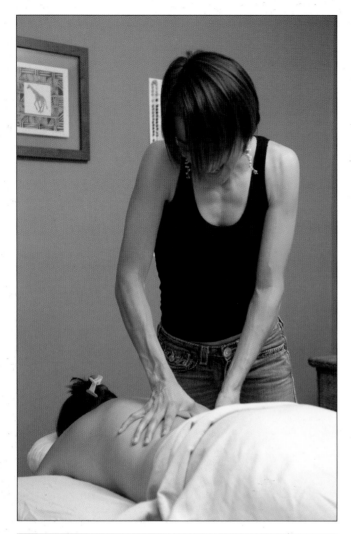

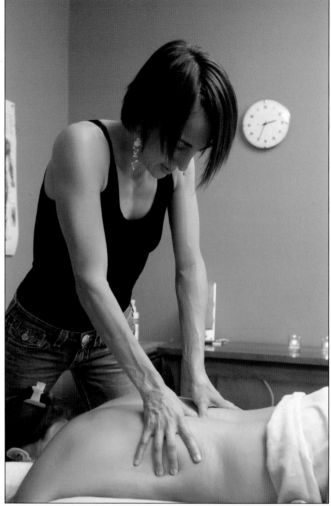

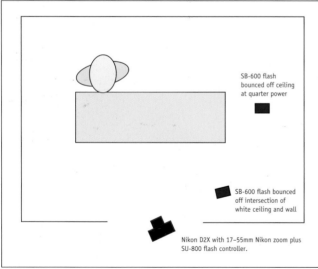

SB-600 flash
bounced off ceiling
at quarter power

SB-600 flash bounced
off intersection of
white ceiling and wall

Nikon D2X with 17–55mm Nikon zoom plus
SU-800 flash controller.

Images (above) of the deep tissue massage given by Austin Deep Tissue Therapy owner, Jessica Ortiz-Price. In these images, bounce light techniques were used for overall lighting.

In the images on the facing page of Jessica working with a client, a smaller amount of bounced flash was in order to maintain the feeling of semidarkness usually found in the treatment rooms. The existing room light (seen behind Jessica in the top image) was paired with an SB-800 flash to camera left. With an SC-29 off-camera cord, this was used in TTL mode and bounced off the wall next to the door (see basic room diagram to the left).

The next series of shots was of Jessica in action. We photographed in a very small therapy room with very dim existing light. I placed a light on a stand in the far corner of the room, set to TTL exposure and set up in the remote mode. For my main light I used an SB-800, also set to TTL, on an SB-29 off-camera cord and bounced from the wall right over my left shoulder. This was set up as my "master" flash. I used the plus and minus controls on the master flash to vary the intensity of both flashes until I found a pleasing exposure. I set an exposure that would allow me to use the warm light from an existing household fixture as an accent in the photograph.

CASE STUDY 8:
ROGER BROWN, ABBOTT SPINE

I was contacted by one of my corporate clients, Abbott Spine, and asked to photograph members of their man-

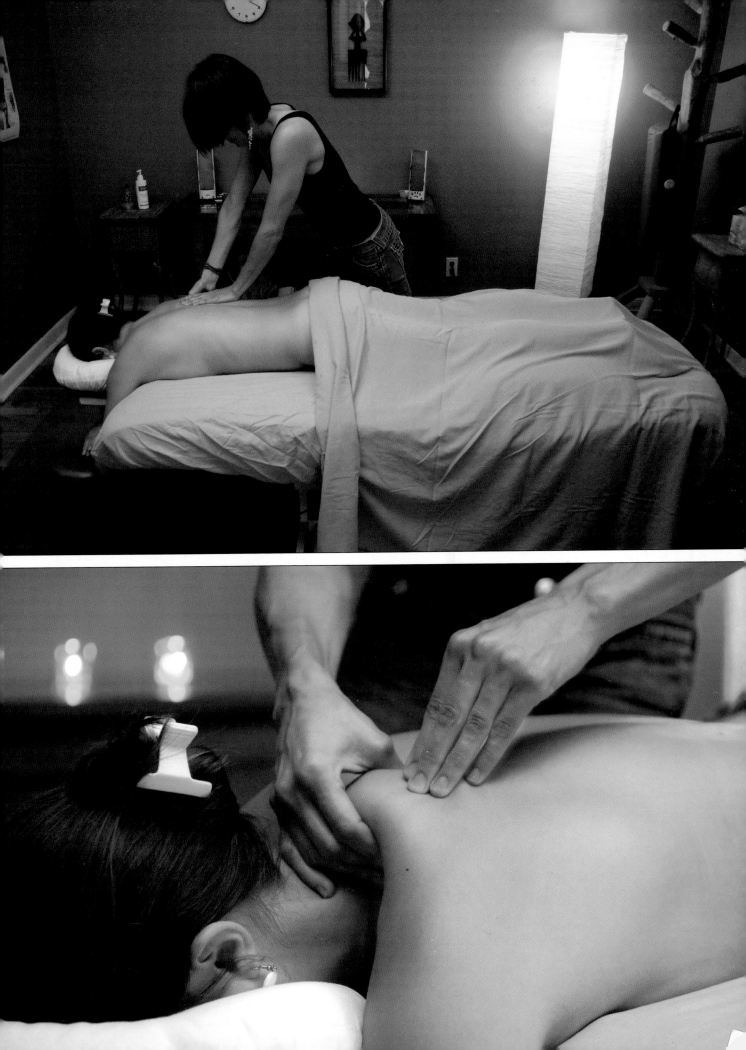

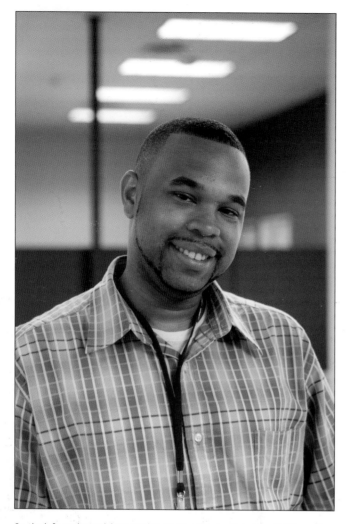

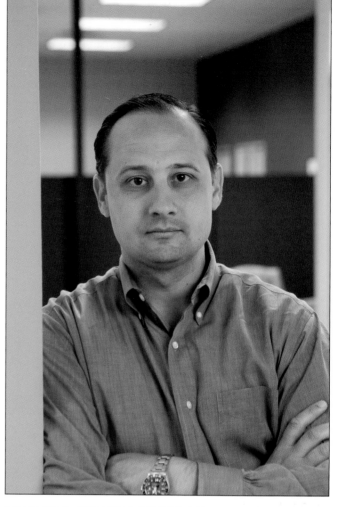

On the left, assistant/photographer Christopher stands in for a lighting setup. With the lighting setup complete, Roger Brown of Abbott Spine (right) steps into our lit location for a series of casual environmental portraits.

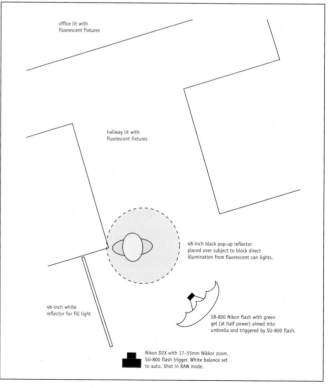

office lit with fluorescent fixtures

hallway lit with fluorescent fixtures

48-inch black pop-up reflector placed over subject to block direct illumination from fluorescent can lights.

48-inch white reflector for fill light

SB-800 Nikon flash with green gel (at half power) aimed into umbrella and triggered by SU-800 flash.

Nikon D2X with 17–55mm Nikkor zoom. SU-800 flash trigger. White balance set to auto. Shot in RAW mode.

agement team. We set up a studio in one of their large conference rooms and photographed each person in front of a large, canvas background. Very traditional, very "old school." After we photographed each executive in the studio we were asked to do an environmental portrait of them somewhere around the offices. We identified four good areas and worked to figure out quick and efficient minimalist lighting schemes for each one.

Here's the setup we used in one area. As in our first case study we were working in an area that had a mix of lighting directly overhead. In this location there was a combination of linear fluorescent tubes as well as "can" lights with high-intensity fluorescent bulbs. Our first order of business was to set up a black pop-up scrim to block any direct light from above our subject's head. With this in place we set up another pop-up diffuser to

the right of the camera just above head height. Shooting through the diffuser was an SB-800 flash set to ½ power. The SB-800 was covered with a plus green filter so that its spectrum would be close to that of the existing fluorescent. The camera was set at the generic fluorescent white balance setting. We shot all the images as raw files so that we could easily correct the global color balance in our raw conversion software during postproduction. Finally, I varied the shutter speed until I found a good balance between the foreground and the background.

The first photograph (facing page, left) shows my assistant Christopher Ferguson standing in for our executive as I build my lighting and check the composition. The second shot (facing page, right) is our final setup with our executive in place.

This is a lighting scheme I use for lots of interior working shots. We vary lighting instruments depending on a number of variables. The important consideration in images like these is to carefully match the intensity of the flash lighting to the ambient light while also matching the color temperatures of the two sources closely. The light blocker is instrumental in changing the overall intensity of the existing lights. If we hadn't blocked the direct overhead can lights (with fluorescent bulbs) the executive would have been standing in a hot spot. To overpower the hot spot it would have been necessary to increase the power of the flash, which, in turn, would have made the back wall darker. It would then be necessary to add lights to balance the back wall. Eliminating a light source can be a much easier solution.

CASE STUDY 9:
SWIM MEET

These two images were shot just for the heck of it at a kid's swim meet at a pool in Austin, TX. In both images the lighting was the same. I was trying out two different techniques in one shot: (1) Using a CTO (the filter that changes daylight flash to the same color temperature as tungsten), I set the white balance of the camera to tungsten and dialed the exposure compensation dial on the D2x digital camera to –1. I dialed the exposure compensation on the SB-800 flash unit to +1, effectively making a 2-stop difference between the two light sources. (2) I used the camera and flash in the FP (focal plane) mode so I could synchronize the flash at a shutter speed of $\frac{1}{1250}$.

This allowed me to shoot a wide open aperture on my 17–55mm Nikon zoom lens, which was instrumental in making the busy background go out of focus.

This is one of the few shots that was taken with the flash mounted directly on top of the camera. It works in this situation because the effect of the contrasting colors serves to increase the saturation of the sky and all the colors unaffected by the flash while keeping all the visible areas of the main subjects a consistent color.

An important facet to making this technique work is always turning your subject away from the direct light of the sun. If the person's face is shaded, it will be easier for the flash to overpower the ambient light and prevent contamination from the two color temperatures.

Ray and Julian at a swim meet in Austin, TX. FP flash mode lit with tungsten-balanced flash.

Ben at a swim meet in Austin, TX. FP flash mode lit with tungsten-balanced flash.

CASE STUDY 10:
MISSY RUTHVEN, TRIATHLETE

In 2005, an Austin advertising agency approached me
with the idea of doing images for a group of physicians
specializing in sports medicine. They wanted a series of
images showing real athletes engaged in their sports. We
spent a hot August week shooting triathletes, runners, cy-
clists, and swimmers doing what they did best. One of
my favorite athletes was Missy, who is a veteran triathlete.
We photographed her swimming and running, but the
softball and biking shots were two situations in which we
really needed to modify the existing light (hot, direct,
mid-afternoon sun!).

The two softball images are classic example of mini-
malist lighting as there are no lighting instruments in-
volved. The art director and I chose a softball field ringed
with great, full trees and well-tended grass. As soon as I
figured out the compositional relationship between the
subject and the background I started setting up my fa-
miliar outdoor light modifying rig. I used a heavy-duty
Lowell light stand, anchored with a Photoflex water bag.
This stand supported a 48-inch, 1-stop translucent dif-
fuser held in place by a reflector holding arm. The dif-

Triathlete, Missy Ruthven, poses for a series of baseball shots for an Austin
Sports Medicine advertising campaign.

Here, Missy poses for an exterior biking shot.

fuser was situated just above Missy's head and blocked the harsh, direct sunlight. Blocking harsh light ensures that the transitions from bright areas to shadow are much gentler and also ensures that shadows hold detail instead of going inky black. The diffuser soaks up 1 stop of light.

Next we added a 48-inch white reflector directly in front of and just below the camera position to bounce some light into Missy's face so we wouldn't lose detail under the bill of her baseball cap. I took a spot meter reading off Missy's face and set the aperture and shutter speed combination that allowed me to limit the depth of field so the busy background softened appreciably. The dark foliage of the trees tolerates overexposure very well. We were helped by the light, sandy soil of the softball field as it bounced lots of soft light into the subject area of the photograph.

These two photographs were taken with a Kodak DCS 760 digital camera, which has a remarkably large dynamic range. That means that the sensor is able to capture a very wide range of tones from dark to light. My colleagues are still amazed at the amount of shadow and highlight detail this particular camera can deliver.

The photo of Missy on the bike is another image that depends mostly on reflectors for its success. Missy's racing bike is anchored on a spinner that allows her to pedal in place without the bike moving. I placed a large 48x48-inch gold reflector just to the front of the bike, reflecting the sunlight directly into Missy's face, arms, and legs. I used the Nikon 80–200mm zoom lens at f/5.6 and, with the camera's ISO set at 80, I was able to synchronize an SB-800 flash at $\frac{1}{320}$ second shutter speed to act as a fill light.

The real secret for images like the bike shot is to get the subject far enough away from the background so that the depth of field is very shallow. The crisp foreground image separates nicely from the background and the out-of-focus character of the background helps to keep it from being a distraction. Additionally, the use of a long

lens adds a feeling of compression to the image while adding to the out-of-focus background.

The campaign generated dozens of successful images. A number of them were output in large poster sizes and are currently used to decorate the practice's various exam and treatment rooms. Had we opted to use conventional lights, the look and feel of all the images would be quite different.

CASE STUDY 11:
DAVE BROWN, VICE PRESIDENT OF DELL, INC.

I love projects like this one. I was asked to photograph a senior executive at Dell, Inc. The company would use the images for a wide number of uses ranging from public relations to the fulfillment of editorial requests. The assignment brief called for a standard head shot against a blue background, to match the style we set years ago. In addition to the headshot they also wanted various envi-

Image 1.

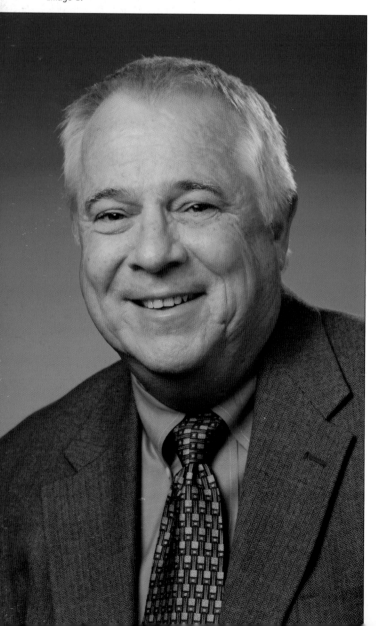

ronmental portraits with a wide range of backgrounds. The assignment needed to be completed at one facility because of the executive's schedule constraints. I would have one hour to scout the location (a customer briefing center in Round Rock, TX), half an hour for the head shot setup, and one hour total with the subject.

The first photograph (image 1) is a classic corporate portrait. I commandeered an empty conference room and set up a short roll of studio blue seamless background paper as my background. The most important part of the lighting for a portrait is to get the exact effect you want on the background. Once that's set everything else should fall in place. I used one Nikon SB flash as a background light and worked with it until I was happy with the intensity, the size of the projected circle, and the quality of the light falloff toward the edges.

With the background set I wanted to place the subject as far away from the background as I could without showing the edges of the seamless (I was using a short roll, which is 52 inches long). I set my zoom lens for a focal length of 135mm and began backing up until I could just see the edges of the paper. I set my camera there and then zoomed in a bit for safety. I then grabbed a passerby and had them sit in for just a minute so I could fine-tune the position of the subject. With the positioning done I got to work on the lighting.

I used a very large, 60-inch diameter white umbrella to the left of the camera aimed directly at the subject. This umbrella (by Photoflex) has a black cover for the back that keeps light from diffusing through the white fabric, striking the walls and ceiling of the room and re-

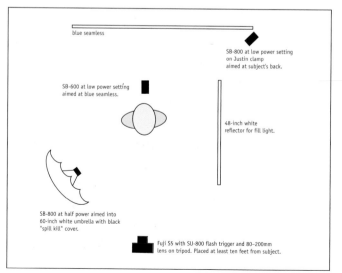

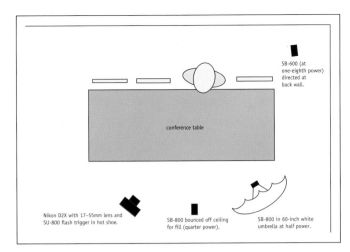

The following labels appear in the lighting diagram:

SB-600 (at one-eighth power) directed at back wall.

conference table

Nikon D2X with 17–55mm lens and SU-800 flash trigger in hot shoe.

SB-800 bounced off ceiling for fill (quarter power).

SB-800 in 60-inch white umbrella at half power.

Image 2.

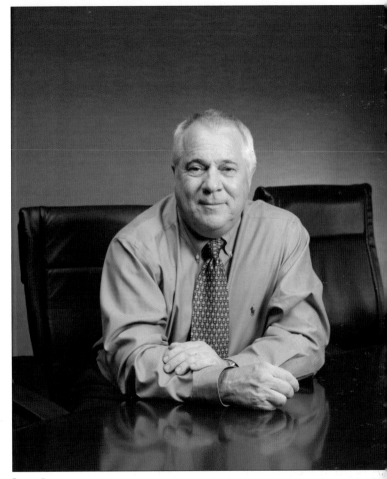

Image 3.

ducing the overall contrast of the image. The large size of the effective light source ensured that while the light would have direction that the transitions from light to dark would not be too harsh. To reduce the contrast and reduce the lighting ratio from one side of the subject's face to the other, I added a 48-inch white reflector panel to the side opposite the flash. I placed the reflector just out of camera view.

With all my lights in place I used the self-timer setting on my Nikon D2x and sat in the subject position to check my overall lighting. Upon evaluation I was happy with the main light and the background light, but I wanted just a touch more separation between my subject and the background. To add this I placed a flash on a Manfrotto Justin Clamp and attached the assemblage to the top of one of the background stands. Aimed directly at the back of the subject's head, and set at a very low power level, this Nikon SB flash added just the right amount of backlight to add dimension to the shot.

All the flashes in this project were triggered and controlled by a camera-mounted SU-800 infrared flash controller. This allowed me to make adjustments to all three lights, individually, from my camera position. It saves me a lot of walking back and forth during the set up. I need only look at the LCD screen on the back of the camera to see what needs to be adjusted. From there it's just the push of a button or two to get the exact level I want.

For the next two shots (images 2 and 3) we stayed in the conference room and turned around to use the conference table and back walls as our new set. With my subject seated and framed in the camera viewfinder I started building a quick, five-minute lighting design. My main light was the same 60-inch umbrella I used for the first

portrait. This was set to camera right and adjusted to yield an f-stop of approximately f/5.6. Next I added a backlight on the floor just behind the subject's chair. The zoom setting on the SB Nikon flash was set to 24mm, and I adjusted the flash to give the same meter reading as that of the main flash. The horizontal photo shows that lighting setup, but it was apparent to me that we needed more fill light. I added an SB flash near the camera posi-

tion and set the flash to bounce off the white ceiling. Next I added a white reflector to the darker (right) side of the subject. With these additions the image was complete and I now had a second setup "in the can."

Just outside the conference room is a hallway lined with wall-mounted LCD monitors (image 4). At the end of the hallway is a bright wall display that is backlit with strong fluorescent lighting. Most of the permanent lighting in the area is tungsten track lighting. I placed the subject at the end of the wall, next to some strikingly saturated blue tiles. I placed a 48-inch diffusion panel to the right of the camera (subject's left) and aimed a Nikon

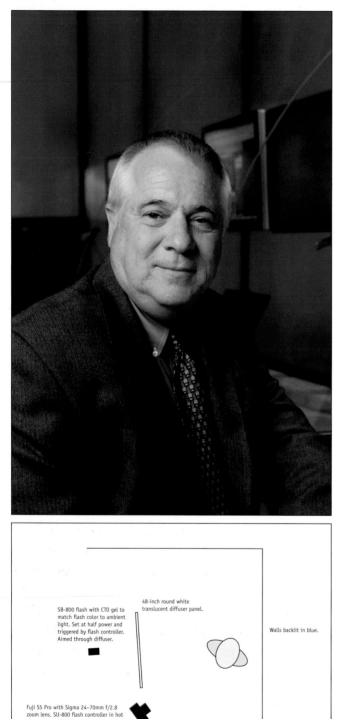

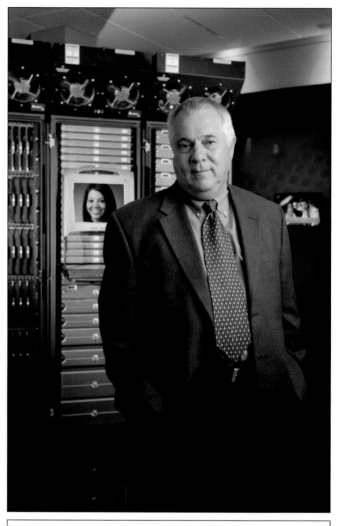

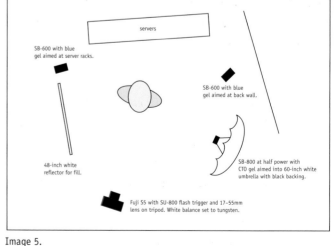

Image 4.

Image 5.

SB flash through the panel as a main light. The flash was covered with a CTO gel to balance its light with the predominant light source, the track lighting. The ambient light was positioned in such a way as to provide good fill light and a bit of backlighting, which added some drama to the shot. The SB flash was set at ¼ power and triggered by an SU-800 flash controller from the hot shoe of a Fuji S5 Pro camera.

For our next setup (image 5) we wanted to show some Dell products in the background, so we chose a spot in the reception area that featured several racks of Dell servers. After figuring out the relationship between my subject and the servers and other background elements I started the lighting process. The room was lit almost entirely with tungsten spotlight and tungsten floodlights. I gelled my main flash with a CTO gel and again used the 60-inch white umbrella with the opaque black backing. I placed the main light to the subject's left side (camera right) and tested the image to find the right exposure. I wanted to get a fairly wide aperture on my 17–55mm zoom lens so I could use shallow depth of field to soften the background elements and keep them from being a distraction. A few quick tests indicated f/5.6. The tests also indicated that the opposite side of my subject required more fill light in order to keep good detail. I added a 48-inch white reflector panel to that side.

In lighting the background elements I decided to accentuate the foreground/background separation by using a contrasting color palette. I set a relatively warm white balance for the CTO-covered main flash. The correct setting would be 3200K, but I chose to set the camera at 3400K in order to warm up the skin tones. Conversely, I used blue color correction gels over the two flashes that illuminated the background areas to enhance the blue tone that daylight-corrected flash would give.

CASE STUDY 12:
PAUL FROUTAN FOR ACCELERATE MAGAZINE

It's always fun to get a call from the art directors who put together AMD's (Advanced Micro Designs) in-house magazine, *Accelerate*. My brief was to head to the offices of Rackspace and make a couple of interesting images of Paul Froutan. I arrived at the Rackspace H.Q. in San Antonio and did a quick scout of the building with a P.R. person. I found several locations I thought would work

Image 1. Paul Froutan for AMD's *Accelerate* magazine. Lit with one large umbrella and one pop-up reflector. Our basic on-location headshot.

well, met with Paul to figure out a quick schedule, and then got to work.

The first setup (image 1) was at the intersection of a hallway and a central reception area. I wanted to do a tight portrait shot here, so I found an angle that would give me strong vertical lines in the background and could be lit without too much trouble. My main light came from a softbox positioned just to Paul's left. A second light was bounced off the ceiling just to the other side of my camera position, providing a nice level of fill light. I'm a sucker for good background treatments, so I made sure that the hallway behind my subject was well lit. There were two lights at 10-foot intervals down the hall that had their reflectors zoomed wide and were aimed at the warm wall and doorway behind the subject.

I was happy with the general lighting, but I felt like it was missing some energy, so I pulled another Nikon SB

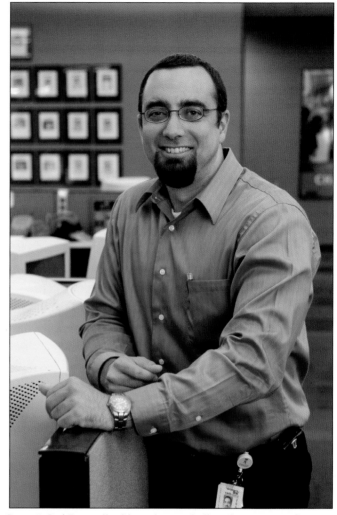

Image 2. An image of Paul, seated in the hallway area and lit with one large umbrella and one pop-up reflector.

Image 3. Paul Froutan lit with one large umbrella and one pop-up reflector.

strobe out of my case and set it directly behind Paul. This strobe was snooted so that it wouldn't add spurious reflections or shadows to my carefully constructed background. I only wanted to see a little rim light around Paul's head.

All the lights had radio slaves attached and they were triggered by a radio transmitter from the hot shoe of a Nikon D2x digital camera. I used a fairly slow shutter speed so that the existing fluorescent light was about 2 stops below the exposure given by the flashes.

Everyone was happy with the first shot, so we turned around and set up our second shot just 20 feet away (image 2). This shot incorporates much of the minimalist philosophy: we used only small, battery-operated, shoe-mount flashes. The added lighting is seamlessly blended with the ambient light sources. The depth of focus is very shallow and concentrates the viewer's atten-

tion directly on the subject. It even leverages the use of green filter gels for fun, accurate color correction.

Here's how it was done. I found a chair with a good heavy visual presence and moved it around until I liked the way it worked with the background. Wanting a good amount of compression effect, I set up my camera almost twenty-five feet from the subject position so I could use a long focal length on my 80–200mm zoom lens. Once the relationship between the background and the subject position was figured out I could get on to my lighting.

The first thing I did was find a way to turn off the fluorescent light banks directly over Paul's head. It was simple—I grabbed a ladder and gave each of the offending tubes a twist, turning them off. Now the hallway was illuminated but not the area around the chair.

I put my favorite 60-inch diameter umbrella directly to Paul's right, at a 90 degree angle to the camera. The

Image 4. An image lit with one large umbrella and one pop-up reflector. This image shows just a bit of reflection in Paul's glasses.

Image 5. The final image, lit with one large umbrella and one pop-up reflector.

umbrella, stand, and flash were moved away from Paul to a distance of about ten feet. This gave a little more contrast to the main light while ensuring a much less dramatic falloff from one side of the subject to the other. The flash at the umbrella setup was covered with a 30 green (or plus green) gel to blend with the fluorescent lighting in the background.

The first test with the umbrella light alone showed me that the side of Paul's face away from the main light would be much too dark and contrasty, so I did two things to smoothly reduce the overall lighting ratio. First, I placed a 48-inch white reflector on the dark side of Paul's face. Second, I added another flash unit, bouncing off the white ceiling to further fill in shadow areas.

All the lights were set manually and triggered with radio slaves. With a wide aperture I was able to make the background go out of focus in a very pleasing way.

With our second shot in the bag we went looking for just a few more opportunities (images 3, 4, and 5). Many subjects run out of patience, but Paul seemed to understand the artistic process and was a very good sport.

For our final location we found a large, open operations center with half-wall cubicles, lots of computer monitors, and a red wall in the background. I started with my 60-inch umbrella light to Paul's right and a fill reflector to the left, but I couldn't quite get the reflection out of his glasses. I switched the umbrella to the other side and used the soft, ambient light from the pervasive banks of fluorescent lights for a fill source. The light was still covered with a green gel, which gave me a perfect balance between existing and added light sources. The final result works, to a large extent, because of the excellent color contrast between the red wall and the blue shirt.

CASE STUDY 13:
PROJECT BREAKTHROUGH

We photographed Jackie for the Project Breakthrough annual report one year ago. Project Breakthrough is a program that mentors and assists committed students who will, potentially, be the first member of their family to attend college. Jackie is a gifted mathematician, so we wanted to photograph her in a location that would allude to her strength. The art director chose a classroom at the University of Texas.

While Jason (the art director) helped Jackie fill the blackboard with equations I designed a lighting setup that would make sense for the scene and set a style for the rest of the annual report.

I set up two lights, 10 feet apart and bounced off the ceiling, to provide a general base of illumination. I added one more light in an umbrella far to camera left (Jackie's right) to give the lighting a subtle sense of direction. The

Student, Jackie, photographed for Project Breakthrough in a classroom at the University of Texas.

SB-28dx bounced into a 32-inch white umbrella to add direction to the light. Used in manual mode at half power.

chalkboard

Two SB-800 flash units triggered by radio slave. Set to half power and fitted with green gels to match color of existing fluorescent lighting.

Nikon D2X with 28–70mm f/2.8 Nikon zoom lens and radio flash trigger in hot shoe. Exposure set to match ambient flourescent light from ceiling.

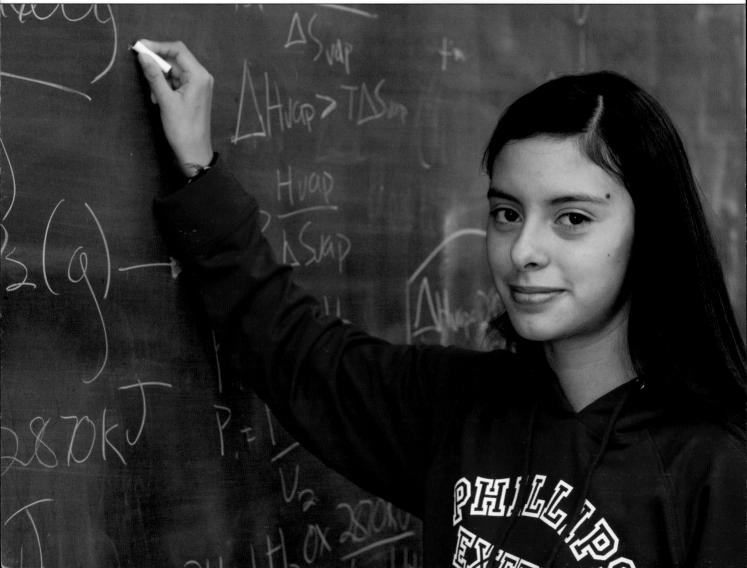

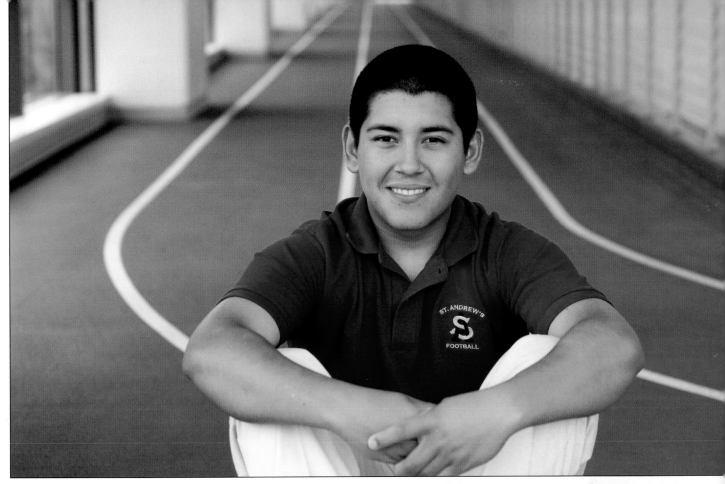

Student, Nico, photographed for Project Breakthrough. The image was shot in an athletic facility at the University of Texas.

lights were all gelled with plus green in order to let me mix the existing fluorescent light with the added lights. The match was very close and was further tweaked during the conversion of the raw files.

Each of the flashes was triggered by a radio slave, and each of the flashes was equipped with an external battery pack so I could shoot quickly without worrying about re-cycle times. Jackie had never been in front of the camera in a situation like this before and I wanted to be able to shoot a lot of frames in order to get her used to the rhythm of a photo session. I also wanted to cover myself with enough good expressions. I needn't have worried. She was a consummate pro in front of the lens.

The second subject for Project Breakthrough was young man named Nico. We discovered that Nico is both a talented student and an athlete so we elected to photo-graph him on the indoor running track at one of the gyms on the University of Texas at Austin. When we walked into the track area I immediately fell in love with the diminishing perspective of the long corridor, set between large windows to the outside on my left and

smaller windows opening into a series of basketball courts on my right. The dominant light source was daylight from the floor-to-ceiling windows. I used two very soft, very large umbrellas outfitted with strobes to provide a shadowless fill light. Both flashes were dialed down to $\frac{1}{16}$ power.

I used a shutter speed of $\frac{1}{250}$ second, which allowed me to shoot almost wide open with my 80–200mm zoom lens. Though I love Nico's energy and expression, the thing I love most about the shot is the wonderful per-spective of the background coupled with the ever soften-ing focus as your eye moves back in the frame.

CASE STUDY 14:
SUPERHEROES FOR PERISCOPE

Our final case study is about an assignment for an Austin company called Periscope. Their advertising agency brainstormed a web-based campaign that would show-case various users of their products as superheroes. After working with the agency to cast the right talent we followed the creative brief that outlined photographing our talents in typical office and work situations, but with a hint of almost comic book–like superheroism.

Image 1. Talent, Mike Harris, as one of the superheroes for an ad campaign. This frame shows the original concept without added light.

Image 2. This frame shows a more heroic angle and just enough added light to clean up the image and provide vital separation between the foreground subject (Mike) and the background.

Our first example is "Periscope Man" (images 1 and 2). The comprehensive layout called for an image of our character in an alley pulling his shirt off to reveal his su-perhero costume underneath. Our first shot followed the comp pretty accurately and the first photo was shot with available light because the agency wanted the shot to look "real" instead of set up. We tried a number of variations, and the client and agency were fairly satisfied. As we were walking back to the cars I noticed the office building across the street and thought it had a more "Superman" feel to it. Crossing the street I set up my Nikon D2x with a 28–70mm lens and com-posed the background first. Satisfied with the look of the frame I asked Mike to step in and we worked to position him correctly in the frame. Our first few shots were good, but I felt that we needed to add just a touch of light to fill in the shadows a bit, separate Mike from the background, and introduce a little color temperature difference between Mike and the building/background.

I set up a Nikon SB flash on a small Man-frotto stand, aimed into a small-sized soft-box, and dialed the flash power way down. Fortunately, Mike's glasses had antireflective coatings and, with the correct angle, we had no reflections or glare on Mike's lenses. When I compare these two photographs I'm immediately aware of how much more pol-ished that little touch of flash makes the sec-ond image. The total setup of the added light was accomplished in less than five minutes!

Our second "hero" is Oscar, emerging from the phone booth to fight evildoers everywhere (images 3 and 4). We were work-ing in late August in Texas, where the heat and humidity are really oppressive. Moving quickly was imperative as we didn't want our talent to sweat profusely. The first step (as al-ways) was to find an angle that gave me an optimum relationship between the fore-ground subject (Oscar and the phone booth) and the background. Once I had that lined up I was ready to start on the lighting. I didn't want direct sunlight striking Oscar, so

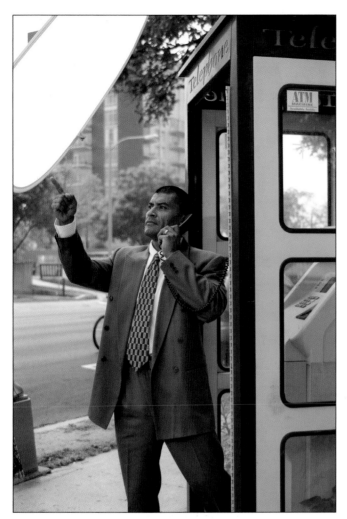

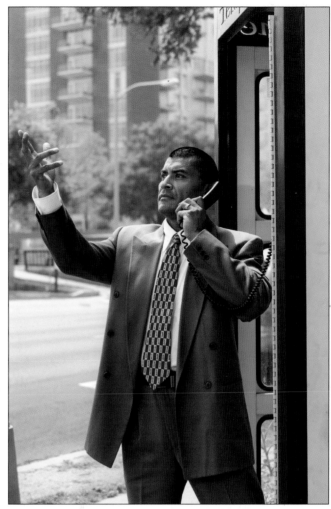

Image 3. Talent, Oscar Lainez, as one of the superheroes for an ad campaign. This frame shows the edge of a white reflector that is blocking direct sunlight from Oscar. Flash has not yet been added to the mix.

Image 4. This image of Oscar shows a near final shot with light modifiers in place and a flash providing fill on the shadow side.

I set up a large white diffusion panel on a sturdy stand. This blocked a great deal of the hazy sunlight and reduced the overall contrast of the shot. I knew I would need to add back some clean light to keep the shadows open and detailed and to keep the light of the open shade from going too blue. I set up a flash with a small softbox 5 feet to the left of the camera and as close to Oscar as I could without entering the edge of the frame. I wanted a very controlled depth of field as I wanted the building in the background to go out of focus gracefully. The correct exposure for the ambient light was f/4 at $\frac{1}{1250}$ second, 100 ISO. I needed to keep this exposure to make the image work, so I set the camera and flash to take advantage of the FP (focal plane) mode. In this setting the flash is pulsed over the course of the entire exposure so that the frame is evenly lit even though the shutter moves past the sensor as a small slit. In the regular mode the

flash dumps its entire load of energy at the precise moment that the sensor is completely uncovered. In most cameras that would mean a top sync speed of around $\frac{1}{250}$ second. This would have required an aperture setting of around f/11. The background would have been too much in focus at that setting.

As it was, the lower power of the FP flash was barely sufficient. In retrospect I probably should have added a second flash unit to the softbox in order to boost the power by 1 stop or $\frac{1}{2}$ stop, but without the ability to use FP the shot could never have looked like this.

The third hero in the Periscope pantheon is Lynn (images 5 and 6). We wanted to capture his larger-than-life gestures in a typical conference room. After selecting the background and the basic composition, I started lighting. My first consideration was to keep the feeling that the scene was as it would appear in a real conference

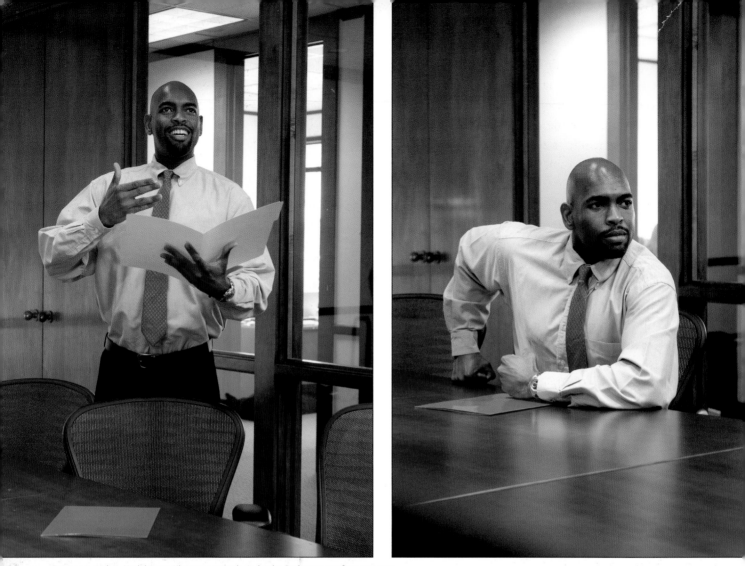

Images 5 and 6. Model Lynn King as a superhero in the Periscope conference room.

room. This meant adding lights to improve the technical quality of the photographs while incorporating the existing fixtures in the mix. I upped the general light level of the room with two lights aimed at the white ceiling for a low-contrast fill. I added a light to a small softbox and placed the fixture right on the conference table to camera right (Lynn's left). The softbox gave just enough direction to the light to keep the effect from feeling too flat or lifeless.

Next we added a direct light to the white wall at far camera left for a gentle side light effect and a second light on the dark wood doors of the cabinet behind Lynn's right arm to keep the wood from going too dark.

At this point the image was really starting to come together. The only element that bothered me was the greenish, dim light coming from the office across the hallway. I placed an SB flash unit against the near wall of that office and aimed the wide beam at the wall showing directly behind Lynn's head. Just to add a bit of color contrast I covered the flash in the far office with a very light blue filter.

A final point is the realism that the highlights on Lynn's forehead add. The ambient room lights give a subtle warmth to the photograph without shifting the overall color of the scene.

The light in the office is triggered by a radio slave. The other lights are triggered with a combination of radio slaves and optical slaves. In all we used six lights to complete this series of shots, but all of the equipment reflected the minimalist philosophy of being small, portable, and quick to set up. Our entire setup and testing for these shots took less than a half hour.

The final set of images in the series are of Ann images 7, 8, 9, and 10). In her superhero persona, she is "looking into the future." The creative team wanted to show a stylized office space with warm, rich colors. As the space

was fairly confined we didn't have a lot of leeway with our composition. The lighting needed to have the same feel as the other images with a slight sense of direction given to the main light on the subject. Our first light was the main light in a medium-sized softbox, placed slightly above Ann's head and to camera left. We then needed to add enough fill light to reduce the contrast and the ratio between the highlights and the shadows.

We used three lights bounced off the ceiling for a smoother effect. One light is coming from the back corner of the room, behind Ann. There wasn't enough space to place a light stand, so that flash unit was placed on its small shoe holder and put on top of a convenient bookshelf. The space limitations also led to the use of the Justin Clamp to hold one of the other bounce flashes to the top of the office door just to camera right.

As with any job where there is an art director in tow, we tried many variations of costume, cup holding, and expression.

The client was impressed with the time savings our new lighting methodologies imparted, and this was important as several of the locations used in the campaign were borrowed and we didn't want to inconvenience the actual occupants. The web campaign was very well received and was immediately fleshed out into a print campaign and direct mail initiative. That illustrates a point: it's always a good idea to shoot at your digital camera's highest resolution settings.

Images 7, 8, 9, and 10. Variations on a theme. Model Ann Phipps as a superhero for Periscope.

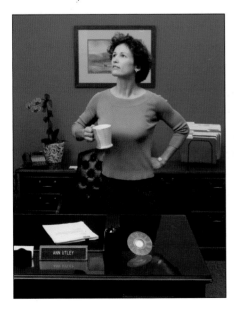

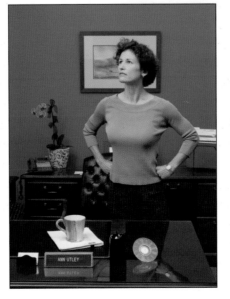

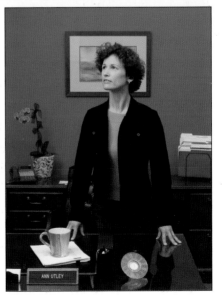

6. THE WRAP-UP

As you've no doubt seen, the entire field of photography is changing very quickly, and nowhere is this more obvious than in the field of lighting. Each year camera manufacturers introduce really cool new products that add more features and more flexibility. I predict that future products will be Wi-Fi enabled and will be controllable from a laptop. Battery power keeps improving, and a logical step for major camera makers will be to incorporate the same rechargeable batteries used in their lines of digital cameras into their semi-pro flash units. I know most photographers would rejoice at having to stock only one type of battery for all their photo gear. It would reduce the variety of chargers required while offering much greater convenience.

Even though the cameras keep improving their high ISO capabilities I don't think we'll ever stop needing to know about good lighting techniques. Skillful lighting is about more than just "correcting" a scene. It's about making a scene and a photograph come alive. The photographers who take the time to understand most of the concepts about lighting are the ones whose photographs will stand apart from the pack and add real value to a project. These will be the photographers who continue to run profitable businesses.

The philosophy behind being a minimalist lighter is really about giving you more choices by giving you less choices. It's more important to select a small, usable kit, and learn to really leverage its potential than it is to have a vast array of options on each project. When you reduce your options you increase your mastery over the instruments you do use. With increased mastery comes the freedom of knowing just what you'll get in every situation. As you simplify your kit you'll enjoy more creative freedom and you'll be a happier photographer.

If you want to know more about lighting, there are a number of excellent web sites that we recommend (see the Resources section at the end of this book). But no matter what you read or what you see, nothing replaces the value of experimenting with new techniques and learning from your own results. With the instantaneous feedback provided by today's digital cameras there is no excuse for not getting to work on your lighting immediately. There's no better time to start!

Kirk R. Tuck
Austin, TX, July 2007

*T*here are an amazing number of choices to be made in every little corner of photography. And because each person brings their own personalized set of preferences and idiosyncrasies there are few areas in which any one product can be clearly identified as the "ultimate" choice. With that in mind I've put together a catalog of companies, websites, forums and stuff together for your convenience. In most categories there are multiple choices and you'll find, through trial and error, which "camp" you belong in. Most research can be done on the web, but where gear and real money are involved you'll want to head to a real "bricks and mortar" establishment and experience the "look and feel" as well as the ergonomics of the items you'll use frequently. For example, I could never buy a camera without holding it. My hands aren't really big and I use a camera for hours at a time. I want to make sure everything falls conveniently to hand because, in my experience, tactile "hiccups" and "glitches" seem to get worse with time, not better.

FORUMS, BLOGS, AND EDUCATIONAL WEBSITES

These are the websites I go to when I want to read reviews of products that interest me, hear about good and bad experiences from other users, and read articles by people who really know their stuff. As with any foray onto the web you'll have to surf with care as some days everyone acts like experts even when they are in total disagreement.

Equipment Reviews

www.dpreview.com—This is the grandaddy of all the review sites. Created by Phillip Askey, the reviews tend to be long and detailed, and it is obvious that the reviewers know their stuff and really look into each feature. If you're contemplating a new camera, this is the place to start.

www.photozone.de—I go for quasi-scientific appraisals of lenses. They test popular lenses with specialized software and the quantitative results make it easy to compare the performance of one brand over another.

www.stevesdigicams.com—If I'm looking for a second opinion about cameras I come here and see how much they agree and disagree with dpreview. Steve's reviews are more subjective, but he tells a nice story for each piece he reviews.

www.luminous-landscape.com—This site attracts a lot of professionals and the owner, Michael Reichman does a good job reviewing lots of very high-end equipment. It may be the "go to" site for medium-format digital cameras on the entire web. His forums are also aimed at professional users and well moderated. Go here to ask questions about more esoteric equipment.

www.reidreviews.com—This site is the elite among sites that review cameras and lenses. Sean Reid is a gifted writer and when he reviews a lens or a camera he may write three to five thousand word essays that don't just give you the numbers but describe the experience of a gifted photographer working through the process of breaking in a new piece of gear. This site is only accessible via yearly subscriptions but for Leica users, rangefinder fans, and people who buy their cameras to make real art, it is priceless.

All About Lighting

www.strobist.blogspot.com—This is the gold mine. David Hobby is a former newspaper photographer who felt like the average impassioned photographer was being sold a Humvee when many times all that is needed is a Toyota Corolla. By that I mean that many photographers are taught

to do lighting based on the "old school" methodologies. David debunks big studio strobes and offers really well-executed examples, along with step by step "how to" advice for the photographer who wants to learn to light well with small lights.

www.photoflexlightingschool.com—This is a commercial site, and they are trying to sell you their products. But the products are pretty good and the information is nicely presented. It's updated frequently and the important thing is that you can glean the why and how of each lesson and they overlay that knowledge with your new insight about small strobes and creative lighting workarounds. I especially like the section about using softboxes.

www.studiolighting.net—This is a smaller site than the two above, but it's got lots of information for people who are trying to do studio quality lighting on a budget.

www.prophotoresource.com—This is a smaller site that brings together a couple dozen successful photographers who write monthly columns about photography. Several commentators routinely write about new ways to light. I write a column about location lighting for them. Sometimes we have rousing arguments. It's a site that's growing quickly by appealing to skilled amateurs who may be looking toward becoming pros.

www.flickr.com/groups/strobist—This is a discussion forum that's tied to the Strobist site listed above. Much good information concerning the creative use of small flashes is discussed on this forum and, thus far the "signal-to-noise" ratio isn't bad. I browse it weekly and am nearly always rewarded with interesting stuff.

LIGHTING EQUIPMENT

www.manfrotto.com—Manfrotto is an Italian company whose products are imported in the United States by Bogen Corporation. I'm listing Manfrotto first because their site is a treasure trove of cool lighting support stuff. Light stands, grip equipment, tripods, articulated arms, clamps and much, much more. Start here on your search for hardware that supports lights.

www.lowell.com—Lowell is a company that started out supplying lights and lighting gear to the cinema and video industries. Their specialty has always been small tungsten and florescent fixtures that are light, rugged and professionally designed. Browsing their site is an adventure in seeing all the ways things can be lit. Part of their site is called Low-

ell EDU and contains really valuable lighting information for beginners as well as more advanced lighters.

www.chimeralighting.com—This is a candy store for fully addicted lighting guys. They are one of the first companies to design, make and market portable softboxes, strip lights, and other modifiers. I use many of their products and have always found their stuff second to none. Take a look at their lighting tutorials for a rich source of new ideas.

www.profoto-usa.com—A Swedish Company, their flash units are the first choice of most rental houses and snobby professionals. But for good reason: These lights are pretty bullet proof and the range of accessories is amazing. For the opposite price range look at the next site down.

www.alienbees.com—There's no other way to say it. These people make the best "plug in the wall" studio strobes for the money on the planet. They are a wacky company run by a true eccentric but they really deliver the goods. And their service is legendary. For less money than a number of hot shoe flashes you can have a real, A/C modeling-light-toting studio flash with all kinds of control. And you can have it in any of five different colors. Go there just to see how different lighting manufacturers can be. "Greetings Earthlings," indeed.

www.metz.de—So, you don't want to buy the flash your camera manufacturer offers? Well, you might be interested in the products from this Germany company. They've been making battery-operated flashes for professionals for many decades and they are the class act in the third-party flash market. I like looking at the German site but if you need buying information you'll need to head to Bogen's site. They are the U.S. distributor.

www.bogenimaging.us—These guys import most of the stuff I use and more of the stuff I lust after for my working gear. They bring in the gold standard of tripods, the French Gitzo, as well as the next tier down of tripods sold under the Bogen and Manfrotto names. They import Metz flashes and a bunch of fun lighting reflectors from Lastolite. If you need to learn more about Metz or tripods, this is the place.

www.henselusa.com—Hensel. When you want a big pop of flash on location and you don't have any place to plug something in, this is one of the manufacturers you'll probably turn to for a really good portable flash. It's not budget gear, but it's the pros' choice.

www.elinchrom.com—Elinchrome is a Swiss company that makes some portable products that compete with

Hensel. Beautiful flash head and pack systems with their own built in batteries for untethered, reliable location lighting. But, as above, this is not the economical solution.

www.fjwestcott.com—Westcott is a manufacturer of tons of cool lighting modifiers and several interesting lighting units. They make collapsible backdrops, collapsible reflectors, as well as photographic umbrellas and softboxes. We use a lighting unit called a Spiderlite TD-5 which houses five fluorescent light bulbs and comes with its own softbox. Sometimes a weird fixture like this is just what the lighting doctor called for.

MAGAZINES

While the web seems to be everybody's first resort for information there's rarely the kind of depth there that avid readers enjoy. Even though predictions concerning the death of print have been rampant for a decade there are still a number of great publications that seem to offer cutting edge information about photography of all kinds. They still tend to set trends and then the web writers take their cues and add the new ideas to their sites. Below is a short list of my favorites. Be aware that magazine choice is a lot like color choice or flavors. It's very much a matter of taste. Head over to a well-stocked book store and hit the magazine section. You'll discover some that I don't cover but you might just like better.

American Photo. Published by the same group that produces *Popular Photography,* this is their upscale, smarter magazine. The editorial staff does a good job balancing articles about business, art, social trends and fine arts with the usual homage to equipment. Not the vehicle to pick up if you are looking for specifications and numerical measures of the latest digital camera, but a good read with a regular nod to documentary and advertising photography as it is practiced by the best.

Photo District News. Sample them at their website, www .PDN-Pix.com. This magazine grew out of a very specialized publication that was dedicated (in the 1980s) to keeping its finger on the pulse of the New York City commercial photo market. It has expanded to serve the entire country and is the reference source for who's doing what in the major markets. The articles are well researched and very up to date. If you want to work in the advertising markets, this is a must.

Digital Photo Pro. Check out their website at www .digitalphotopro.com. These guys are relative newcomers but the magazine has quickly become a solid resource for all things digital. Recent articles include: Reviews of medium format digital systems, extensive articles on raw formats., and humorous articles about marketing and working with models.

BOOKS

There are a number of great specialty books on the market that are indispensable for all levels of photographer. You'll find plenty if you browse the selections offered by my publisher, Amherst Media. Their web site is: www.amherst media.com. Search and you'll find the technical things you need.

The hardest books to come by are the ones that inspire you to be creative and to move forward with your highest and best inspirations. All the talent and insight in the world is nothing if you don't use it and share it. To that end I am recommending one (non-photo) book that has had the most profound effect on my professional life and my enjoyment of photography: *The War of Art,* by Steven Pressfield. This is a small volume with the power to change the lives of artists, writers, and photographers. And I mean big change. Working photographers today face incredible challenges in the marketplace. And keeping up with the latest in digital trends, distribution and sales channels is daunting. It's so easy to fall prey to anxiety and paralysis. This book cuts straight to the point and gives us all a firm pathway to success. I consider it a "must read" for any photographer and for anyone who's feeling "stuck."

INDEX

CHILDREN'S PORTRAIT PHOTOGRAPHY
A PHOTOJOURNALISTIC APPROACH

Kevin Newsome

Learn how to capture spirited images that reflect your young subject's unique personality and developmental stage. $34.95 list, 8.5x11, 128p, 150 color images, index, order no. 1843.

PROFESSIONAL PORTRAIT POSING
TECHNIQUES AND IMAGES FROM MASTER PHOTOGRAPHERS

Michelle Perkins

Learn how master photographers pose subjects to create unforgettable images. $34.95 list, 8.5x11, 128p, 175 color images, index, order no. 2002.

STUDIO PORTRAIT PHOTOGRAPHY OF CHILDREN AND BABIES, 3rd Ed.

Marilyn Sholin

Work with the youngest portrait clients to create cherished images. Includes techniques for working with kids at every developmental stage, from infant to preschooler. $34.95 list, 8.5x11, 128p, 140 color photos, order no. 1845.

MONTE ZUCKER'S
PORTRAIT PHOTOGRAPHY HANDBOOK

Acclaimed portrait photographer Monte Zucker takes you behind the scenes and shows you how to create a "Monte Portrait." Covers techniques for both studio and location shoots. $34.95 list, 8.5x11, 128p, 200 color photos, index, order no. 1846.

DIGITAL PHOTOGRAPHY FOR CHILDREN'S AND FAMILY PORTRAITURE, 2nd Ed.

Kathleen Hawkins

Learn how staying on top of advances in digital photography can boost your sales and improve your artistry and workflow. $34.95 list, 8.5x11, 128p, 195 color images, index, order no. 1847.

LIGHTING AND POSING TECHNIQUES FOR PHOTOGRAPHING WOMEN

Norman Phillips

Make every female client look her very best. This book features tips from top pros and diagrams that will facilitate learning. $34.95 list, 8.5x11, 128p, 200 color images, index, order no. 1848.

THE BEST OF PHOTOGRAPHIC LIGHTING
2nd Ed.

Bill Hurter

Top pros reveal the secrets behind their studio, location, and outdoor lighting strategies. Packed with tips for portraits, still lifes, and more. $34.95 list, 8.5x11, 128p, 200 color photos, index, order no. 1849.

MASTER LIGHTING GUIDE
FOR WEDDING PHOTOGRAPHERS

Bill Hurter

Capture perfect lighting quickly and easily at the ceremony and reception—indoors and out. Includes tips from the pros for lighting individuals, couples, and groups. $34.95 list, 8.5x11, 128p, 200 color photos, index, order no. 1852.

POSING TECHNIQUES FOR PHOTOGRAPHING MODEL PORTFOLIOS

Billy Pegram

Learn to evaluate your model and create flattering poses for fashion photos, catalog and editorial images, and more. $34.95 list, 8.5x11, 128p, 200 color images, index, order no. 1848.

THE ART OF PREGNANCY PHOTOGRAPHY

Jennifer George

Learn the essential posing, lighting, composition, business, and marketing skills you need to create stunning pregnancy portraits your clientele can't do without! $34.95 list, 8.5x11, 128p, 150 color photos, index, order no. 1855.

BIG BUCKS SELLING YOUR PHOTOGRAPHY, 4th Ed.

Cliff Hollenbeck

Build a new business or revitalize an existing one with the comprehensive tips in this popular book. Includes twenty forms you can use for invoicing clients, collections, follow-ups, and more. $34.95 list, 8.5x11, 144p, resources, business forms, order no. 1856.

ILLUSTRATED DICTIONARY OF PHOTOGRAPHY

Barbara A. Lynch-Johnt & Michelle Perkins

Gain insight into camera and lighting equipment, accessories, technological advances, film and historic processes, famous photographers, artistic movements, and more with the concise descriptions in this illustrated book. $34.95 list, 8.5x11, 144p, 150 color images, order no. 1857.

PROFESSIONAL PORTRAIT PHOTOGRAPHY
TECHNIQUES AND IMAGES FROM MASTER PHOTOGRAPHERS

Lou Jacobs Jr.

Veteran author and photographer Lou Jacobs Jr. interviews ten top portrait pros, sharing their secrets for success. $34.95 list, 8.5x11, 128p, 150 color photos, index, order no. 2003.

EXISTING LIGHT
TECHNIQUES FOR WEDDING AND PORTRAIT PHOTOGRAPHY

Bill Hurter

Learn to work with window light, make the most of outdoor light, and use fluorescent and incandescent light to best effect. $34.95 list, 8.5x11, 128p, 150 color photos, index, order no. 1858.

THE SANDY PUC' GUIDE TO
CHILDREN'S PORTRAIT PHOTOGRAPHY

Learn how Puc' handles every client interaction and session for priceless portraits, the ultimate client experience, and maximum profits. $34.95 list, 8.5x11, 128p, 180 color images, index, order no. 1859.

FILM & DIGITAL TECHNIQUES FOR
ZONE SYSTEM PHOTOGRAPHY

Dr. Glenn Rand

Learn how to use this systematic approach for achieving perfect exposure, developing or digitally processing your work, and printing your images to ensure the dynamic photographs that suit your creative vision. $34.95 list, 8.5x11, 128p, 125 b&w/color images, index, order no. 1861.

THE KATHLEEN HAWKINS GUIDE TO
SALES AND MARKETING FOR PROFESSIONAL PHOTOGRAPHERS

Learn how to create a brand identity that lures clients into your studio, then wow them with outstanding customer service and powerful images that will ensure big sales and repeat clients. $34.95 list, 8.5x11, 128p, 175 color images, index, order no. 1862.

LIGHTING TECHNIQUES
FOR MIDDLE KEY PORTRAIT PHOTOGRAPHY

Norman Phillips

In middle key images, the average brightness of a scene is roughly equivalent to middle gray. Phillips shows you how to orchestrate every aspect of a middle key shoot for a cohesive, uncluttered, flattering result. $34.95 list, 8.5x11, 128p, 175 color images/diagrams, index, order no. 1863.

SIMPLE LIGHTING TECHNIQUES
FOR PORTRAIT PHOTOGRAPHERS

Bill Hurter

Make complicated lighting setups a thing of the past. In this book, you'll learn how to streamline your lighting for more efficient shoots and more natural-looking portraits. $34.95 list, 8.5x11, 128p, 175 color images, index, order no. 1864.

PHOTOGRAPHER'S GUIDE TO
WEDDING ALBUM DESIGN AND SALES, 2nd Ed.

Bob Coates

Learn how industry leaders design, assemble, and market their outstanding albums with the insights and advice provided in this popular book. $34.95 list, 8.5x11, 128p, 175 full-color images, index, order no. 1865.

LIGHTING FOR PHOTOGRAPHY TECHNIQUES FOR
STUDIO AND LOCATION SHOOTS

Dr. Glenn Rand

Gain the technical knowledge of natural and artificial light you need to take control of every scene you encounter and produce incredible photographs. $34.95 list, 8.5x11, 128p, 150 color images/diagrams, index, order no. 1866.